PRINT+PRODUCTION FINISHES FOR CD+DVD PACKAGING

LOEWY: LONDON

CONTENTS\\\\\\\\\\\\\\\\\\\\
INTRODUCTION\\\\\\\\ 006
MATERIALS\\\\\\\\\\\\\ 008
FORMATS\\\\\\\\\\\\\\\\ 044
PRINT\\\\\\\\\\\\\\\\\\\\\\ 092
FINISHES\\\\\\\\\\\\\\\\\ 148
GLOSSARY\\\\\\\\\\\\\\\ 184

\\\\ INTRODUCTION

It is an undeniable truth that the music industry has not had the easiest time of late. The advent of MP3 players and the associated file sharing took a sizable chunk out of many companies' profits. Why purchase a CD that has to be physically stored when an entire album can be downloaded digitally in a couple of clicks? And it's not just music. Films are now released, have a limited cinema run and, before you know it, are for sale "three for the price of two." Yet whether it's music or film, each release must still prove profitable, and one of the most obvious areas to cut costs is in packaging.

So many designers are now charged with creating memorable packaging to ever-diminishing budgets. Packaging that has to have standout. Packaging that's brave, not "me too." Packaging that says something about the contents, and the purchaser. Packaging that cries out that it's worth the purchaser's investment in time and money. The item itself—not just its contents—needs to be desirable. It needs to tap into the idea of collecting, and say that a true collection would be incomplete without it.

Bearing all this in mind, what have we discovered? What is the current state of the CD and DVD packaging industry? Well, as this book will demonstrate, we've found that designers are rising to the challenges they face. They're looking at the product, its target audience, and the budget, and are creating hard-working designs. By playing with tactility, surprise, and just creating pretty special pieces, agencies are encouraging CD and DVD purchasers to own and collect. They want people to indulge in the pleasure of unwrapping, opening, and revealing, because this is

something that buying online simply cannot hope to emulate. Designers are creating an emotional experience for people to be part of.

So it's all about buying in. Purchasers are buying into a band or film, but more than this, they're buying into the film or artist's "brand." The content (the actors or musicians, the songs, the film) is a reflection of this brand. So, as well as being tactile and interesting, the packaging must reinforce or enhance the brand. It must say something good about both the brand and, perhaps even more so, the purchaser. The CD or DVD has to be something they can proudly display within their own private collection. Like a coffee-table book, the packaging has to fit within the purchaser's vision of their own personal esthetic. And it must tell a story, excite and inspire, and possess an element of intrigue that makes people want to know what's inside.

This is no small task, so how does an agency go about ensuring people still want to buy and own CDs and DVDs? Split into chapters, this book explores the many ways designers today are making inventive use of packaging to achieve this goal.

"Materials" examines the way designers are moving beyond the much-maligned jewel case, using interesting stocks to reinforce and bolster the design and set the packaging apart from the very first touch.

"Print" looks at unusual print techniques. From letterpress, to fluorescent inks printed directly onto a jewel case, this chapter perhaps best demonstrates what can be achieved on a limited budget.

Within "Format" we again see the move away from the jewel case, with self-enclosed packs and multi-disk boxes, along with other, less common formats, proving evermore popular. Inside the packaging, designers seem to be increasingly dissatisfied with the "standard insert." The necessary information appears in any number of ways: on fold-out posters, note cards, and in books. The list goes on.

In "Finishes" we discuss other print and production techniques—from die-cutting, to embossing, to elaborate pop-ups—that enable designers to create sleek packaging which still serves the purpose of housing the CD. Whether fulfilling a practical requirement, or developing the overall esthetic, many agencies are turning to finishes as a way to add interest to otherwise conventional packaging.

The consistent factor throughout the book? Quality of work, quality of design, and quality of production. In whatever way they're applied, designers are using print and production techniques to create simply good design. Will their efforts be enough to save the hard copy CD and DVD? The jury's out, but we certainly hope so.

\\LOEWY: LONDON
+44 (0)20 7798 2000
\\\\\\\\\\\\\\
\\CREATIVE DIRECTOR
PAUL BURGESS
\\DESIGNERS
PAUL BURGESS
ANDY GREER
BEN EDWARDS
\\\\\\\\\\\\\\
\\WORDS
HANNAH WORTHINGTON
\\\\\\\\\\\\\\
\\ARTWORK
SHANE LOWES
PETE USHER
JAMES JUDGE
\\\\\\\\\\\\\\

MATERIALS \ CD+DVD

\\ART DIRECTOR
MAT JONES

\\DESIGNER
MAT JONES

\\CLIENT
MN2S

\\PROJECT
CD PACKAGE

\\SPECIFICATION
DOUBLE CD
JEWEL CASE
DIE-CUT STICKER
WITH PERFORATION,
FLUORESCENT PINK +
SILVER TRANSPARENT
DIE-CUT CARDS

\\\\\\ 001
\\\\ JONES
\\\\\\\\\\ MN2S MASTERCLASS #01
\\\\\\\\\\ UNITED ARAB EMIRATES \\\\\\\\\\

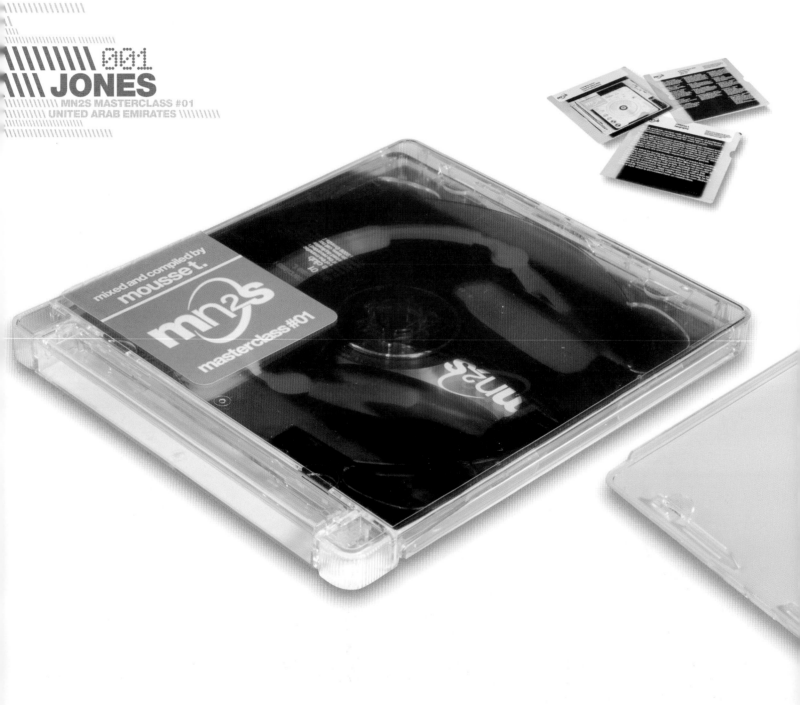

For the release of MN2S's album *Masterclass #01*, Mat Jones wanted to get across the idea of being inside the head of the musician. He used the idea of X-rays to convey this. Replacing the standard insert, a series of die-cut transparencies contains an introduction as well as notes on the musician and his music. A fluorescent pink and silver sticker has been applied to the back and front of the CD, labeling the package as well as holding it together, and forcing users to tear the perforation to open it.

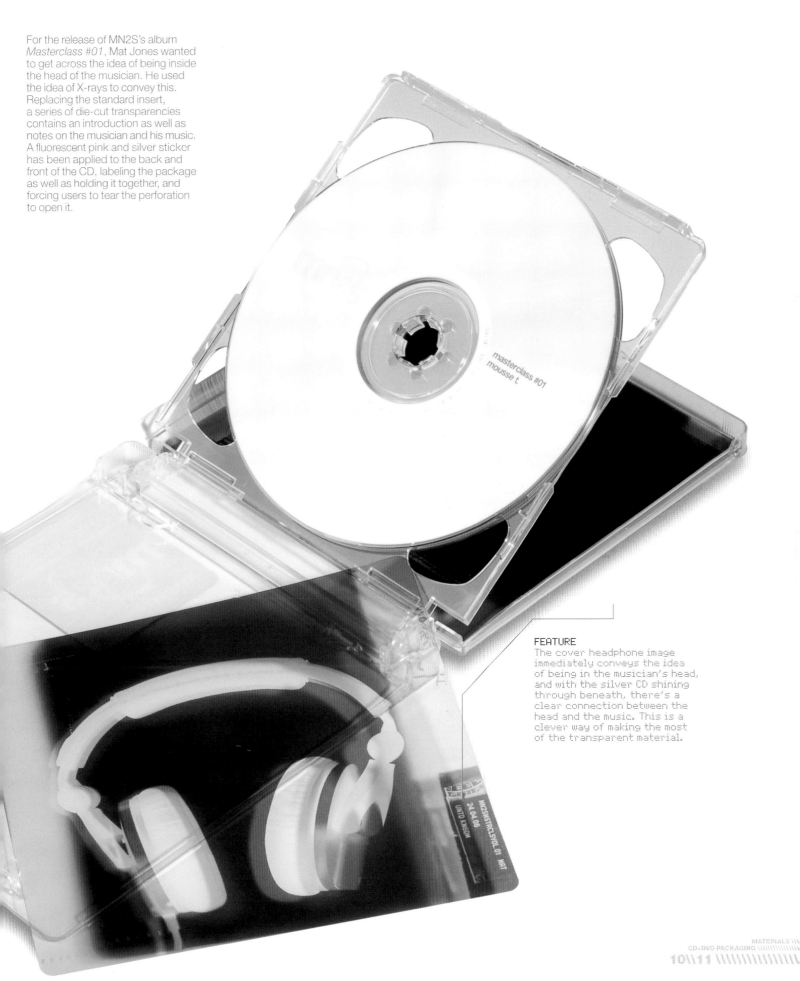

FEATURE
The cover headphone image immediately conveys the idea of being in the musician's head, and with the silver CD shining through beneath, there's a clear connection between the head and the music. This is a clever way of making the most of the transparent material.

\\ART DIRECTOR
CHRIS BILHEIMER

\\DESIGNER
CHRIS BILHEIMER

\\CLIENT
WARNER BROS/WEA

\\PROJECT
LIMITED-EDITION CD PACKAGING

\\SPECIFICATION
WRAPPED BOX WITH
14 POSTERS AND
1 SLIPCASE BOX: MATTE
VARNISH POSTERS:
UNCOATED NEWSPRINT

002
CHRONICTOWN
R.E.M.: AROUND THE SUN
USA

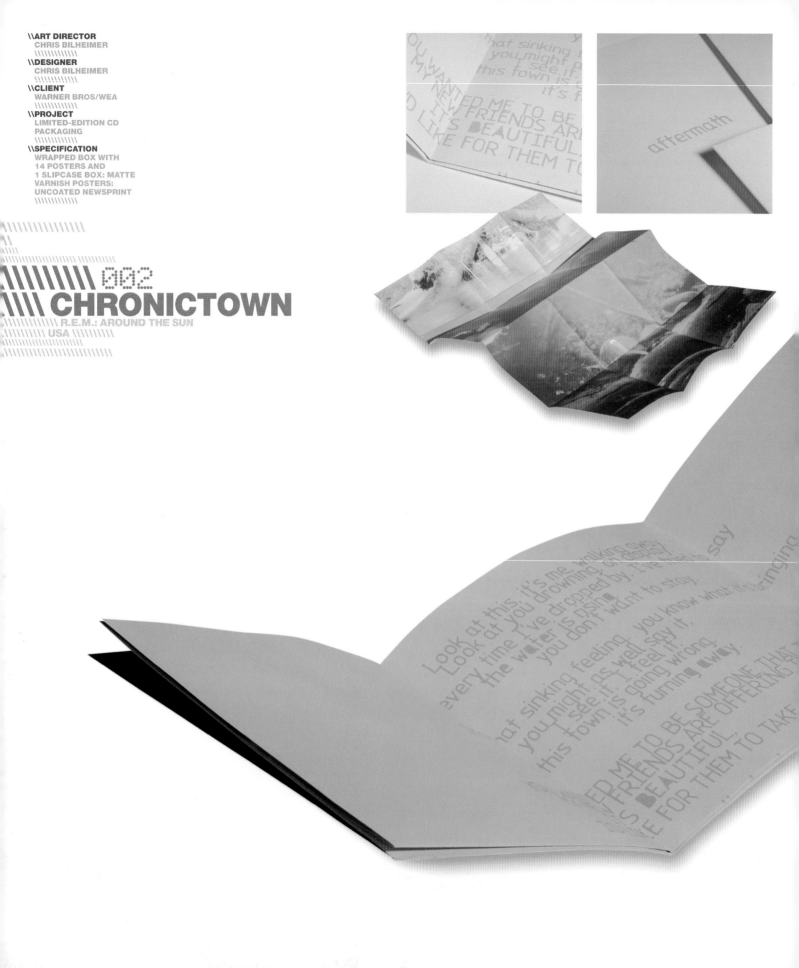

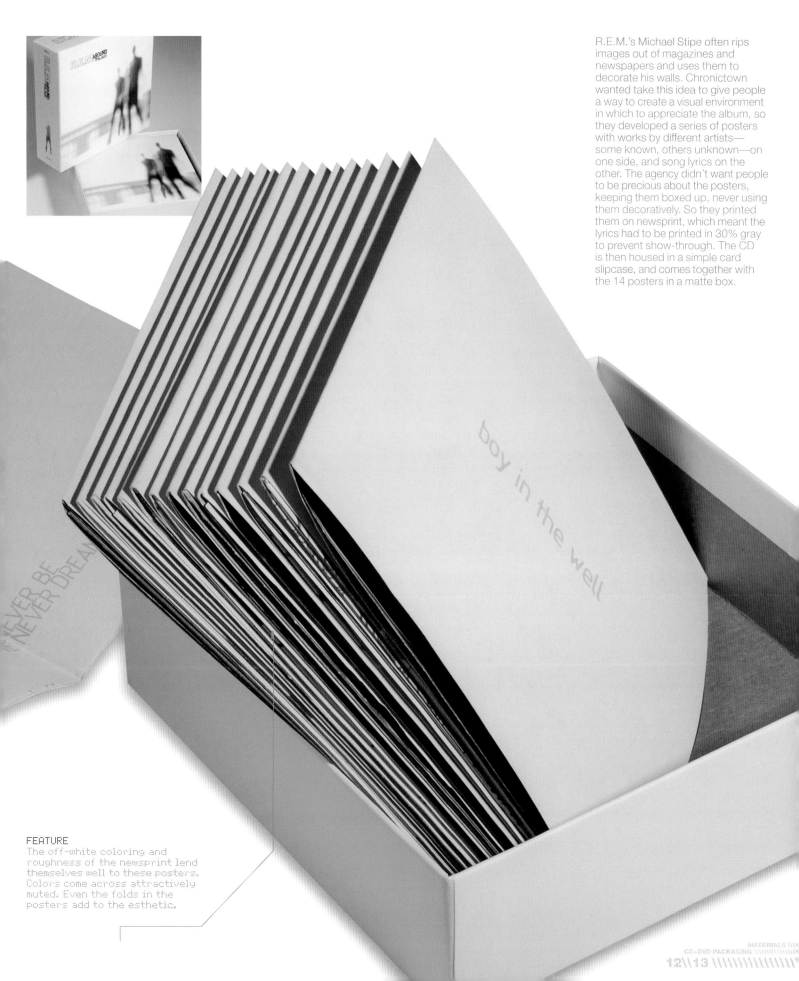

R.E.M.'s Michael Stipe often rips images out of magazines and newspapers and uses them to decorate his walls. Chronictown wanted take this idea to give people a way to create a visual environment in which to appreciate the album, so they developed a series of posters with works by different artists—some known, others unknown—on one side, and song lyrics on the other. The agency didn't want people to be precious about the posters, keeping them boxed up, never using them decoratively. So they printed them on newsprint, which meant the lyrics had to be printed in 30% gray to prevent show-through. The CD is then housed in a simple card slipcase, and comes together with the 14 posters in a matte box.

FEATURE
The off-white coloring and roughness of the newsprint lend themselves well to these posters. Colors come across attractively muted. Even the folds in the posters add to the esthetic.

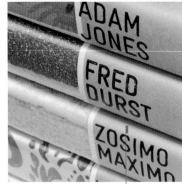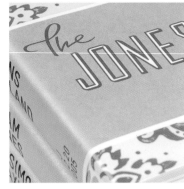

||||||||| 003
PH.D
THE JONESES
USA

FEATURE
As a cost-effective way of naming the DVDs, Ph.D applied adhesive labels to the outside of the packaging. When lined up, the spines produce an appealing "library" effect.

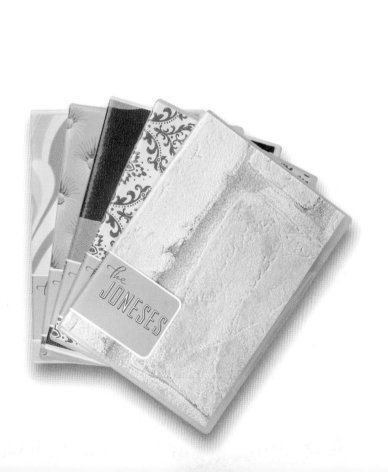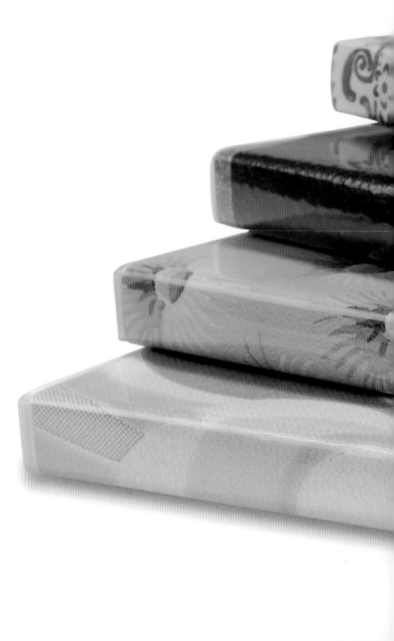

\\ART DIRECTOR
CLIVE PIERCY

\\DESIGNERS
CLIVE PIERCY
JOHN HUGHES

\\CLIENT
THE JONESES

\\PROJECT
DVD REEL PACKAGING FOR COMMERCIAL PRODUCTION COMPANY

\\SPECIFICATION
BOX WITH FULL WRAPAROUND WALLPAPER INSERT AND ADHESIVE LABEL

Produced to promote commercial production company The Joneses, this DVD packaging reflects the individuality of the different directors, while sitting together as a set. Using cut-to-size retro wallpaper as a full wraparound insert, they instantly take us into the suburbs, and the world of "keeping up with the Joneses." With bold designs and colors, the kitsch wallpapers are visually striking, and the clear packs allow the different textures to show through.

While Ph.D initially thought that removing the need for print on the sleeve itself would reduce production costs, vintage wallpapers turned out to be "hellishly" expensive.

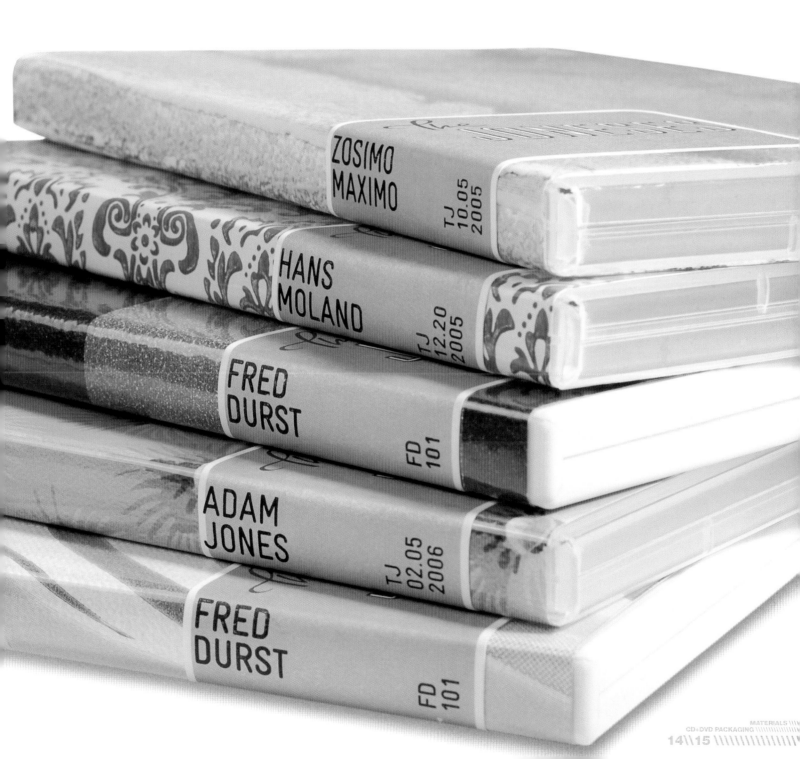

\\ART DIRECTOR
SAM ALOOF

\\DESIGNER
ANDREW SCRASE

\\CLIENT
ANJALI SISTERS

\\PROJECT
CD SINGLE AND SLEEVE

\\SPECIFICATION
LITHO PRINT 1 COLOR (PMS 462U) ONTO RECYCLED BOXBOARD, DIE-CUT AND GLUED 3-PANEL SLEEVE

004
ALOOF DESIGN
ANJALI SISTERS: RA MA DA SA
UK

FEATURE
This cover really plays to its simplicity, using raw materials and clean graphics very effectively. The low budget has in no way hindered the final outcome. It just goes to show what can be done even when both time and money are tight.

This CD features a series of healing mantras sung by classically trained opera singers. Taking this as the inspiration, Aloof Design selected recycled paper, an earthy color palette, and an illustrative style that reinforced the calming, holistic nature of the content. The brief stipulated that the design should incorporate the peony—an iconic flower long associated with healing—so the agency chose to use this as an illustration in a stripped-back and understated way. The typeface (Skia) is similarly soft and natural, and the overall effect is in stark contrast to mainstream CD packaging. The CD itself also plays to this simplicity. Printed in a solid color, the copy and illustration are reversed out, allowing the reflective silver color of the CD to shine through.

So were there any constraints on the project? Well, the CD was launched at a live gig, and time frames and budget were "ridiculously" tight. Aloof completed the entire project—brief to product delivery—in just one week. But the outcome of all this was actually pretty positive, forcing the agency to go with its instincts and removing the complications that can arise in more drawn-out projects.

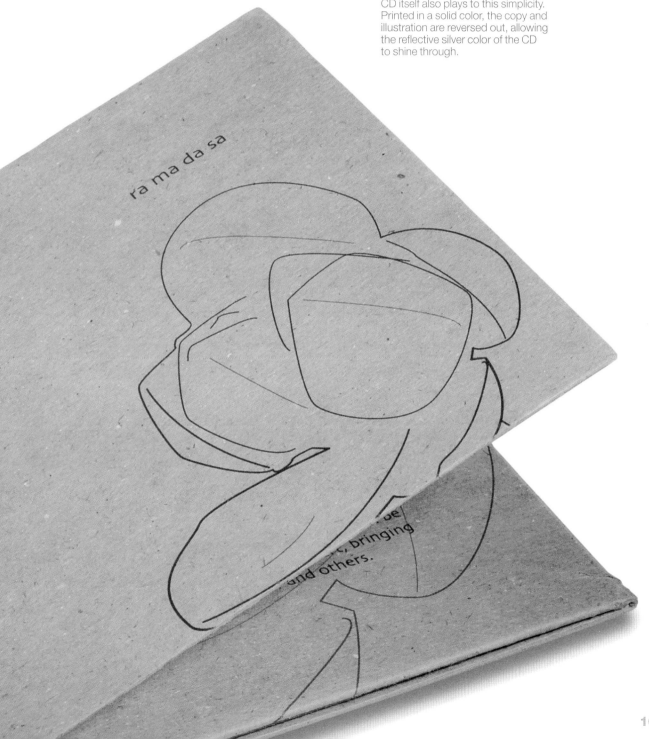

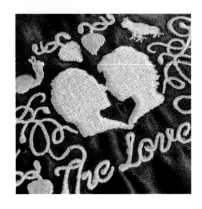

005 PETER AND PAUL
THE LOVERS
UK

Only 1,500 copies of this kitsch, limited-edition album packaging were produced. Taking inspiration from the playfulness of The Lovers' music, the packaging is a tongue-in-cheek take on traditional "romantic" icons. The $11 (£6) handmade silk pouch is trimmed in black lace, filled with vanilla-scented oils, and lavishly embroidered with a gold crest. The whole piece is more "risqué" than "romance," designed to be reminiscent of the scented pouches used within women's underwear drawers rather than a token of love. The "crest" continues the subversion. The man and woman are facing each other, surrounded by hearts and curlicues, but on closer inspection we see that the twirling gold lines actually resemble sperm. And, in place of the standard lion and unicorn, there's a frog and a snail. In contrast to the pouch's silkiness, the cardboard CD wallet is made from a rough, unfinished card, featuring a foil block print of the same crest. The combined elements make a very unusual piece, catering to every sense except taste.

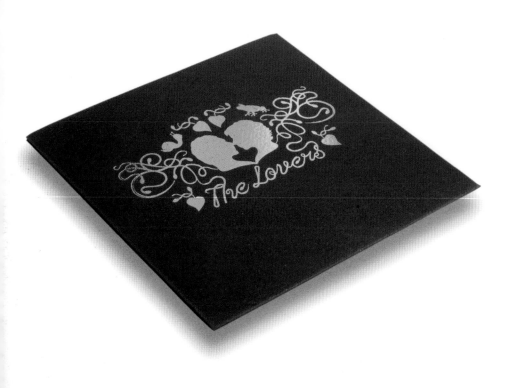

FEATURE
"Handmade" and "silk" are traditionally seen as marks of quality. This pouch challenges those ideas. It's a fun subversion of "romance," taking it to its tackiest extremes. It tells people the band are about fun, not serious love ballads.

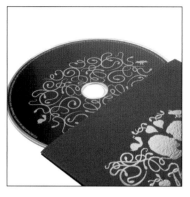
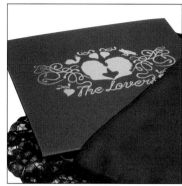
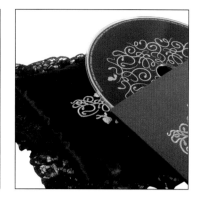

ART DIRECTOR
PETER DONOHOE

DESIGNER
PAUL REARDON

CLIENT
DISCOGRAPH

PROJECT
LIMITED-EDITION ALBUM PACKAGING

SPECIFICATION
POUCH: BLACK SILK WITH LACE TRIM, GOLD EMBROIDERY, AND SCENTED-OIL FILLER
CD WALLET: GOLD FOIL BLOCKING ON CURIOUS ARCHES BLACK

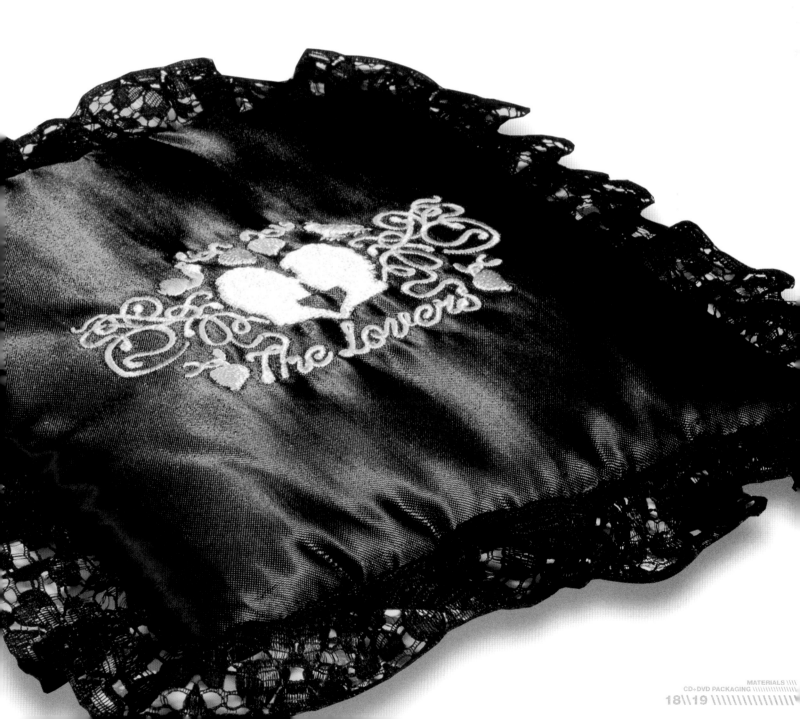

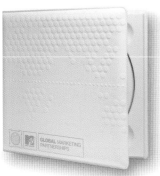

Blast wanted to reflect the modernity of MTV in this project and inspiration came in the form of plastics samples received prior to being commissioned. The agency felt that the rubber echoed this modernity, and the use of different colored materials also suggested diversity. The main constraint on the project was that the packaging had to be fairly generic as each case would house a bespoke presentation. So Blast chose to use a global atlas graphic, but styled in an unusual and modern way, and embossed for a little more subtlety.

\\ART DIRECTORS
GIFF GIFFORD
MARTIN COX

\\DESIGNERS
ANDY MOSELY
DAVID AZURDIA

\\CLIENT
MTV GLOBAL

\\PROJECT
MEDIA SALES PRESENTATION PACKAGING

\\SPECIFICATION
SCREEN-PRINTED, HEAT-SEALED EMBOSSED RUBBER

006 BLAST
MTV: GLOBAL MARKETING PARTNERSHIPS
UK

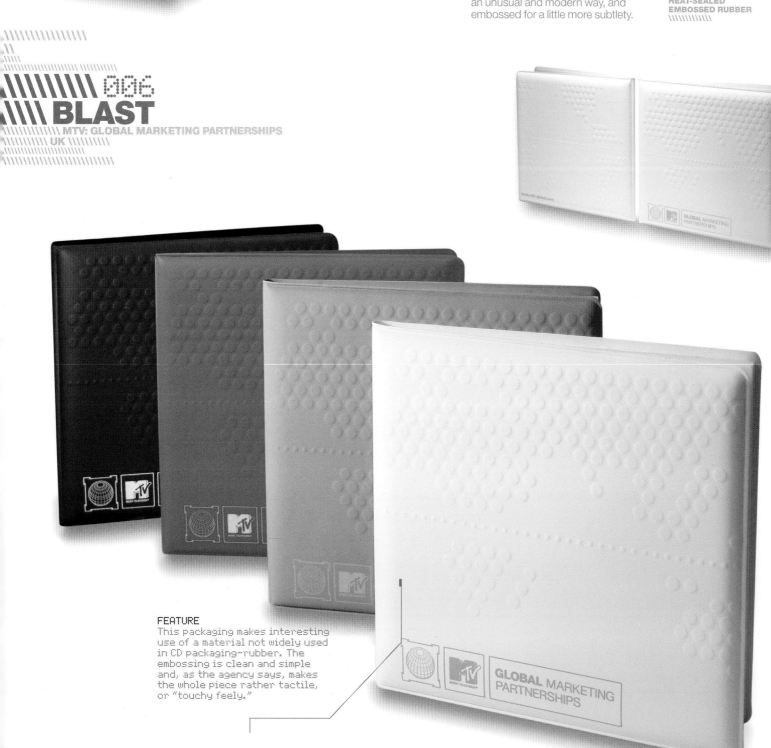

FEATURE
This packaging makes interesting use of a material not widely used in CD packaging—rubber. The embossing is clean and simple and, as the agency says, makes the whole piece rather tactile, or "touchy feely."

Looking to convey her interpretation of the song's sentiment and lyrics, designer Erna Hreinsdóttir commenced working on this project to a tight budget. Reusing spare materials, she took wallpaper samples and handpainted watercolor illustrations, which she then scanned. The wallpaper design is used either within the illustrations or for entire spreads, including the CD label, which sits in a simple die-cut slot.

\\DESIGNER
ERNA HREINSDÓTTIR

\\CLIENT
SELF-INITIATED

\\PROJECT
CD SINGLE PACKAGING

\\SPECIFICATION
HANDMADE COVER
PRINTED USING
HOME INK-JET PRINTER
ONTO CARDBOARD
AND CARTRIDGE PAPER.
STITCHED BINDING

\\\\\\ 007
\\ ERNA HREINSDÓTTIR
THE GREENHORNES: THERE IS AN END
UK

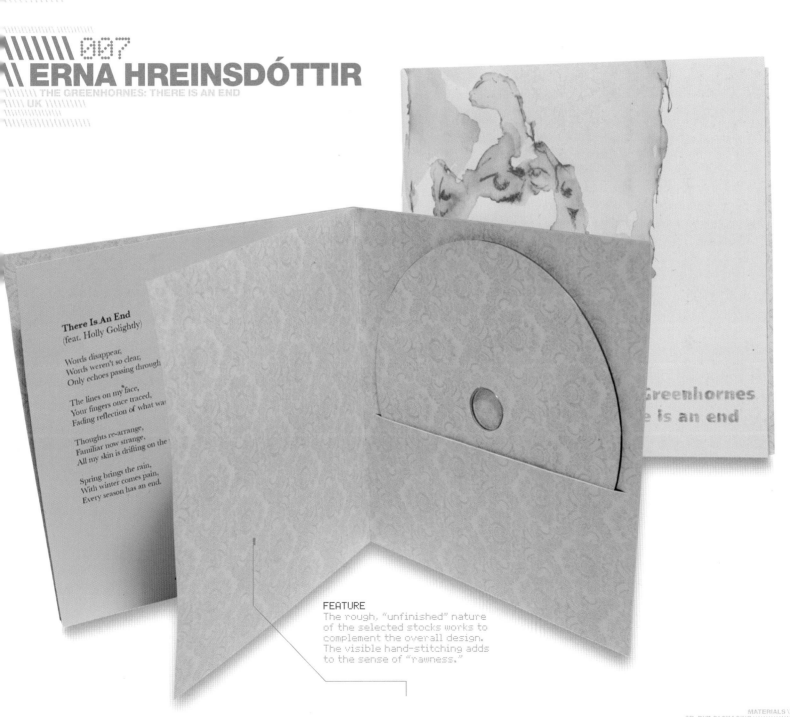

FEATURE
The rough, "unfinished" nature of the selected stocks works to complement the overall design. The visible hand-stitching adds to the sense of "rawness."

008 BLAST
BBC POST PRODUCTION: ARE YOU CLEAR?
UK

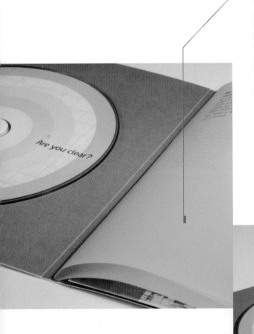

FEATURE
The Canadian-bound front cover of this CD case/booklet adds sturdiness, so the CD can be better held in place. By layering transparent pages, the booklet effectively tells the "story" of the postproduction process, thus demonstrating the final benefit: clarity.

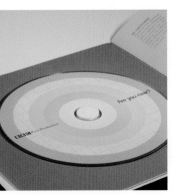

Taking its inspiration from the processes and techniques used by the BBC's postproduction unit, the central theme of this piece is that, as the Spectral pages are turned, the image on the inside back cover becomes clearer. The illustration that is revealed was specially commissioned for the piece, visually describing what the business does, without going into specifics.

"Are You Clear?" had to sit alongside a higher-budget piece called "Focus on You." Produced to adhere to BBC guidelines, Blast overcame the budget restrictions by using slightly cheaper materials and using just two colors for this piece—injecting color with the Spectral lemon pages.

ART DIRECTOR
GIFF GIFFORD

DESIGNER
DAVID ATKINSON

CLIENT
BBC POST PRODUCTION

PROJECT
DVD PROMOTING REMASTERING SERVICE

SPECIFICATION
CANADIAN-BOUND FRONT AND ROLL-FOLD BACK COVER COVER: 2-COLOR PRINT ON SPLENDORGEL TEXT PAGES: 1-COLOR ON SPECTRAL LEMON

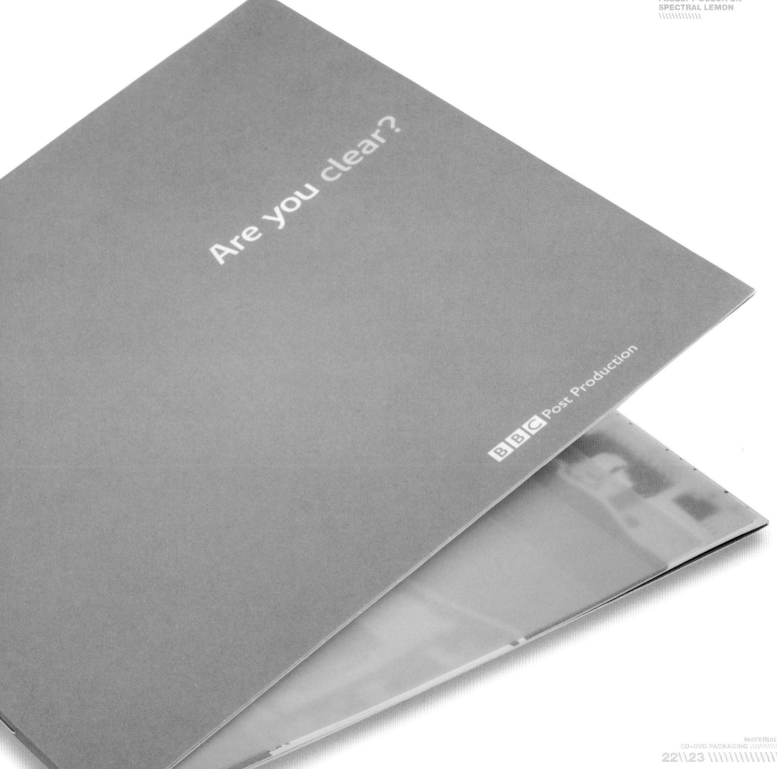

The only constraints on this project were a set budget and the brand guidelines. In other words, the agency had something of a blank slate to work with. It decided to blow the budget on the cover, choosing an unusual stock and making it oversized to give the piece more presence. Its choice of Kapok board then meant that the cover had to be screen printed. As for the inspiration, the agency chose to use a montage of images to communicate the idea of the number of processes involved in postproduction work.

009 BLAST
BBC POST PRODUCTION: FOCUS ON YOU
UK

FEATURE
This CD booklet uses an interesting combination of materials to add texture. The outer cover is very simple and clean, belying the many levels at work, which are revealed as soon as the cover is opened. The varying size and color of pages work with the images to reinforce the overall montage effect.

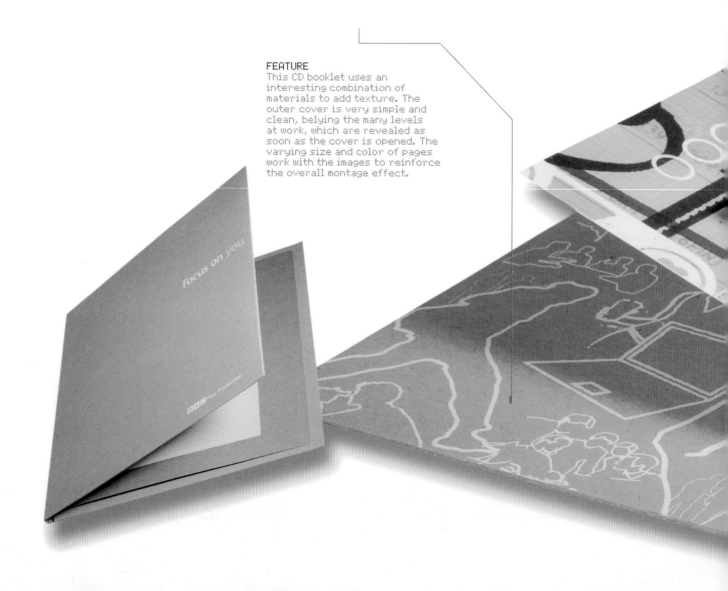

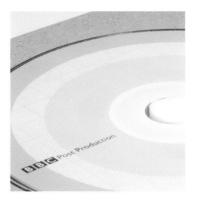

ART DIRECTOR
GIFF GIFFORD

DESIGNER
DAVID ATKINSON

CLIENT
BBC POST PRODUCTION

PROJECT
PROMOTIONAL BROCHURE/
DVD PACKAGING

SPECIFICATION
CANADIAN-BOUND
COVER WITH 8-PAGE
BOOKLET GLUED
INSIDE BACK COVER
COVER: KAPOK BOARD
2-COLOR SCREEN PRINT
BOOKLET: SPLENDORGEL
PRINTED 4 COLOR + 1
SPECIAL, WIRE STITCHED
THEN GLUED IN PLACE

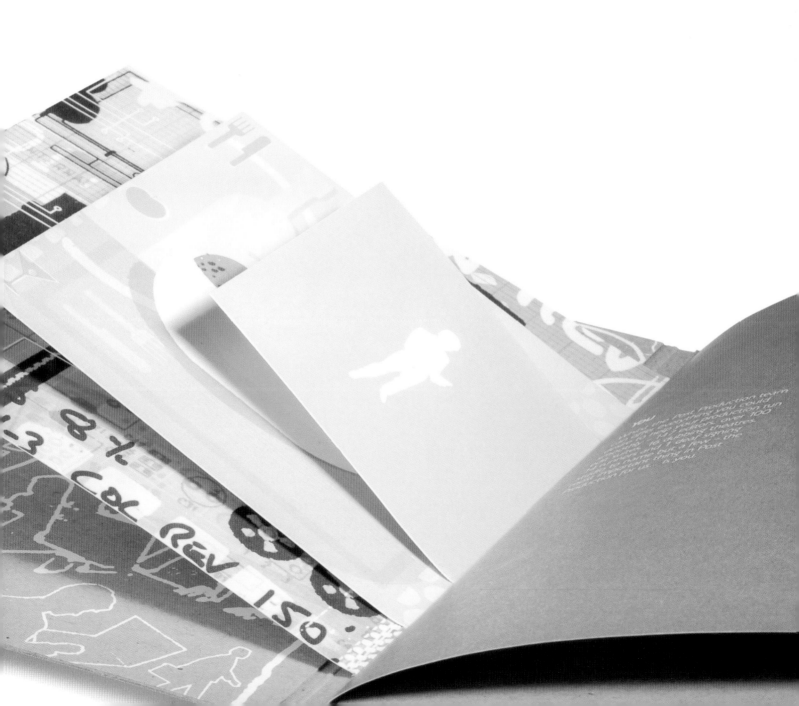

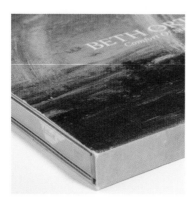

The watercolor on the front of this packaging is owned and loved by the musician Beth Orton. Presented with this, Zip decided to use it as a basis for the CD's design. Wanting to create an "aged" feel, the agency used a highly textured stock for both the slipcase and the outer pages of the insert. While complementing some of the painting's colors, the handwritten notes and hand-drawn illustrations add modern contrast.

\\ART DIRECTOR
PETER CHADWICK

\\DESIGNER
DANIEL KOCH

\\CLIENT
EMI RECORDS

\\PROJECT
CD PACKAGING

\\SPECIFICATION
JEWEL CASE, 8-PAGE INSERT, ONBODY, INLAY WITH SLIPCASE. TEXTURED CHALLENGER STOCK

010 ZIP DESIGN
BETH ORTON: COMFORT OF STRANGERS
UK

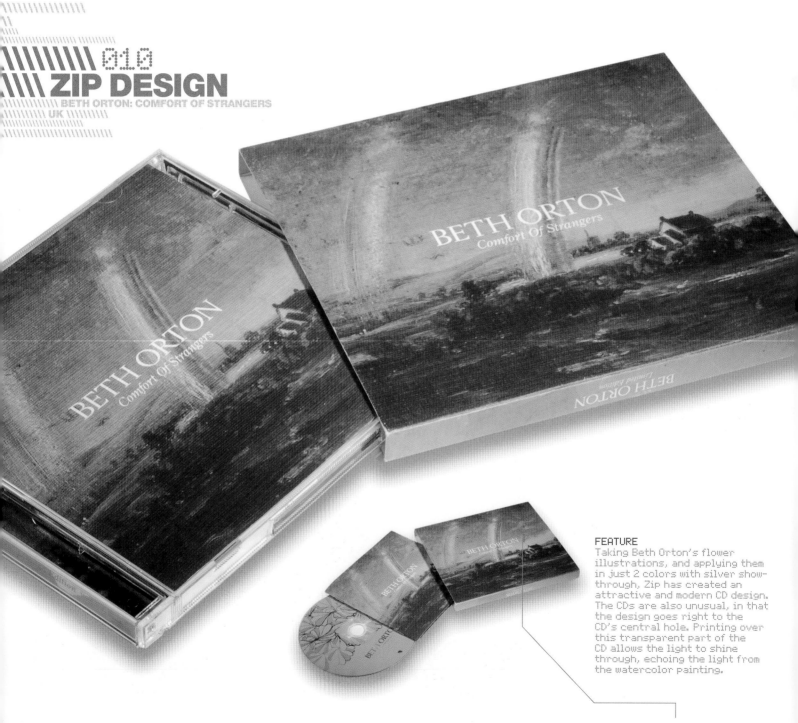

FEATURE
Taking Beth Orton's flower illustrations, and applying them in just 2 colors with silver show-through, Zip has created an attractive and modern CD design. The CDs are also unusual, in that the design goes right to the CD's central hole. Printing over this transparent part of the CD allows the light to shine through, echoing the light from the watercolor painting.

\\\\\\\\\\ 01.1
\\ MADEBYGREGG
\\\\\\\\ THE RED HOT VALENTINES: SUMMER FLING
\\\\\ USA \\\\\\\\

Polyvinyl is an independent record label, and therefore "not flush with cash." In a bid to save money, madebygregg decided to print on the reverse side of a standard Digipak, creating an uncoated effect, rather than paying for a more expensive stock. The agency's inspiration was to mimic the notebook of a "typical grade schooler." The uncoated stock has added to this "homemade" feel, and a handwritten notebook paper insert is glued into the front cover. Being the same age, the band and designer Gregg Bernstein shared memories of decorating schoolbooks with doodles which, in combination with the mini Polaroid photos, form the packaging imagery. Gregg confesses to resorting to dragging in every member of the band, the label, and their girlfriends to handwrite the copy, though, as his own writing is, to quote, "quite illegible."

\\ART DIRECTOR
GREGG BERNSTEIN

\\DESIGNER
GREGG BERNSTEIN

\\CLIENTS
POLYVINYL RECORDS/
THE RED HOT VALENTINES

\\PROJECT
CD PACKAGING

\\SPECIFICATION
STANDARD DIGIPAK
CMYK PRINT ON
UNCOATED STOCK

FEATURE
Matte finishes are prevalent throughout this schoolbook-style piece, from the reversed-out Digipak to the CD's finish. The insert uses a matte stock to replicate schoolbook pages, along with nice finishing touches such as the visible staples.

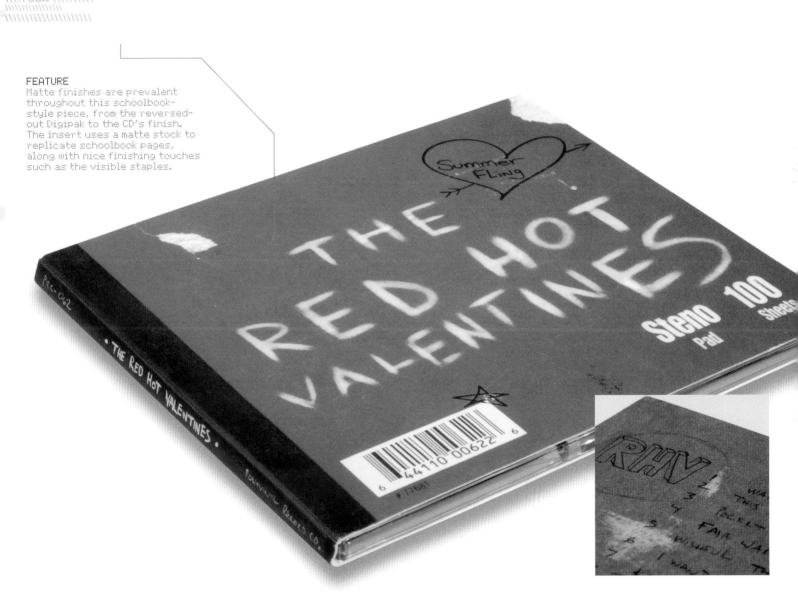

\\DESIGN STUDIO
RED DESIGN
\\\\\\\\\\\\

\\CLIENT
RED RECORDS
\\\\\\\\\\\\

\\PROJECT
LIMITED-EDITION CD BOX SET
\\\\\\\\\\\\

\\SPECIFICATION
**2 MANILA ENVELOPES PRINTED 1-COLOR + 1-COLOR STAMP
5 PHOTOGRAPHS, GLASS LAMINATE
2-COLOR POSTER ON UNCOATED STOCK
BESPOKE HANDMADE CARDBOARD BOX, PLUS STICKERS FRONT AND BACK**
\\\\\\\\\\\\

01.2
\\\\ RED DESIGN
LUCKY JIM: OUR TROUBLES END TONIGHT
UK

FEATURE
There are many elements at play within this packaging, from the bespoke cardboard box and lightweight poster, to the manila envelopes and high-gloss photos. The natural hues reinforce the homegrown element of the music, and combine to create a tactile and interactive product.

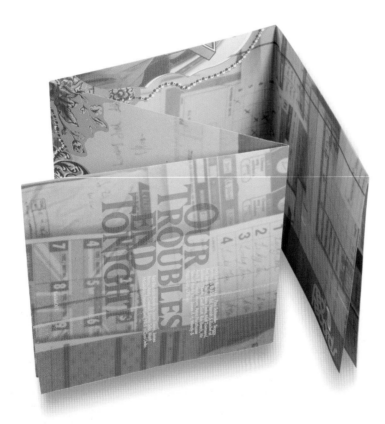
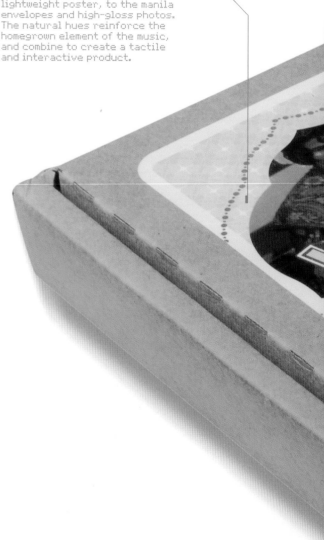

Red Design owns the Red Records label, thus it could afford to have a bit of fun with the design. It wanted the fact that this is limited-edition packaging to be an immediate selling point, and to reflect the "homegrown" nature of the music. Red Design didn't restrict itself to standard packaging, but included "extras" such as the poster and box.

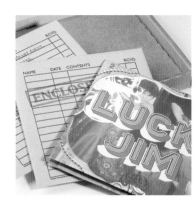

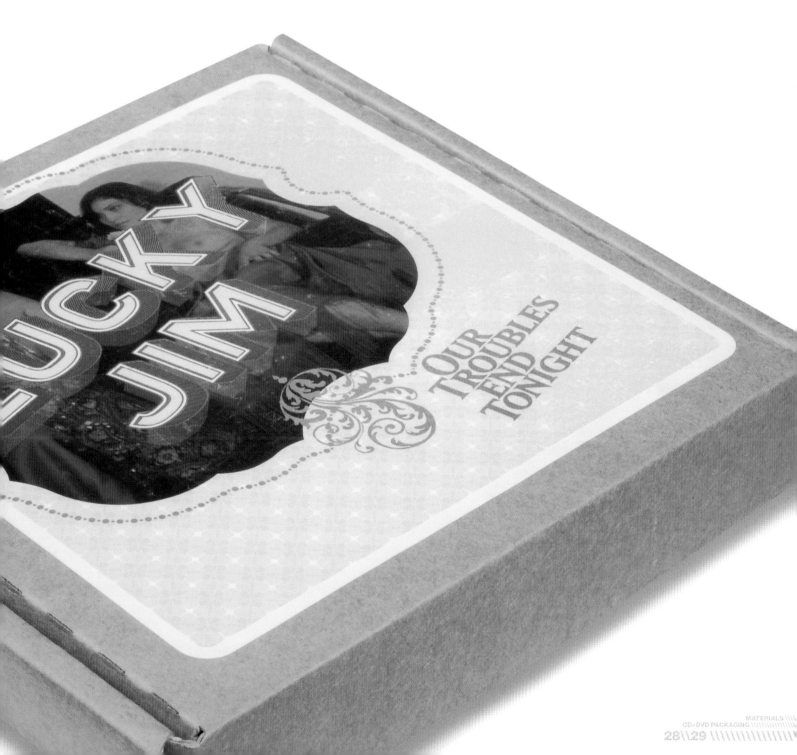

\\ART DIRECTOR
ZACHARY LARNER

\\DESIGNER
ZACHARY LARNER

\\CLIENTS
JOSEPH ARTHUR/
14TH FLOOR RECORDS

\\PROJECT
LIMITED-EDITION CD
PACKAGING

\\SPECIFICATION
DVD CASE: 110-PAGE
HARDCOVER BOOK,
T-SAIFU CLOTH WRAPPED
WITH COPPER FOIL
DEBOSSED STAMP
UNCOATED STOCK

01.3
BOMBSHELTER DESIGN
JOSEPH ARTHUR: WE ALMOST MADE IT
USA

FEATURE
Section-stitched and cloth covered, this piece in no way resembles traditional CD packaging. When the book is closed, there is no indication of the presence of the CD, sitting neatly in the back cover on the rubber nub. Highly sympathetic to Joseph's artwork, the agency has created a piece which is both unusual and ambitious.

Originally pitched to the client as a full-size coffee-table book, Bombshelter Design had to repitch with a smaller format and budget to get the project off the ground. With a print run of just 5,000 copies, the launch marked the first ever book of original art by Joseph Arthur—a musician who creates paintings as he performs on stage. In something of an about-turn for the music industry, the CD was created to accompany the artwork, rather than the other way round. Joseph's sketches and paintings provided the agency with its primary influence.

Choosing to use the images in as large a format as possible, Bombshelter selected an uncoated stock, as it felt this was the best stock for presenting artwork—especially inks, watercolors, and paintings. The book is elegantly finished with a traditional black fabric, then debossed with a simple copper motif. The copper blocking adds real vibrancy.

\\ART DIRECTOR
KATJA HARTUNG

\\DESIGN STUDIO
SOPP COLLECTIVES

\\CLIENT
FERAL MEDIA

\\PROJECT
REPACKAGING OF ALBUM RELEASE FOR AUSTRALIAN MARKET; INDUSTRY PROMO BOX

\\SPECIFICATION
CD SLEEVE: SCREEN PRINT (DOUBLE PRINTED) ON 366GSM BOXBOARD; FM TAB: LOOPED WOVEN LABEL BOX: 2-PIECE BOX, BLACK OPTIX WITH BLACK FOAM BASE AND PAPER TAB FOR LIFTING BOX CONTENTS AND WRAPPER: PHOTOCOPIES ON VARIOUS MATERIALS, PHOTOGRAPH, FEATHERS, MARBLES, LEAVES, ENVELOPE

Feral Media wanted different packaging from the versions already released in the UK to launch Tunng's "Mother's Daughter and Other Songs" into the Australian market. It commissioned the Sopp Collective to produce 500 CD sleeves and 50 promotional packs, which would be sent to radio stations and key people within the music industry. The limited quantities meant the box had to be hand-assembled, and screen printing the box proved more cost-effective than a 4-color offset print. The agency used this to its advantage, making more creative use of materials, print techniques, and finishes. The promotional box contained snippets of information about the band, telling a visual story about it as well as being a keepsake. As for the CD packaging, the woven label was designed to give Feral Media—a small, independent label—visual standout, linking all future releases together. Stitched into every single sleeve, it also reflects the handmade, high quality and creative nature of Feral Media.

01.4 SOPP COLLECTIVES
THIS IS ... TUNNG
AUSTRALIA

FEATURE
This packaging has an air of earthy authenticity about it. The natural colors and uncoated stock work well with the fabric label. What's interesting is that it's not perfect—stray threads have been left to hang loose.

01.5
\ GIULIO TURTURRO
THE COMPLETE ELLA FITZGERALD & LOUIS ARMSTRONG ON VERVE
USA

Looking to evoke a 1950s feel, Giulio Turturro turned to natural materials; no plastics, just paper and metal. Images were photocopied then scanned to add to this sense of age. Combining various complementary stocks, the packaging is highly tactile, and the paper bellyband lets the owner make their own mark when it is torn open. The client specified that the packaging be the same size as a standard jewel case and Giulio decided to create accordion-style packaging, with a silver metallic print on the inside. However, the design proved somewhat complicated as—to fit within budget—the container had to fit within a stock sheet size. In the end Giulio arrived at the solution of using two sheets, but constructed in such a way that it would feel like one.

\\ART DIRECTOR
GIULIO TURTURRO

\\DESIGNER
GIULIO TURTURRO

\\CLIENT
VERVE RECORDS

\\PROJECT
3-CD COMPILATION SET IN CUSTOM-MADE, ACCORDION-STYLE PACKAGING

\\SPECIFICATION
CARD CONTAINER WITH 5 SLOTS, SILVER METALLIC PRINT ON INSIDE; 3 CDS IN PAPER SLEEVES; 2 BOOKLETS; SEALED WITH 2-COLOR PAPER BELLYBAND; DECKLED EDGE BLACK-AND-WHITE PHOTO STUCK ON FRONT

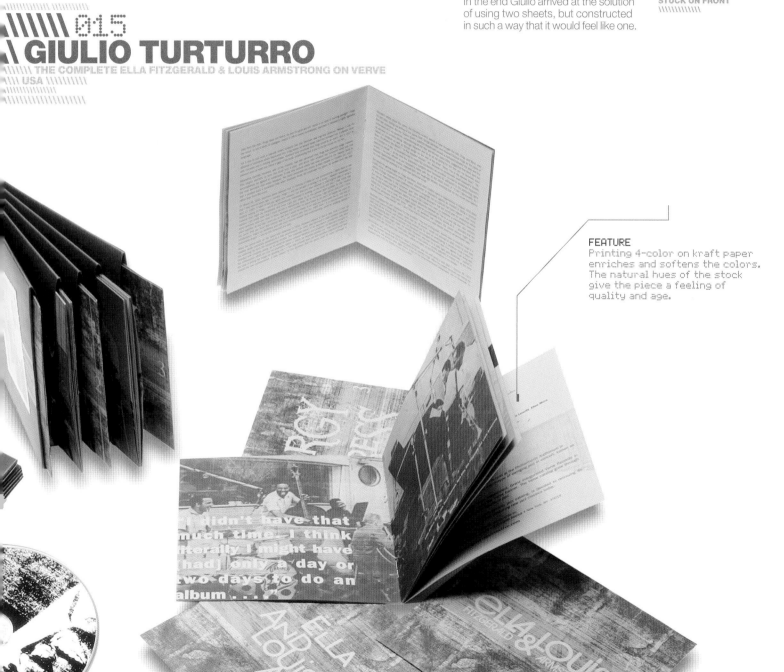

FEATURE
Printing 4-color on kraft paper enriches and softens the colors. The natural hues of the stock give the piece a feeling of quality and age.

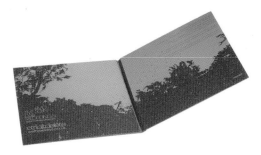

\\ART DIRECTOR
SAM HODGSON

\\DESIGNER
SAM HODGSON

\\CLIENT
MOTIVESOUNDS RECORDINGS

\\PROJECT
CD SLEEVE DESIGN

\\SPECIFICATION
GATEFOLD SLEEVE:
GF SMITH GMUND BIER BOCK 250GSM

Owing to financial constraints, Sam Hodgson had to create a design using just 1 color; an ink that had to be matched to a previously printed CD. The packaging also needed to tie in with a previously released EP, retaining its rustic, homemade feel. Therefore, Sam selected stock that would make the most of color, contrasting strongly without becoming gaudy. The only other project constraint was that, in order to reach a wider audience, the packaging had to be as accessible as possible. As such, it took the form of fairly traditional gatefold CD packaging so that retailers would not refuse to display it. The band had previously switched from logo to logo, so Sam worked to create something of a visual identity that could work here and in future contexts.

It was clear from an early meeting with the band that the design had to encompass something of its ideas or ideology, so designer and musicians worked closely together discussing ways the music could be interpreted visually. The basic concept is that music can be used to change people's moods or states of minds; seeds are planted in the minds of individuals and left to grow. Sam created a flowing and organic typeface and used reversed-out tree silhouettes, as he felt this would lend itself well to the print process. The washed out orange against brown maintains the slightly low-key esthetic, which is also evident on the disc through use of a tint to dull the harsh reflective surface.

016
SAM HODGSON
CTRLALTDELETE: MONDAGREENS
UK

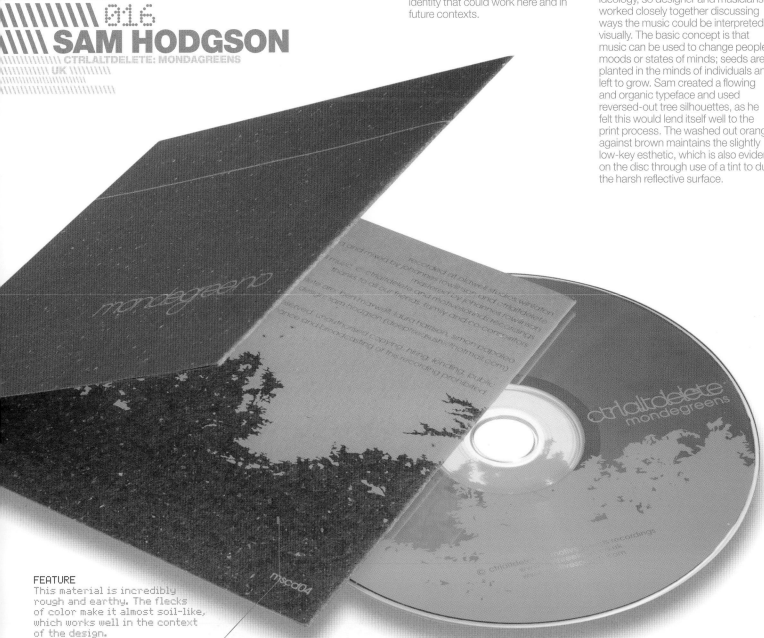

FEATURE
This material is incredibly rough and earthy. The flecks of color make it almost soil-like, which works well in the context of the design.

\\ART DIRECTOR
CARL RUSH

\\DESIGNER
CARL RUSH

\\CLIENT
QDF

\\PROJECT
CD PACKAGING

\\SPECIFICATION
CD BOW WITH
"ANTISTATIC" BAG OUTER

QDF's producer was apparently "obsessed" with outer space, so wanted Crush to create a piece of packaging that would look right at home in a space shuttle. Featuring a graphic representation of a hysteresis loop, the CD is packaged in a silver foil and see-through wrap, similar to the packaging used for space food. A simple sticker is applied to the front as the main label. The agency was briefed to keep the packaging low budget, but found that this helped it to think about the project in a more creative way.

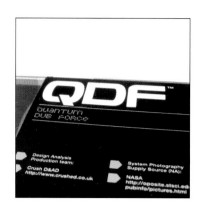

017
\\CRUSH
QDF
UK

FEATURE
Using an unusual material, the agency has managed to differentiate what is otherwise a jewel case CD on a tight budget.

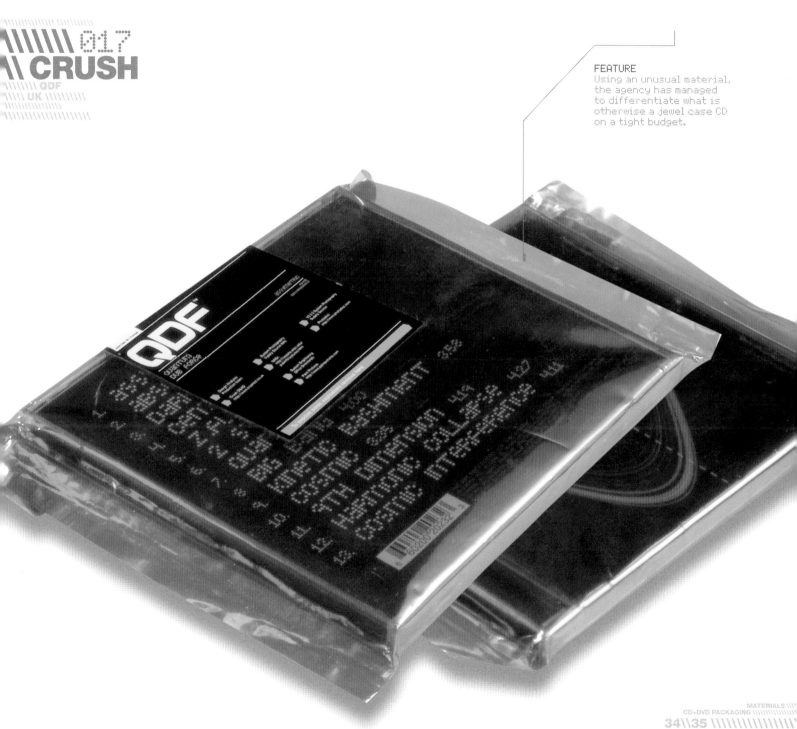

01.8 INTERKOOL
CARSTEN HÖLLER: LOGIC
GERMANY

This exhibition catalog had to contain a lot of information, so Interkool split the content into three parts. First the text—a booklet about the life and works of the artist, Carsten Höller. Second the images—another booklet, in this instance featuring pictures taken from the exhibition. Third and finally, the audiovisual—a DVD about the films shown within the exhibition. The agency wanted a classic and elegant way to include the DVD in this large-format packaging. It settled on a paper-covered wooden CD tray the same size as the booklets, and a high-quality handmade slipcase to hold all the pieces together.

FEATURE
Made from a matte silver fabric with glossy silver foil blocking, this handmade slipcase has a quality art/coffee-table book feel. The fabric also contrasts nicely with the gloss and matte covers of the booklets within.

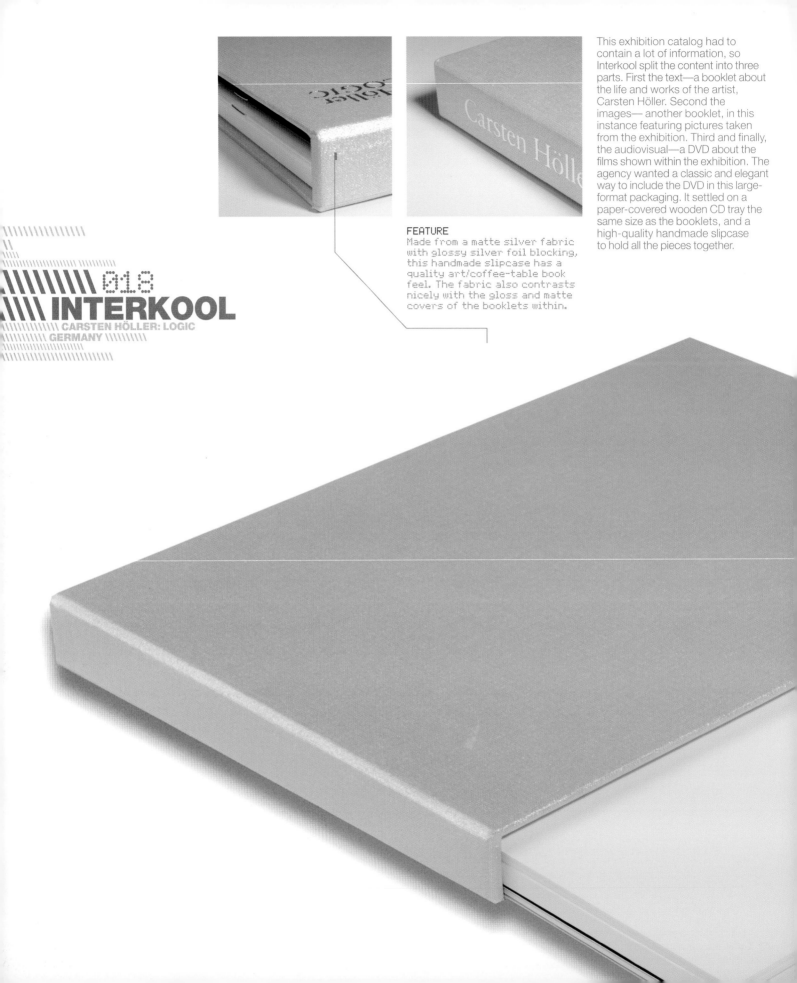

ART DIRECTOR
CHRISTOPH STEINEGGER
\\\\\\\\\\\\\\\\
DESIGNER
CHRISTOPH STEINEGGER
\\\\\\\\\\\\\\\\
CLIENT
GAGOSIAN GALLERY
\\\\\\\\\\\\\\\\
PROJECT
DVD PACKAGING AS
PART OF EXHIBITION
CATALOG
\\\\\\\\\\\\\\\\
SPECIFICATION
HANDMADE DVD
SLIPCASE HIGH-END
PAPER STOCK; PRINTED
WHITE ON SILVER
\\\\\\\\\\\\\\\\

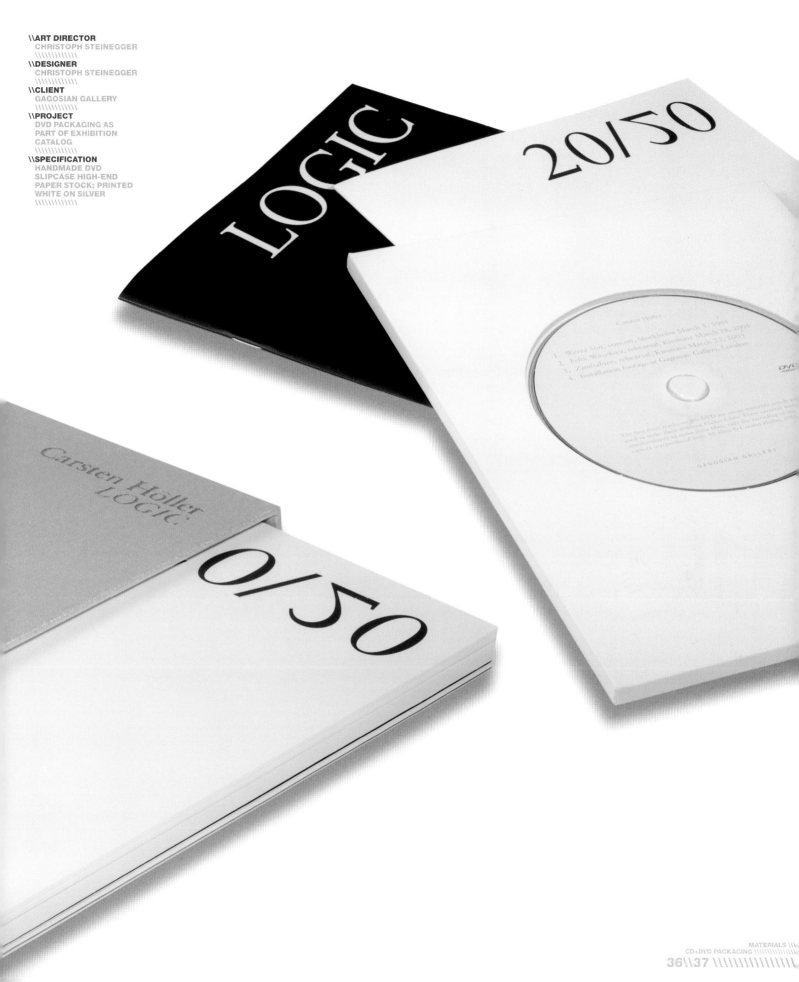

Designed as a promotional piece to attract viewers to the launch of new TV series, "!Huff," this DVD packaging had to hold two DVDs and be sturdy enough to be delivered by mail without being damaged. YESDESIGNGROUP opted for a hardboard box covered in brown linen fabric with foil block labeling. Inside, the agency created a curved flap to hold the first CD, so it would be obvious that another was housed beneath, while providing easy access to both discs.

\\ART DIRECTOR
TIM GLEASON

\\DESIGNER
LORI J. POSNER

\\CLIENT
SHOWTIME

\\PROJECT
DOUBLE DVD PACKAGING PLUS BROCHURES

\\SPECIFICATION
LINEN-COVERED HINGED BOX WITH TURNED EDGE FOIL-STAMPED COVER AND FRONT EDGE 8-PAGE BROCHURE

019 YESDESIGNGROUP
!HUFF
USA

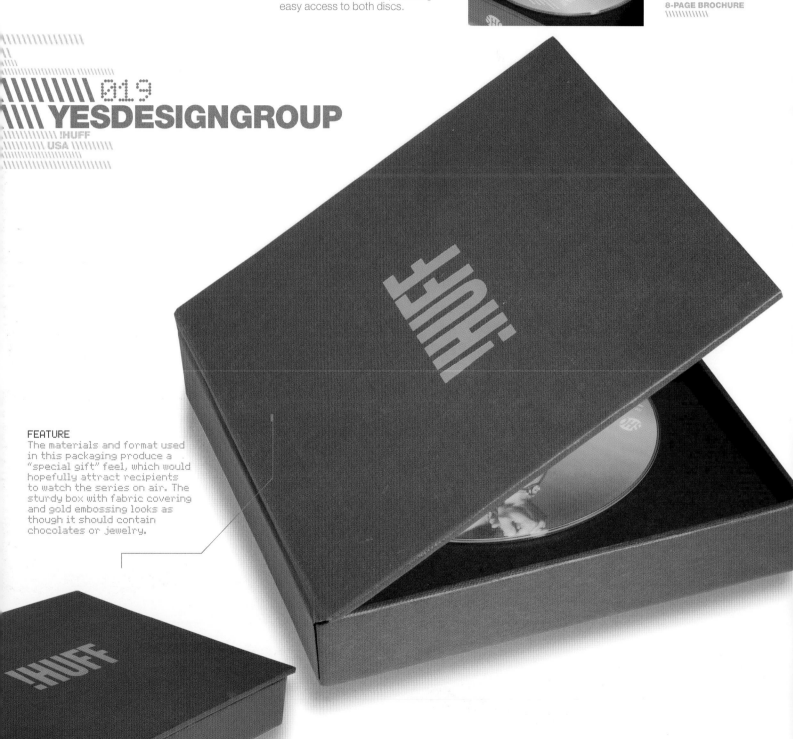

FEATURE
The materials and format used in this packaging produce a "special gift" feel, which would hopefully attract recipients to watch the series on air. The sturdy box with fabric covering and gold embossing looks as though it should contain chocolates or jewelry.

TGB's primary inspiration for this project was sound. The illustrations create a montage of images that represent noise visually. The CD insert is printed on aluminum foil paper. The stock's lack of absorption qualities make it a notoriously difficult stock to print on, so the agency decided on a UV print.

\\ART DIRECTOR
MASARU ISHIURA

\\DESIGNER
MASARU ISHIURA

\\CLIENT
VICTOR ENTERTAINMENT INC.

\\PROJECT
CD PACKAGING

\\SPECIFICATION
ALUMINUM FOIL PAPER WITH UV PRINT

\\ 020
\\ TGB DESIGN
CUBE JUICE: EXPLOSION
JAPAN

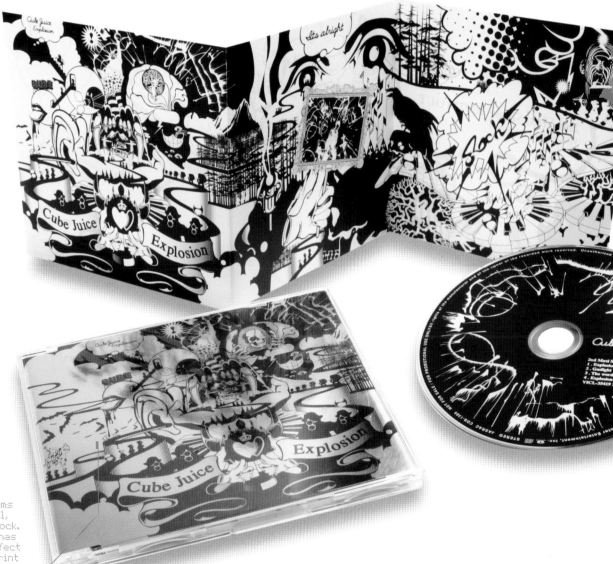

FEATURE
Owing to the inherent problems with printing on aluminum foil, it is an unusual choice of stock. In this instance the agency has used the material to best effect by opting for a 1-color UV print throughout.

\\\ 021
\\\ ILUMINURAS
\\\ GIL & MILTON
\\\ BRAZIL

Commemorating the meeting of two of Brazil's most famous musicians, Gilberto Gil and Milton Nascimento, this packaging was designed to resemble an old family photo album. The recycled stock and printing colors were chosen for their texture and natural hues, reflecting the artists' skin tones. The gold foil blocking further complemented the color palette while highlighting the artists' names. Unusually, the CD is housed within specially designed flaps on the inside cover. Owing to high print costs in Brazil, this packaging was reserved for the limited-edition release, with a jewel case version also produced.

\\ART DIRECTORS
CRISTINO PORTELLA (CONCEPT AND GRAPHICS) ISABEL DUEGUES (PHOTOS)

\\DESIGNER
CRISTINO PORTELLA

\\CLIENT
WARNER MUSIC BRASIL

\\PROJECT
DELUXE EDITION CD PACKAGING

\\SPECIFICATION
HARDCOVER RECYCLED PAPER 1 PANTONE COLOR PRINT + 4-COLOR INSERT ON COATED STOCK GOLD FOIL STAMPING 35-PAGE BOOKLET ON LIGHT YELLOW 120GSM OFFSET STOCK, 4-COLOR PRINT LABEL: SCREEN PRINTED IN 3 COLORS

FEATURE
The uncoated stock has been used to create three flaps inside the front cover which protect the CD. The rounded design echoes the circular graphics and the organic nature of the whole piece.

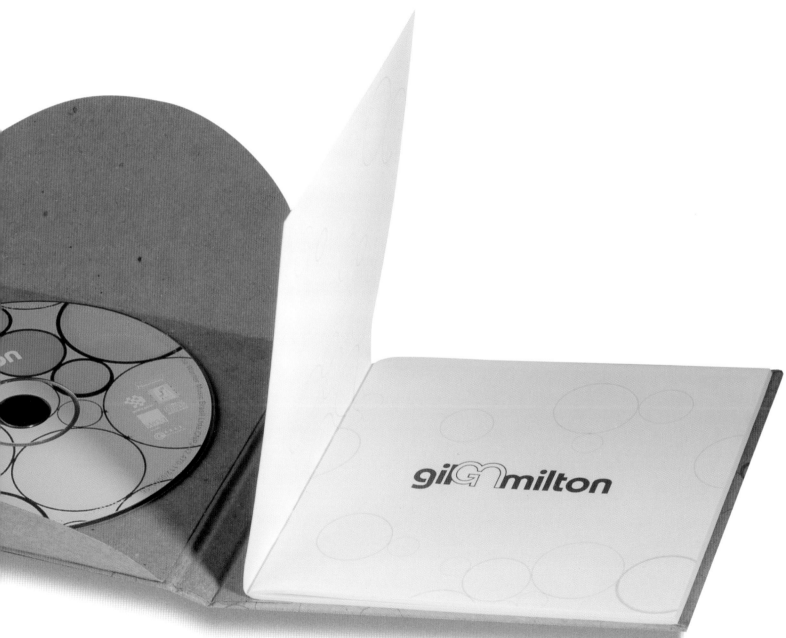

\\ART DIRECTOR
CHRIS BILHEIMER

\\DESIGNER
CHRIS BILHEIMER

\\CLIENT
WARNER BROS/WEA

\\PROJECT
LIMITED-EDITION
CD PACKAGING WITH
BONUS CD

\\SPECIFICATION
ACETATE O-CARD WITH
3-COLOR SPOT PRINT;
DOUBLE SLEEVE
CARDBOARD CASE
40-PAGE 4-COLOR
BOOKLET

For this compilation of R.E.M.'s work, Chronictown used halftone dots to represent a collection of previously published music. The dots are purposely misregistered, creating something of a scrapbook effect. The piece includes a roll-fold double CD sleeve and newsprint fold-out poster of the band, as well as a scrapbook-style booklet.

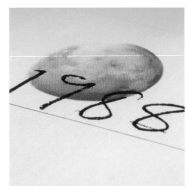

022 CHRONICTOWN
THE BEST OF R.E.M.: IN TIME 1988–2003
USA

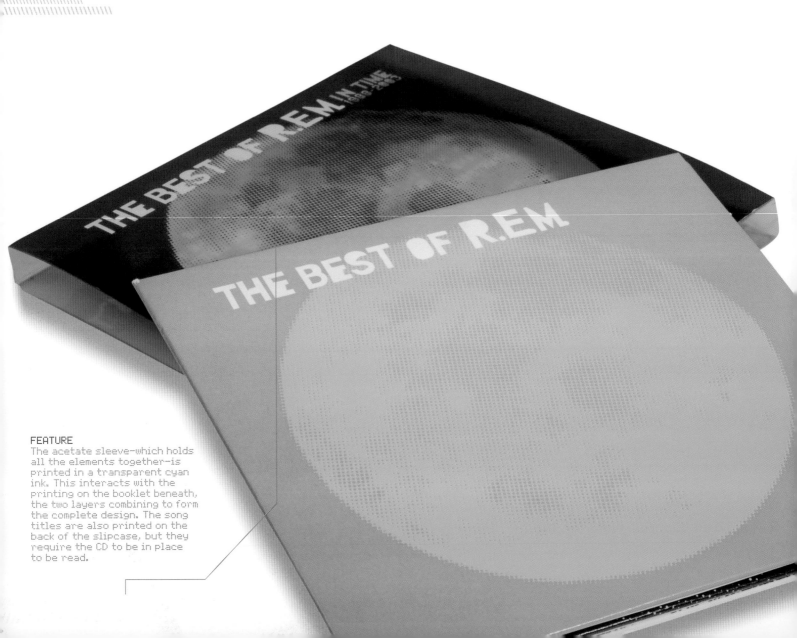

FEATURE
The acetate sleeve—which holds all the elements together—is printed in a transparent cyan ink. This interacts with the printing on the booklet beneath, the two layers combining to form the complete design. The song titles are also printed on the back of the slipcase, but they require the CD to be in place to be read.

\\ART DIRECTORS
CARLOS SEGURA
TNOP
CHRIS MAY

\\DESIGNER
CARLOS SEGURA

\\CLIENT
Q101 RADIO, CHICAGO

\\PROJECT
PROMOTIONAL CD

\\SPECIFICATION
ENVELOPE, BELLYBAND, JAPANESE PAPER, ROLL-FOLD, GLUED-IN INSERT, UNCOATED STOCK, PERFORATED FORM, DIE-CUT POCKET

Released as a promotional CD by Q101 Radio, *An Alternative Ritual* invites people to enter a competition to see The Red Hot Chili Peppers live in Italy. Enclosed within an envelope and bellyband, the outer packaging is made from a Japanese paper that Segura has not seen used since; it is very expensive. Open the packaging and it reveals a 10-page, roll-fold, glued-in insert on uncoated stock. Smaller than the outer case, it details the competition and has a perforated entry form at the end. Finally, behind the roll-fold we discover the CD itself within a die-cut pocket. Cut to an unusual shape, it works with the CD print to create something of a "jaws" effect.

023
SEGURA INC.
AN ALTERNATIVE RITUAL: THE Q101 PARTY
USA

FEATURE
The packaging incorporates multiple paper stocks that work in harmony as all are uncoated. The unusual Japanese outer paper immediately gives the piece standout.

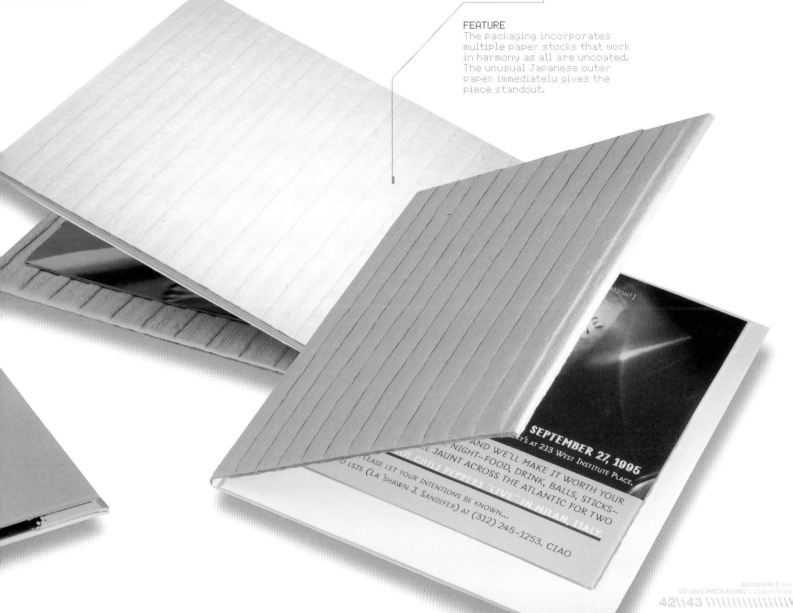

FORMATS CD+DVD

024
BRUNO PORTO COMUNICAÇÃO
THE BEST OF THE DROPPIN' SIDES: PIRATAUTORIZADO
BRAZIL

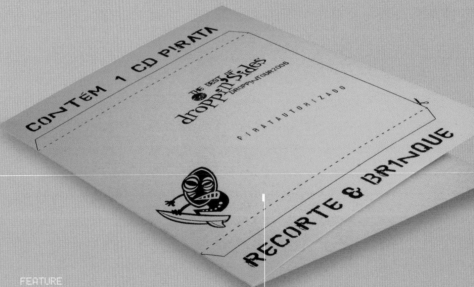

FEATURE
There is a sense of simplicity, humor, and rawness in this packaging. The idea behind the title Piratautaorizado, which means "authorized pirate," pervades everything from the warning note and instructions, through to the stock, type, and basic stapling mechanism. The packaging is clearly cheap, but intentionally so.

\\ART DIRECTOR
BRUNO PORTO

\\DESIGNER
BRUNO PORTO

\\CLIENT
THE DROPPIN'SIDES

\\PROJECT
CD PACKAGING

\\SPECIFICATION
180G ORANGE MARRAKESH PAPER, LASERJET PRINTED, FOLDED IN HALF, AND STAPLED TO HOLD THE CD IN PLACE

Bruno Porto Comunicação (BPC) was commissioned to produce low-cost CD packaging for Brazilian surf music band the Droppin' Sides when the original run of its CDs sold out. The general idea was that the band could run out a few copies of the CD and packaging to sell to fans at gigs for the price of a couple of beers. The CD is stapled inside, so the buyer just needs to remove the staples and follow the "dummy's instructions" to assemble their own CD sleeve.

The packaging is basically a parody of/homage to JA & Brad Klausen's designs for Pearl Jam's live concert albums (fully credited on BPC's packaging), with type designed by Brazilian typographers Bily Bacon and Marcello Rosauro. To maintain consistency with the original CD artwork, the cover features the band's logo and a Marcelo Martinez illustration. But—so as not to mislead people, and to inject a little humor—the CD's clear WARNING tells people not to expect any hidden bonuses.

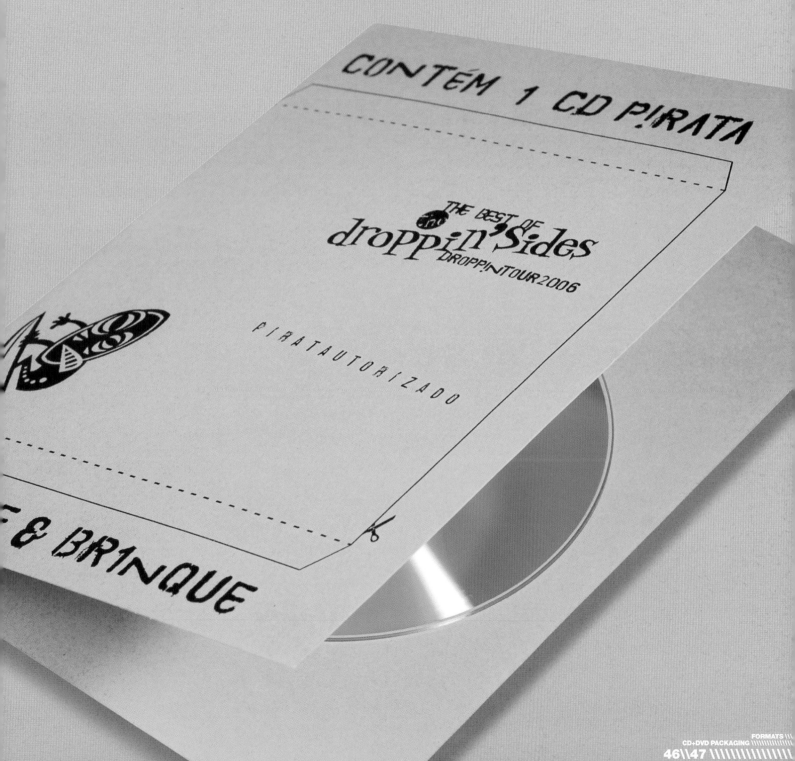

\\ART DIRECTOR
SEAN WOOD
\\DESIGNER
SEAN WOOD
\\CLIENT
SONY PLAYSTATION 2
\\PROJECT
PRESS PACK
TO PROMOTE
GAME LAUNCH
\\SPECIFICATION
CD, WIRE-O BOUND
INSTRUCTION MANUAL,
MOCK POLAROID
PICTURES, HUMAN HAIR,
FOAM-LINED METAL TIN,
BROWN PAPER, AND
TAPE OUTER WRAPPING

025
999 DESIGN
THE GETAWAY PRESS PACK
UK

Designed to promote the launch of *The Getaway* for the PlayStation 2 in the UK and Europe, 999 Design wanted to create a press pack ransom-note package with an authentic look and feel—mirroring the theme of the game itself. Sent to games journalists wrapped in brown paper, the tin pack resembles a foam-lined gun case and contains a doctored A to Z instruction manual, Polaroid stills from the game, a sample of human hair, as well as a press disc of the game itself. And the greatest challenge the agency faced? Getting permission to use UK Ordnance Survey maps—and real human hair.

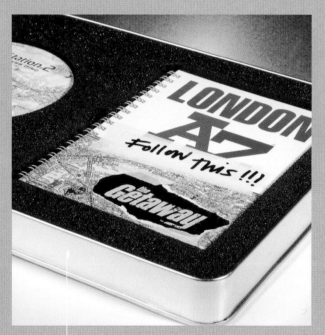

FEATURE
There are lots of elements at play in this pack that combine to produce a piece with real standout. It's clearly a very polished end product, but touches such as the brown-paper-and-tape wrapping, and scrawled marker handwriting make it feel more authentic.

\\ART DIRECTOR
HENRIK WALSE

\\DESIGNER
HENRIK WALSE

\\CLIENT
BAD TASTE RECORDS

\\PROJECT
CD SLEEVE

\\SPECIFICATION
DIGIPAK, 4-COLOR CMYK
AND PANTONE GRAY

The agency decided to recreate the band's logo as a 3-D plastic model as a starting point for this packaging design. Walse Custom Design felt this would give a better final result than computer-generating a 3-D image. Other than this, the design is relatively straightforward and clean, making use of gray type. This gives a certain drama to the splashes of red "blood."

FEATURE
The CD's insert is a simple 10-page roll-fold, heavily typographic, with a single large image. This simple approach is unusual within CD packaging. Most would prefer to use a more easy-to-hold booklet, but the panoramic effect works well for the insert's content.

026
WALSE CUSTOM DESIGN
DANKO JONES: SLEEP IS THE ENEMY
SWEDEN

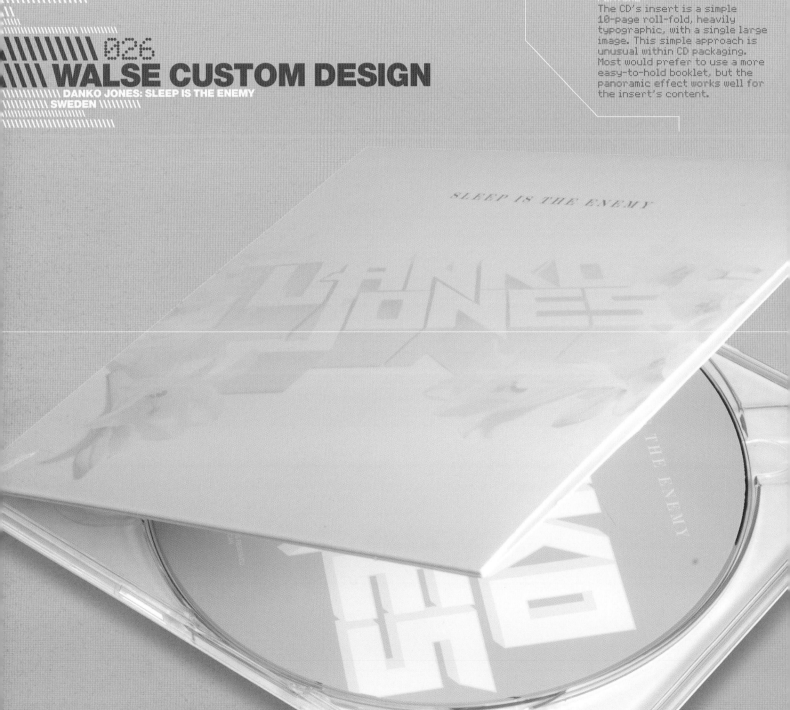

\\ART DIRECTOR
STEFAN SAGMEISTER

\\DESIGNER
MATTHIAS ERNSTBERGER

\\CLIENT
RHINO

\\PROJECT
CD BOX SET

\\SPECIFICATION
MATTE-LAMINATED COVER WITH ELASTIC SLIP BAND; 100-PAGE PANORAMIC BOOKLET

If it's true that a good CD cover has to feature a bear, a dismembered limb, and a naked person, then the Talking Heads *Once in a Lifetime* box set has the makings of something truly great: 3 bears, 12 frolicking nudes, and a fair few severed body parts. Combining a book and CD packaging; and containing a time line, a retrospective of the band's albums to date, extensive essays, and over 100 rare photos, the extreme panoramic format has the added benefit of preventing shoppers from accessing any of the competition's CDs stored behind it.

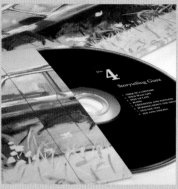

FEATURE
Sagmeister has used this unusual extreme panoramic format to the full, particularly in its selection of archive images. The packaging also features 5 "invisible" pockets, housing the CDs which are sheathed in cardboard sleeves. The elastic fastening mechanism is an original way of holding the whole piece together.

027
\SAGMEISTER, INC.
TALKING HEADS: ONCE IN A LIFETIME
USA

\\ART DIRECTORS
GIFF GIFFORD
MARTIN COX
\\DESIGNER
MARTIN COX
\\CLIENT
D&AD
\\PROJECT
PROMOTIONAL CD-ROM
\\SPECIFICATION
1-COLOR SCREEN PRINT ONTO CD. OFF-THE-SHELF PLASTIC WALLET WITH STICKER AFFIXED. CONCERTINA-FOLD INSERT LEAFLET PRINTED 4-COLOR AND DIE-CUT

These miniature CD-ROMs were handed out, with a set of fake vampire teeth, to designers and art directors at D&AD events. Designed to promote the charity's Bloodbank on-line talent database, the piece has obviously taken "blood" as inspiration and continued it throughout, from the CD printed to look like a red blood cell, through the vampire teeth imagery and die-cut teeth marks on the folded insert. As D&AD is a charity, the budget was low, which led Blast to selecting off-the-shelf plastic wallets with a sticker attached and a 1-color print on the CD itself. Typography throughout is clean, fresh, and unobtrusive.

028 BLAST
D&AD: GETTY IMAGES BLOOD BANK
UK

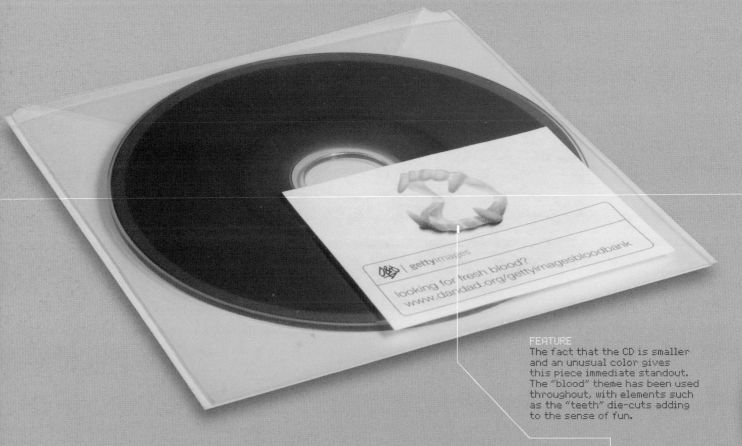

FEATURE
The fact that the CD is smaller and an unusual color gives this piece immediate standout. The "blood" theme has been used throughout, with elements such as the "teeth" die-cuts adding to the sense of fun.

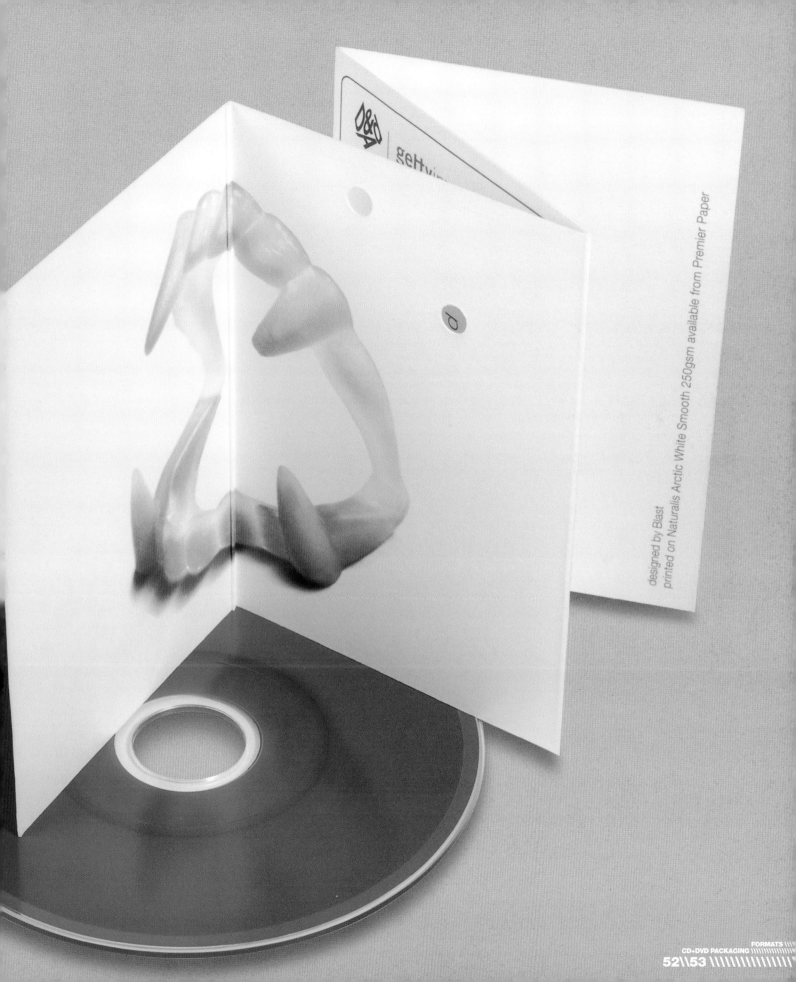

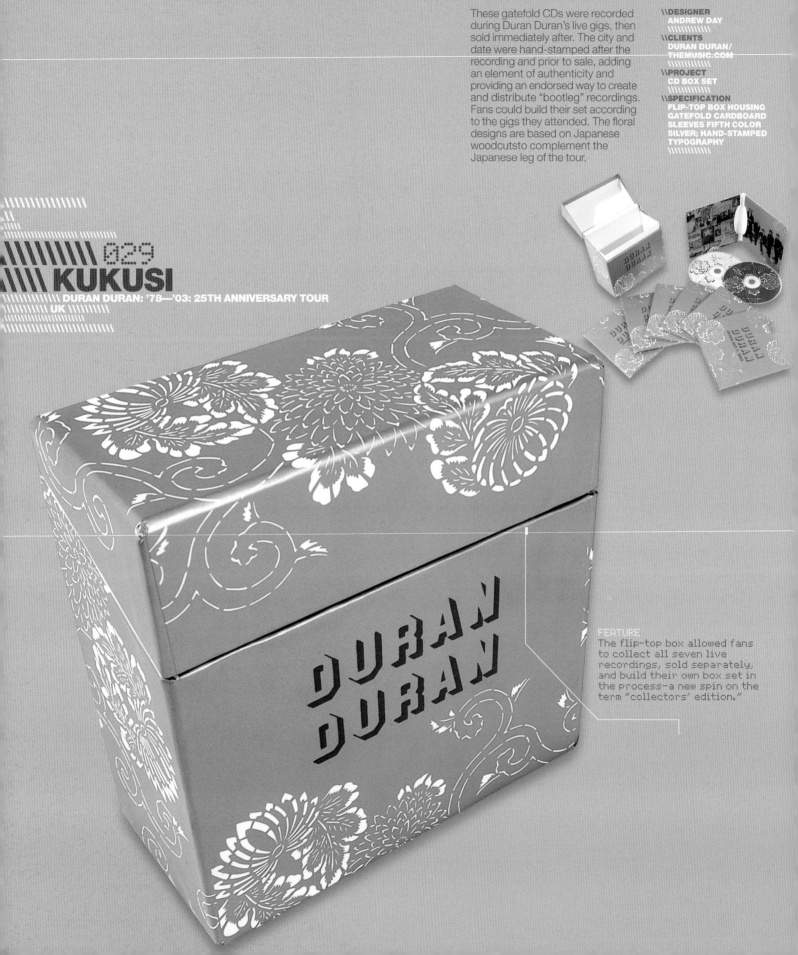

These gatefold CDs were recorded during Duran Duran's live gigs, then sold immediately after. The city and date were hand-stamped after the recording and prior to sale, adding an element of authenticity and providing an endorsed way to create and distribute "bootleg" recordings. Fans could build their set according to the gigs they attended. The floral designs are based on Japanese woodcuts to complement the Japanese leg of the tour.

\\DESIGNER
ANDREW DAY

\\CLIENTS
DURAN DURAN/
THEMUSIC.COM

\\PROJECT
CD BOX SET

\\SPECIFICATION
FLIP-TOP BOX HOUSING
GATEFOLD CARDBOARD
SLEEVES FIFTH COLOR
SILVER; HAND-STAMPED
TYPOGRAPHY

\\\\\\\\\\\\ 029
\\\\ KUKUSI
UK
DURAN DURAN: '78—'03: 25TH ANNIVERSARY TOUR

FEATURE
The flip-top box allowed fans to collect all seven live recordings, sold separately, and build their own box set in the process—a new spin on the term "collectors' edition."

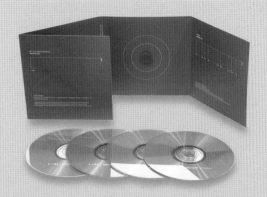

Launched in conjunction with his first live performance, this piece brings together four CDs of Richard Chartier (yes, designer and musical artist!) released on LINE. Only 100 cases were produced, each of which was numbered and signed. As such, the packaging was printed with another LINE release, so the agency faced the challenge of adding just 1 color to an existing job to make the two pieces appear completely different. Incorporating the liner notes from each of the four releases, the design uses clean and simple graphics.

\\ART DIRECTOR
RICHARD CHARTIER

\\DESIGNER
RICHARD CHARTIER

\\CLIENT
LINE

\\PROJECT
PACKAGING HOLDING 4 CDS

\\SPECIFICATION
4-CD/DOUBLE GATEFOLD PACKAGING 3 PANTONE SPOT COLOR ON FINE FINCH 100LB STOCK; HIGH-DENSITY FOAM CD HUBS; DIE-CUT VELLUM INSERTS

030
\\RICHARD CHARTIER
RICHARD CHARTIER: EDITION
USA

FEATURE
Making clever use of foam hubs, this packaging holds four CDs in a neat and compact case.

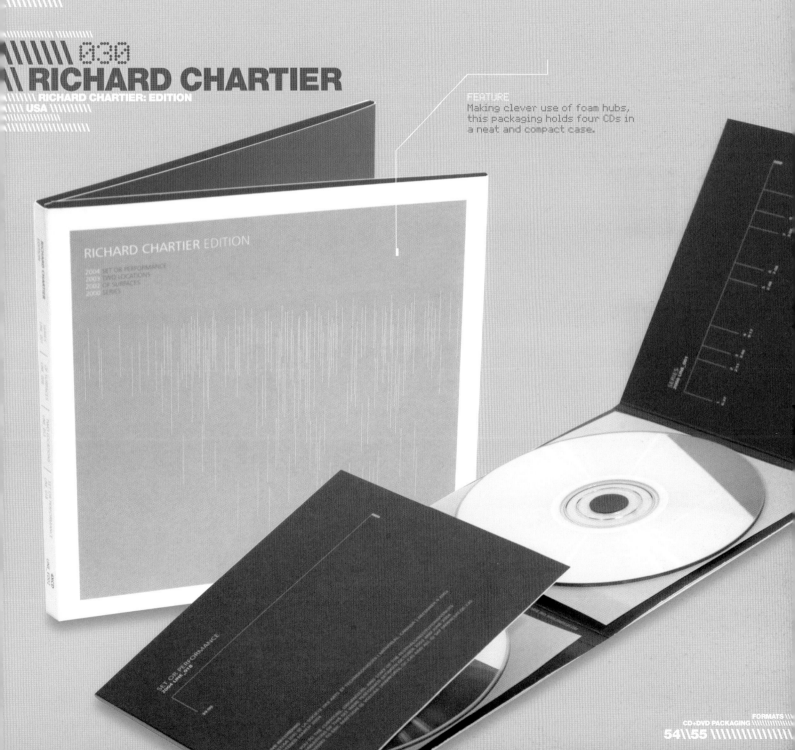

This packaging uses a simple fold-out poster on recycled matte stock as an insert. Colors and type are kept to an absolute minimum so as not to compete with the illustrations by Lance Sells, which were inspired by Arctic flowers and isolation.

\\ART DIRECTOR
PETER CHADWICK

\\DESIGNER
DAVID BOWDEN

\\CLIENT
TUNDRA RECORDS

\\PROJECT
CD PACKAGING

\\SPECIFICATION
JEWEL CASE WITH FOLD-OUT POSTER INSERT ON UNCOATED, RECYCLED STOCK

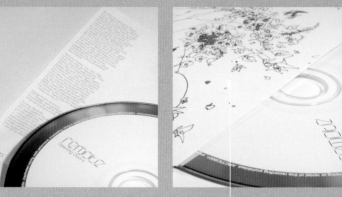

FEATURE
The recycled stock lends itself well to this packaging, which is also reflected in the unusual matte finish of the CD itself. It's also refreshing to see packaging that respects the illustrations, rather than overcrowding them with print.

031
ZIP DESIGN
REMOTE: OPENING DOORS
UK

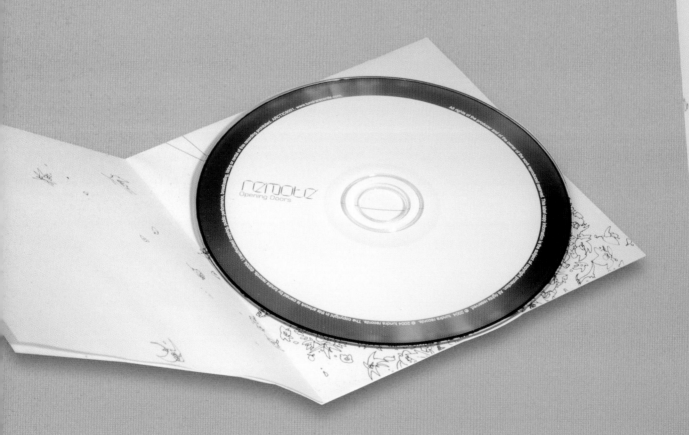

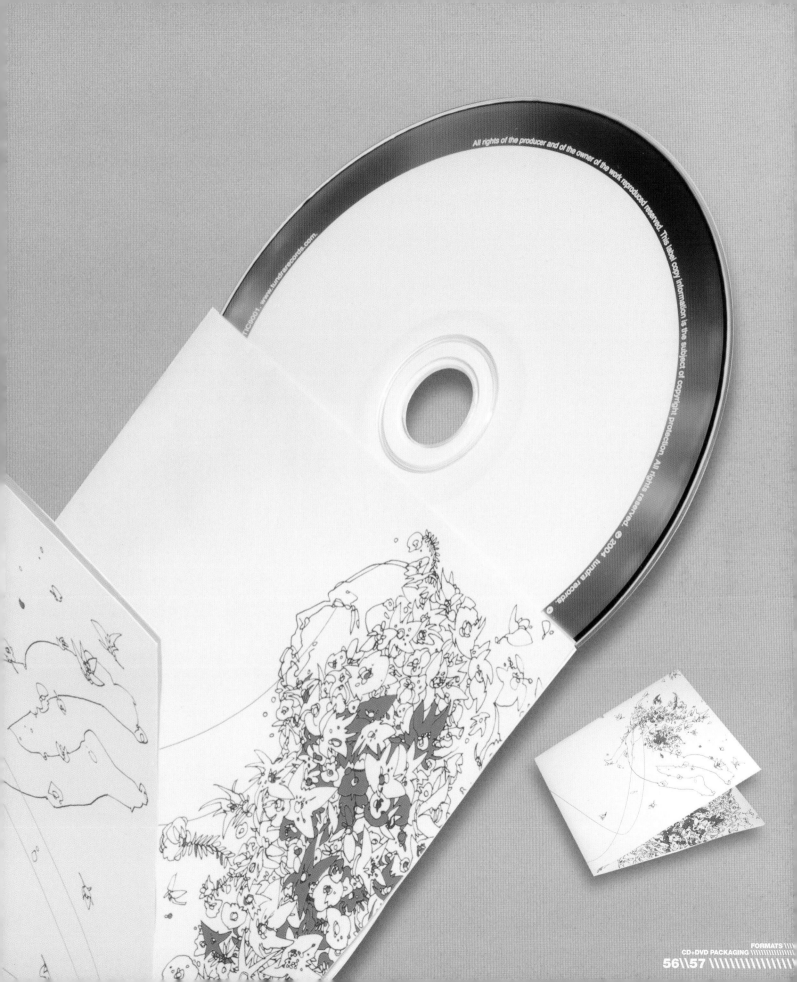

032 ZIP DESIGN
TIM DELUXE: THE LITTLE GINGER CLUB KID
UK

FEATURE
The ring-bound finish is a novel way to convey the photo-album feel, and also to hold the whole thing together in a way that can easily accommodate the black CD pocket on the back cover.

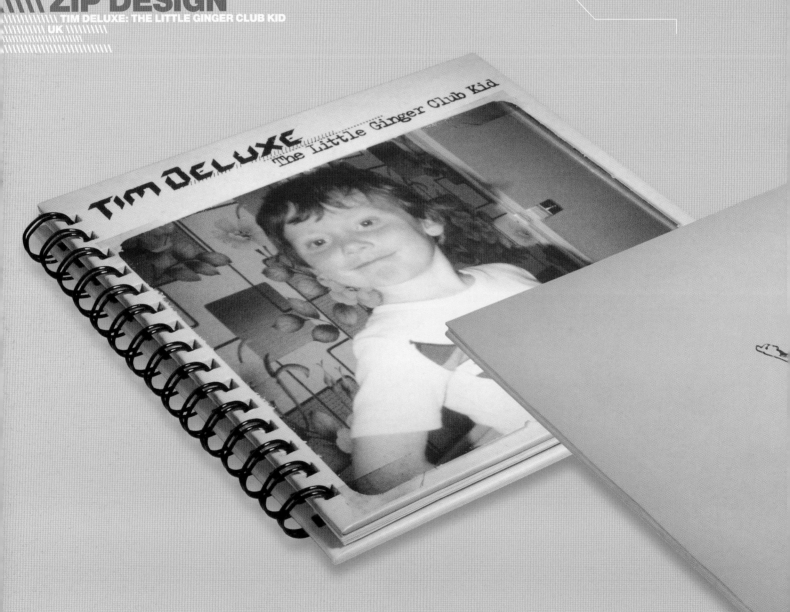

\\ART DIRECTOR
PETER CHADWICK

\\DESIGNER
NEIL BOWDEN

\\CLIENT
UNDERWATER RECORDS

\\PROJECT
SPECIAL-EDITION
CD PACKAGING

\\SPECIFICATION
SPIRAL-BOUND BOOKLET
WITH CD POCKET,
UNCOATED STOCK PAGES
WITH HARDBACK FRONT
AND BACK COVERS

The primary inspiration for this project came from the artist himself. Tim Deluxe wanted to incorporate childhood photos, so Zip decided to use a mini-photo-album format. The spiral-bound finish, matte stock, and "taped in" photos all add to this effect. The CD sits in a simple, matte-black pocket at the back. Being more expensive, this format was reserved for the limited-edition packaging, with a more cost-effective jewel case version produced for general release.

Wanting to capture the filmic quality of Bonobo's music, Red Design took a series of abstract and figurative images. Both organic and intriguing, they resemble stills from a film. Unfortunately, there was no budget for imagery, so the agency resorted to raiding its own personal collections, as well as the work of its late friend, Dominic Howard.

However, the agency was pretty happy with the outcome, as the "images seem more personal and scrapbook-like." The photos' subject matter and colors give the piece something of a retro feel, which is further reflected in the format. Using a slightly discolored heavy board gatefold wallet, the agency has created packaging reminiscent of the vinyl album covers from the late 1960s and early 1970s.

033 RED DESIGN
BONOBO: DIAL "M" FOR MONKEY
UK

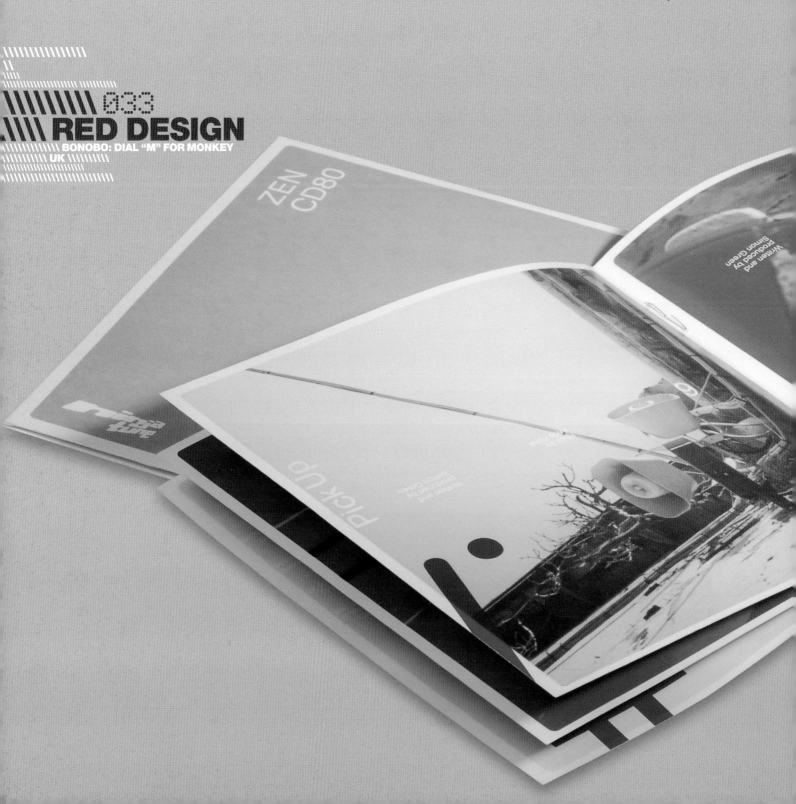

\\ART DIRECTOR
ED TEMPLETON
\\DESIGNER
ED TEMPLETON
\\CLIENTS
BONOBO/NINJA TUNE
\\PROJECT
CD ALBUM DESIGN
\\SPECIFICATION
GATEFOLD CD WALLET WITH 12-PAGE BOOKLET AND INNER CD SLEEVE CASE: HEAVY BOARD WITH MATTE-LAMINATE FINISH BOOKLET: SILK STOCK, UV FINISH CD SLEEVE: MATTE UV

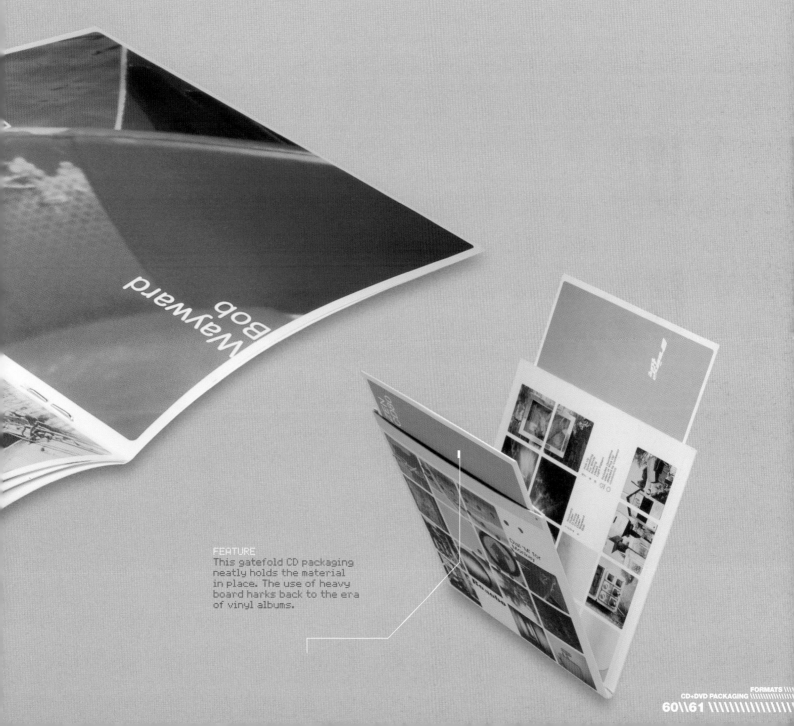

FEATURE
This gatefold CD packaging neatly holds the material in place. The use of heavy board harks back to the era of vinyl albums.

034 RED DESIGN
SUPER COLLIDER: RAW DIGITS
UK

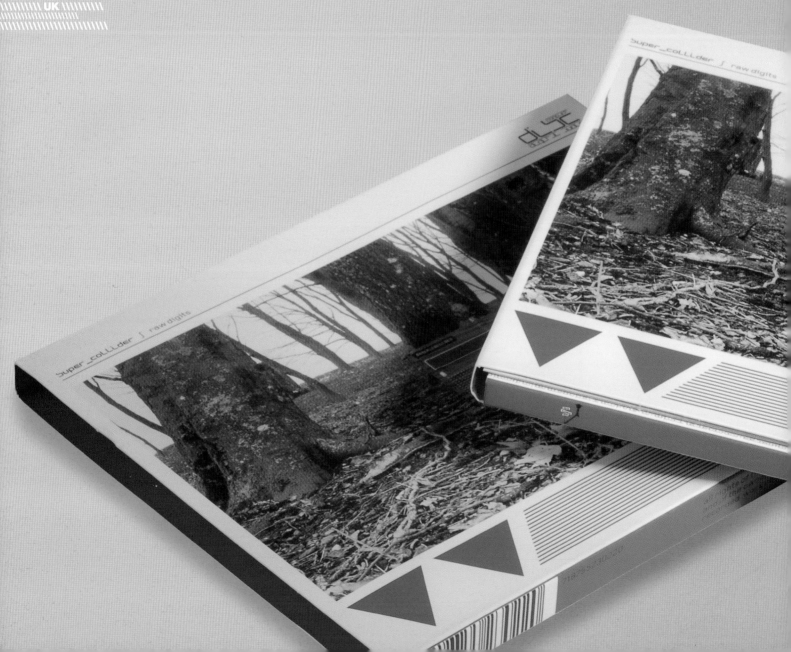

\\ART DIRECTOR
ED TEMPLETON
\\DESIGNER
ED TEMPLETON
\\CLIENTS
NO FUTURE/RISE
ROBOTS RISE
\\PROJECT
ALBUM PACKAGING
DESIGN
\\SPECIFICATION
T-SHAPED CD DIGIPAK
CMYK + CMYK RED
INSIDE PRINT;
EMBOSSED COVER

Owing to affordability considerations, the packaging for Super Collider's *Raw Digits* had to be based on a standard format. The design is predominantly red and white, with black-and-white images featuring a primitive graphics machine—built especially for the project and photographed in various locations. The packaging is designed to resemble a 1960s Russian textbook, and the outer slipcase features a subtly embossed graphic.

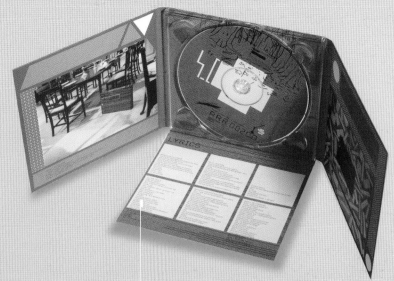

FEATURE
The packaging had to comply with standard CD formats, but this didn't mean Red Design took a standard approach. Opting for T-shaped packaging, the agency has created something unusual, and bypassed the need for an additional text insert.

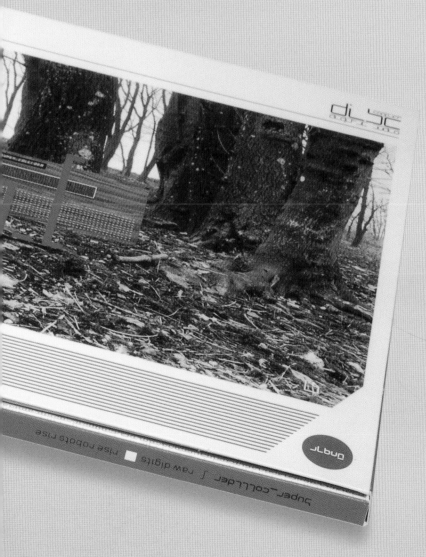

For a reissue of Japan's 1980s album *Tin Drum*, The Redroom's initial inspiration was to restore the original artwork. Working closely with David Sylvian and photographer Fin Costello, the agency had access to previously unseen photographs and was able to make new prints from the original negatives. It faithfully reset the typography to create a very pure reissue, producing a high-quality collectors' edition. The higher budget available for collectors' editions allowed the agency little luxuries, such as the 24-page photography booklet and the clamshell packaging.

\\DESIGNER
ANDREW DAY

\\CLIENT
VIRGIN RECORDS

\\PROJECT
DELUXE COLLECTORS'-EDITION CD PACKAGING

\\SPECIFICATION
LANDSCAPE CLAMSHELL CD BOX; 2-PANEL DIGIPAK; 24-PAGE BOOKLET; GATEFOLD MINI VINYL SLEEVE MATTE LAMINATE; 5-COLOR SILK-SCREENED CD LABEL

035 THE REDROOM
JAPAN: TIN DRUM
UK

FEATURE
This piece features three different types of packaging. First, the outer clamshell box, second, the gatefold "mini vinyl sleeve," and finally, the two-panel Digipak. The combination of all three lends this limited-edition packaging an air of quality.

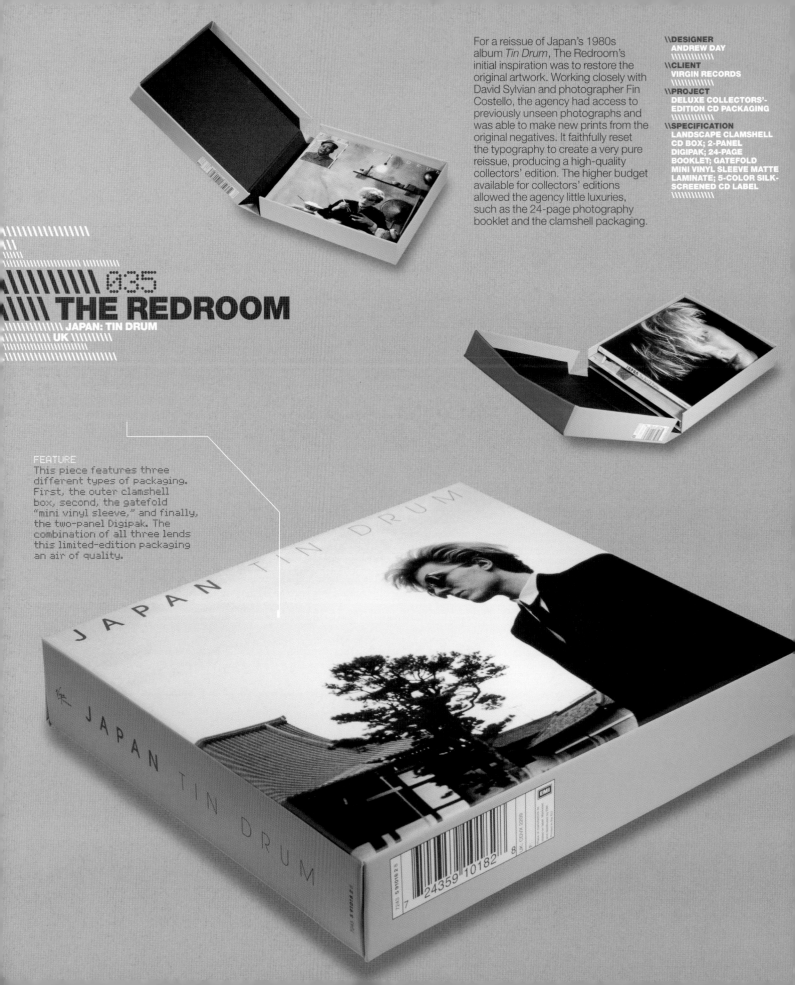

Featuring videos from its entire history, the design for this Genesis DVD features iconic characters from the band's album back catalog. Taking a matte whiteboard, The Redroom created contrast by applying a special silver for the type, and a high-gloss spot varnish to all type and images. The high gloss "Genesis" is reflected on the CD itself through use of show-through. The Redroom initially had ambitions to create much more elaborate packaging for this DVD. Pressure from retailers forced it to stick to a standard size, but it feels it "still made the most" of what it could do.

\\DESIGNER
CHRIS PEYTON
\\CLIENT
EMI RECORDS
\\PROJECT
DVD PACKAGING
\\SPECIFICATION
6-PAGE DIGIPAK, SLIPCASE, 5-COLOR DISC SPOT VARNISH, MATTE STOCK, SPECIAL INKS THROUGHOUT

036
\ THE REDROOM
GENESIS: THE VIDEO SHOW
UK

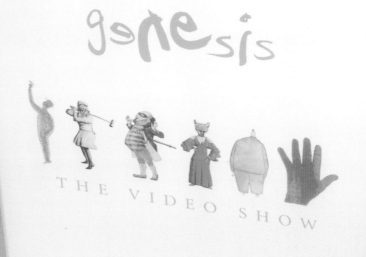

FEATURE
Rather than using the traditional slipcase that fits over the packaging, the agency selected a higher weight of board and opted for a sideways slide-in, more reminiscent of a book than a DVD cover.

CD+DVD PACKAGING

5inch.com—an offshoot of Segura Inc.—produces a collection of custom-designed silk-screened CDs and DVDs. The color-matched trigger packaging is left clear, so that the CD/DVD (which can also be colored on the reverse) becomes the focal point. Claiming to have "done to blank media what Swatch did to watches," the agency targets the products at groups such as musicians, photographers, and designers, providing a professional way for individuals to burn their own media.

\\ART DIRECTOR
CARLOS SEGURA

\\DESIGNERS
CARLOS SEGURA
TNOP
CHRIS MAY

\\CLIENT
5INCH.COM

\\PROJECT
PACKAGING AND SCREEN PRINT FOR BLANK CDS AND DVDS

\\SPECIFICATION
SCREEN-PRINTED CDS AND DVDS WITH COLORED-TRIGGER CASE

087
SEGURA INC.
BLANK CD AND DVD PACKAGING
USA

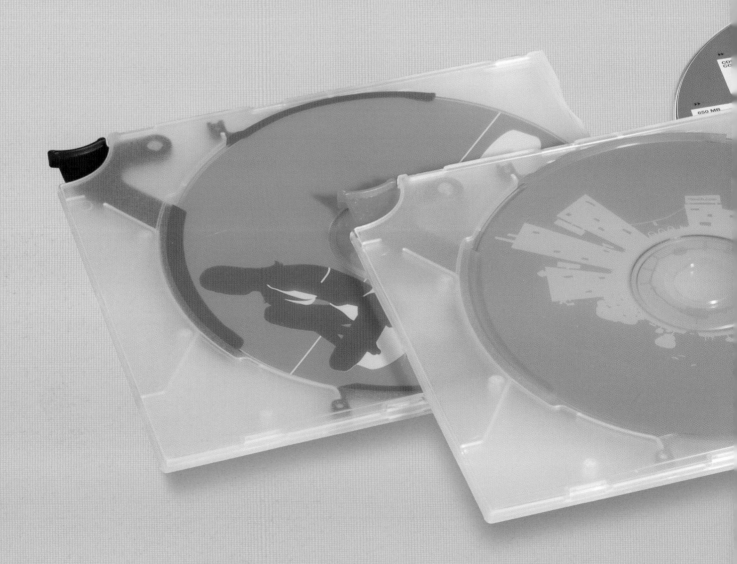

FEATURE

Screen printed in anything from 1 to 5 colors, this collection makes innovative use of both the transparent packaging and the disc as a canvas. The trigger case provides very easy access, and, by coordinating the color of the trigger with the CD's design, the packaging becomes an integral part of the overall design esthetic.

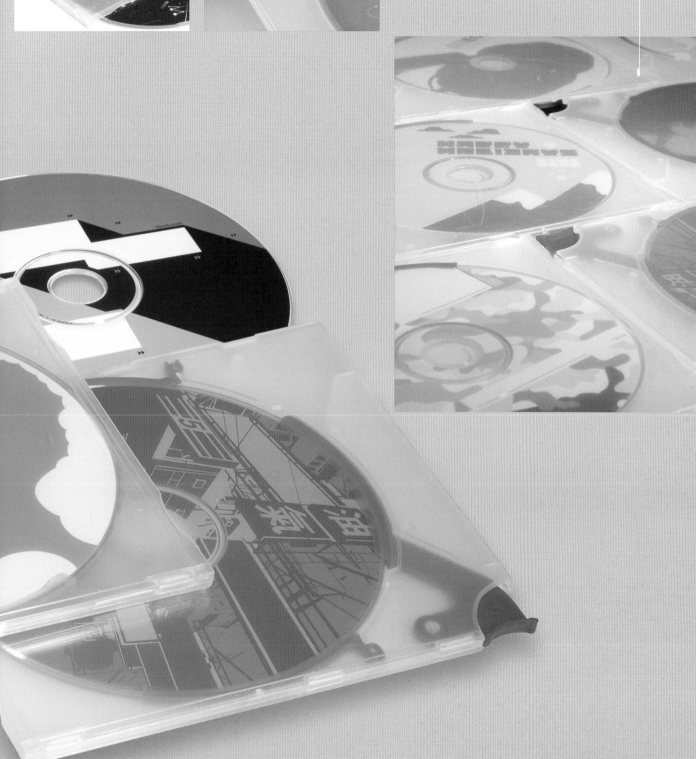

For this reissue, the only elements retained from the album's original packaging are the cover image and the use of a purple-print, plastic case. Taking this as the basic inspiration, the agency decided to reproduce it in an updated way. Retail dictated that the packaging be portrait rather than landscape format, and the agency used the slipcase design to keep the box itself free from text other than the album's title. Inside are multiple elements, including a 2-color poster, high-gloss, large-format postcards, and a book tracking Bowie's life as an artist, interleaved with trace paper pages to break up the large amounts of text. In comparison, the actual CDs—printed with a spot gloss ink—are in fairly simple clear plastic wallets with a metallic purple print.

\\DESIGNER
DARREN EVANS
\\CLIENT
EMI MUSIC
\\PROJECT
4-CD COLLECTORS' BOX SET
\\SPECIFICATION
CLAMSHELL LONG BOX WITH PLASTIC COVER HOUSING 4 POSTCARDS, 96-PAGE BOOKLET WITH TRACE PAGES, 4 DISCS IN CLEAR WALLETS PLASTIC COVER: METALLIC PURPLE; STICKERED BAR CODE BOX: PRINTED WITH METALLIC SILVER BOOK: TRACE PAGES AND METALLIC COVER POSTCARDS: GLASS-FINISH CD WALLETS: PURPLE METALLIC IN CD LABELS: SPOT METALLIC SILVER WITH SPOT GLOSS INK

\\\\\\\\ 038
\\\\ THE REDROOM
DAVID BOWIE: SOUND+VISION
UK

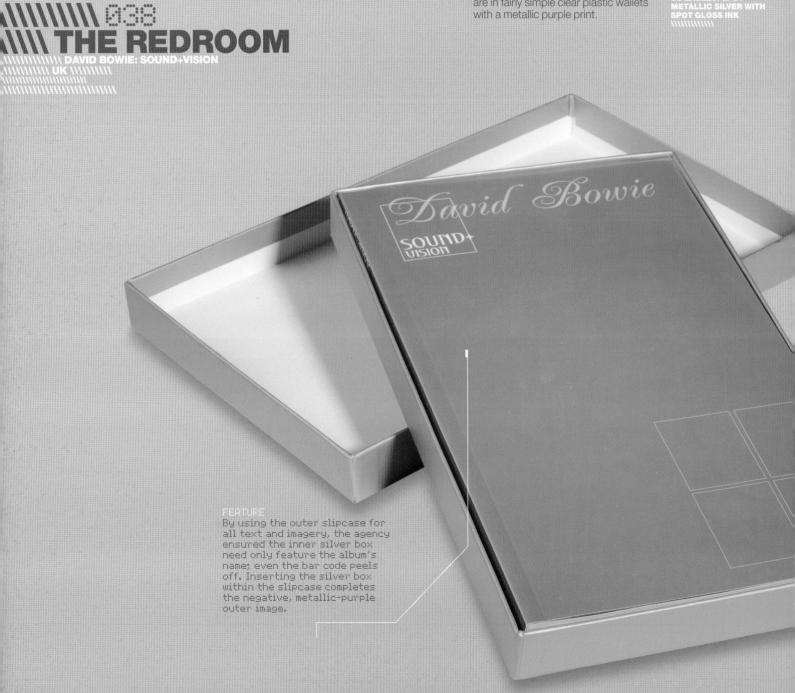

FEATURE
By using the outer slipcase for all text and imagery, the agency ensured the inner silver box need only feature the album's name; even the bar code peels off. Inserting the silver box within the slipcase completes the negative, metallic-purple outer image.

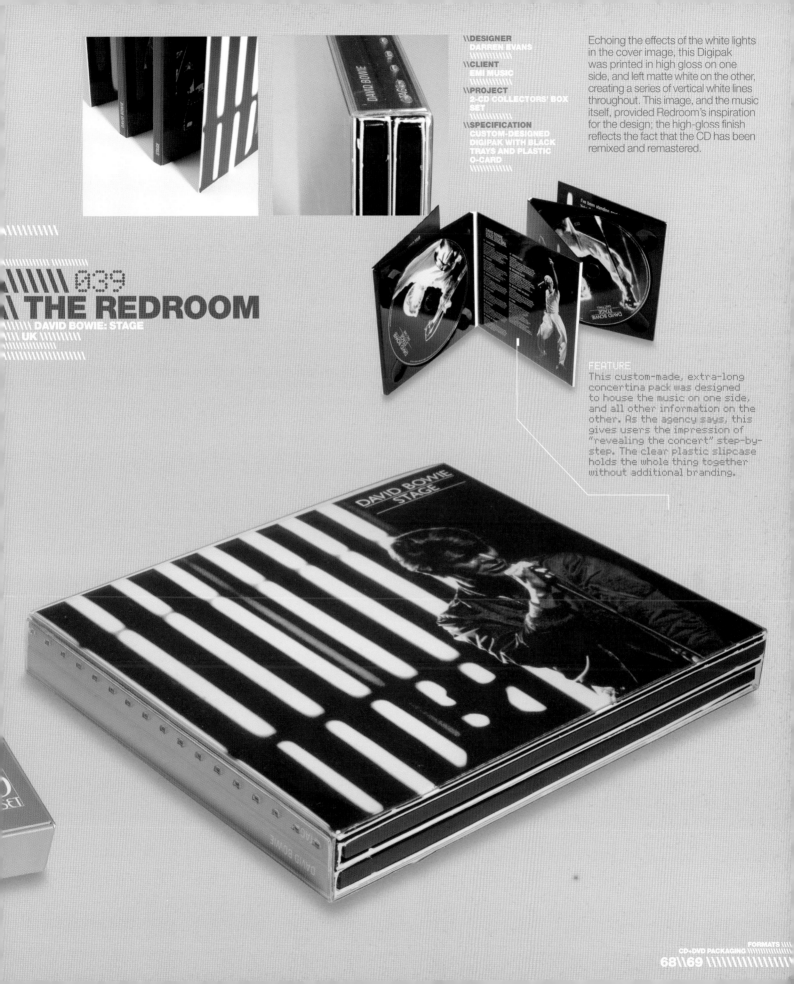

\\DESIGNER
DARREN EVANS
\\CLIENT
EMI MUSIC
\\PROJECT
2-CD COLLECTORS' BOX SET
\\SPECIFICATION
CUSTOM-DESIGNED DIGIPAK WITH BLACK TRAYS AND PLASTIC O-CARD

Echoing the effects of the white lights in the cover image, this Digipak was printed in high gloss on one side, and left matte white on the other, creating a series of vertical white lines throughout. This image, and the music itself, provided Redroom's inspiration for the design; the high-gloss finish reflects the fact that the CD has been remixed and remastered.

039
THE REDROOM
DAVID BOWIE: STAGE
UK

FEATURE
This custom-made, extra-long concertina pack was designed to house the music on one side, and all other information on the other. As the agency says, this gives users the impression of "revealing the concert" step-by-step. The clear plastic slipcase holds the whole thing together without additional branding.

Perfect Match is a CD series designed to promote BMG's music for films and commercials. Zion Graphics took this idea and used it as the basis for its design—each CD featuring another "perfect match" from nature. The pixels to the left of the image were then expanded to create an abstract pattern that wraps around the entire Digipak. All other graphics and imagery are kept to a bare minimum, making the image the main focal point. The agency then created a generic die-cut slipcase that could be used for every CD within the series.

\\ART DIRECTOR
RICKY TILLBLAD
\\DESIGNER
RICKY TILLBLAD
\\CLIENT
BMG PUBLISHING
\\PROJECT
PROMOTIONAL CD SERIES
\\SPECIFICATION
DIGIPAKS WITH SLIPCASES: GLOSSY UV-VARNISHED DIGIPAKS WITH UNCOATED SLIPCASE; DIE-CUTS INNER: 4-COLOR CMYK; OUTER: 2-COLOR PMS

040
ZION GRAPHICS
PERFECT MATCH 01, 02, AND 03
SWEDEN

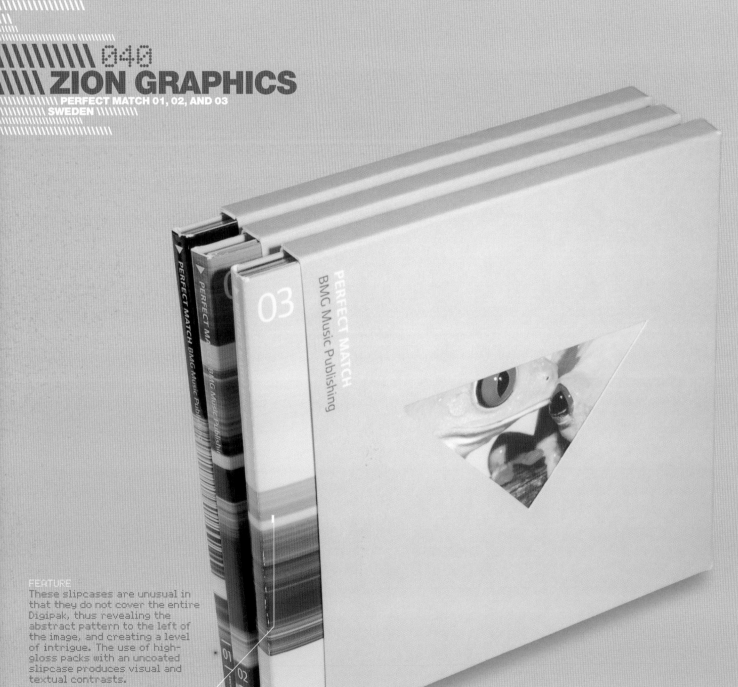

FEATURE
These slipcases are unusual in that they do not cover the entire Digipak, thus revealing the abstract pattern to the left of the image, and creating a level of intrigue. The use of high-gloss packs with an uncoated slipcase produces visual and textual contrasts.

\\\\\\ 041
\ CRUSH DESIGN
\\\\\\ **DJ SPINNA: THE BEAT SUITE**
\\\\ **UK**

Taking a fresh approach to graffiti graphics, Crush's design for DJ Spinna's album features a 1950s-style illustration of two women in the "control room"—the designer's interpretation of the album's title *The Beat Suite*. Printed in a vibrant red, the T-shape gatefold packaging has simple die-cut slots to hold the CDs, and sits inside the outer slipcase.

\\ART DIRECTOR
CARL RUSH
\\DESIGNER
CARL RUSH
\\CLIENT
URBAN THEORY
\\PROJECT
CD PACKAGING
\\SPECIFICATION
CD GATEFOLD;
TRIPLE VINYL BOX

FEATURE
The gatefold CD holder uses a T-shaped format to allow extra space for the graphics. The quarters, in which the CDs sit within the die-cuts are left unusually blank, thus not distracting from the bold, black-and-gold CD designs.

CD+DVD PACKAGING
70\\71

042
LOEWY
INTRO
UK

FEATURE
This fluorescent spincase packaging is unusual, creating immediate standout. However, the color and format are clearly very dominant, so it's important that the CD within is designed with this in mind.

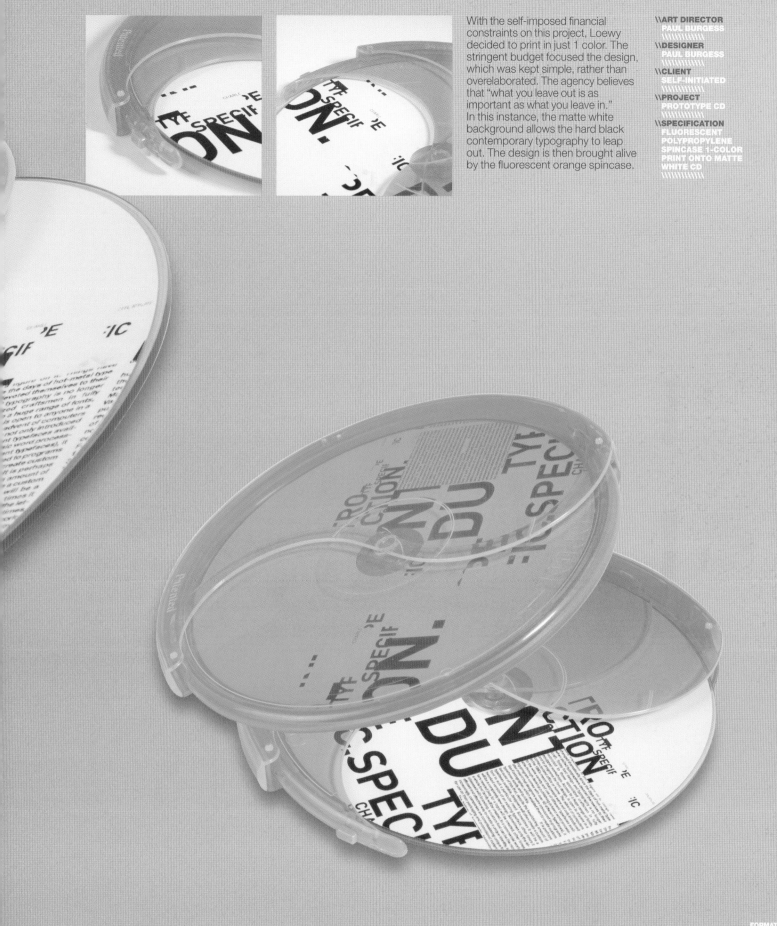

With the self-imposed financial constraints on this project, Loewy decided to print in just 1 color. The stringent budget focused the design, which was kept simple, rather than overelaborated. The agency believes that "what you leave out is as important as what you leave in." In this instance, the matte white background allows the hard black contemporary typography to leap out. The design is then brought alive by the fluorescent orange spincase.

\\ART DIRECTOR
PAUL BURGESS

\\DESIGNER
PAUL BURGESS

\\CLIENT
SELF-INITIATED

\\PROJECT
PROTOTYPE CD

\\SPECIFICATION
FLUORESCENT POLYPROPYLENE SPINCASE 1-COLOR PRINT ONTO MATTE WHITE CD

043
GIULIO TURTURRO
BLUES, BOOGIE, & BOP: THE 1940S MERCURY SESSIONS
USA

Created using vacuum form processes, this radio-shaped CD container was designed to stand out on store shelves and attract buyers. The designer had a book about old Bakelite radios, and Giulio Turturro thought there was no better way to evoke the period than by recreating a Mercury version of the equipment the music would originally have been heard on. However extravagant it may look, this nontraditional project was not without constraints. Financially, the packaging had to fall within the client's profit-and-loss guidelines, i.e. manufacturing it could not be at the expense of making a profit. Physically, the radio had to hold all the components in place while being able to open. The designers worked closely with printers and manufacturers to source vendors who could help them deliver the project to budget.

Inside the "radio" are multiple components, all produced using French's uncoated stock to create a feeling of age. The booklet was designed to look like an owner's manual for the radio, although the die-cut cover gives it something of a contemporary edge. Inside, the pages are printed in metallic silver and black duotones. Then there are seven CDs in modern jackets designed to look as though they are from the 1940s, scuffs and all. Inside the jackets are the inner sleeves, which were made to resemble the 78rpm sleeves of the time, complete with a simulated die-cut with an original record label "underneath."

\\ART DIRECTOR
DAVID LAU
\\DESIGNER
GIULIO TURTURRO
\\CLIENT
VERVE RECORDS
\\PROJECT
LIMITED-EDITION, 7-CD BOX SET
\\SPECIFICATION
VACUUM FORM PLASTICS CONTAINER PLUS 3-COLOR STICKER; 82-PAGE BOOKLET FROM FRENCH'S SPECKLET ONE PAPERS AND BOARD; CD JACKETS WITH SLEEVES IN FRENCH'S CRAFT PAPER PRINTED IN PMS INKS

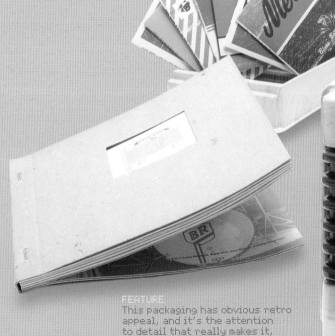

FEATURE
This packaging has obvious retro appeal, and it's the attention to detail that really makes it, from the wood effect and molded plastic grill, through to the tuner sticker and the card panel on the bottom.

\\ART DIRECTOR
GIULIO TURTURRO

\\DESIGNER
GIULIO TURTURRO

\\CLIENT
VERVE RECORDS

\\PROJECT
10-CD BOX SET

\\SPECIFICATION
PAINTED BLACK WOOD AND ACRYLIC CONTAINER PANELS SCREEN PRINTED 2 OVER 1 COLOR; 5 GATE-FOLD MINIJACKETS 4 COLORS; 224-PAGE BOOKLET IN UNCOATED COLORED NEWSPRINT AND COATED WHITE STOCK: CMYK PRINT PLUS PMS METALLIC GOLD AND VARNISH

The music featured in this compilation set was taken from a series of live theater performances, and Giulio Turturro wanted to create packaging to reflect this. Using a dimensional marquee-style font, the outer wood and acrylic box is designed to resemble theater and marquee signage. Inside are five gatefold sleeves featuring the original artwork, which hold two CDs each. The biggest challenge in the project was the amount of information that had to go into the accompanying booklet. Jazz fans look for lots of detailed information, so the booklet had to read well and look good. An introduction, interviews, essays, notes, biographies, the tour itinerary, a history, discography, and photos all had to be included. The designer arrived at the solution of dividing the book into uncoated and coated sections to aid navigation, adding interest in the process. The use of simple screen-printed colors and uncoated stocks adds a feel of age and authenticity to the piece.

\\044
\\GIULIO TURTURRO
THE COMPLETE JAZZ AT THE PHILHARMONIC ON VERVE, 1949
USA

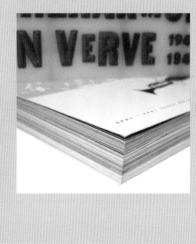

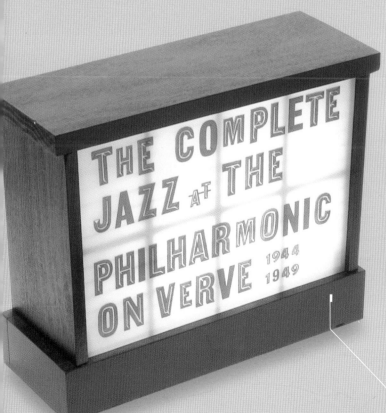

FEATURE
As well as allowing the designer to play with the theater signage theme, this acrylic and wood box has a quality "collectors' item" feel to it. The sturdy base holds the contents neatly, and vertically, in place.

\\ART DIRECTORS
RICKY TILLBLAD
JONAS KJELLBERG

\\DESIGNERS
RICKY TILLBLAD
JONAS KJELLBERG

\\CLIENT
SONY/BMG MUSIC

\\PROJECT
6-CD BOX SET WITH
44-PAGE BOOKLET

\\SPECIFICATION
BOX PRINTED
IN 4-COLOR CMYK
6 CD JACKETS AND
BOOKLET WITH GLOSSY
UV VARNISH; MATTE-
LAMINATE BOX

Working to a fairly limited budget, Zion Graphics was tasked with producing a pack that could hold six CDs featuring the artwork from the original albums, and a 44-page booklet. The agency created a double gatefold with six die-cut slots to hold the CDs, and an additional pocket to hold the booklet. Featuring the six albums released by Agnetha Fältskog prior to her ABBA career, the primary inspiration behind the project was an image the agency discovered of the artist on a black background, which now adorns both the packaging and booklet covers. Black then became the color theme for the entire piece, using gloss and matte variations to create contrast and add interest. The choice of typography—Avant Garde—was used to reflect the 1970s era in which Agnetha was making music.

045
ZION GRAPHICS
DE FÖRSTA ÅREN: AGNETHA FÄLTSKOG: 1967–1979
SWEDEN

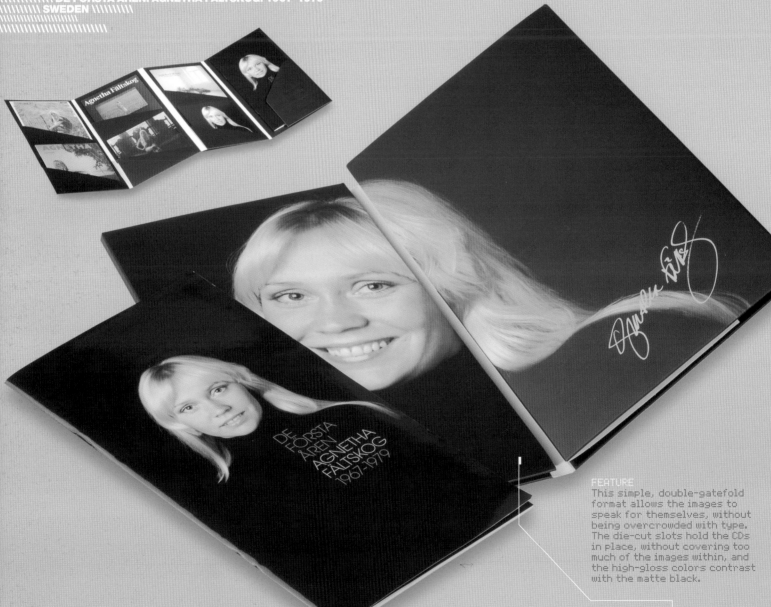

FEATURE
This simple, double-gatefold format allows the images to speak for themselves, without being overcrowded with type. The die-cut slots hold the CDs in place, without covering too much of the images within, and the high-gloss colors contrast with the matte black.

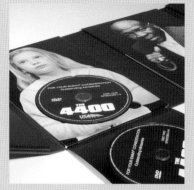

046
YESDESIGNGROUP
USA NETWORK: FYC EMMY 05
USA

Although creating what was essentially a promotional mailer to gain votes in the Emmy Awards, YESDESIGNGROUP designed packaging that would not be out of place in a DVD collector's library. Wrapping chipboard in Kivar 6 stock, the agency created a "compendium" with the client's logo screen printed in clear UV, and a metallic silver stock slipcase to give it a bit of showbiz edge. The project's primary challenge was that the case had to house Emmy entrants from four very different TV genres: Sci-Fi, Police Drama, Documentary, and Comedy. The interior graphics had to represent the individual shows and inspire the viewer, without setting the shows in competition or conflict with each other. In addition, one of the titles needed to include two DVDs—the others only one. The agency decided to shoot a hero character from each show on a black background, which was in keeping with the client's branding and the character-driven nature of the shows. However, as the panels were printed separately, the agency had to pay particular attention to ensure consistent color and quality during press checks: the four finished panels had to match seamlessly.

\\ART DIRECTOR
TIM GLEASON

\\DESIGNER
LORI J. POSNER

\\CLIENT
USA NETWORK

\\PROJECT
PROMOTIONAL MAILER CONTAINING FOUR EMMY "FOR YOUR CONSIDERATION" SCREENERS

\\SPECIFICATION
EXTERIOR: KIVAR 6 BLACK, SILKSCREEN UV; SLIPCASE: SHINE METALLIC SILVER INTERIOR: 10PT LABEL STOCK WITH GLOSS VARNISH, 18PT C2S, 4-COLOR PRINT

FEATURE
Award entries redefine the term "entering a competitive market!" This packaging had to hold a lot of content and create standout. This sturdy double gatefold lets the striking images speak for themselves, with the "invisible" fold-down flaps working well both to house the necessary information and conceal the DVDs beneath. What's more, this flap format neatly provides the space required for the inclusion of two DVDs for one of the shows. The magnetic fastening adds a nice finishing touch.

047 PENTAGRAM DESIGN
THE BLUE BAR
UK

FEATURE
The matchbook-style sleeves are a novel form of CD packaging. The matchbook details have been perfectly replicated, right down to the staple holding the piece together, and the slightly wider spine at the top than the bottom. The outer box is a simple way of holding the set of CDs together.

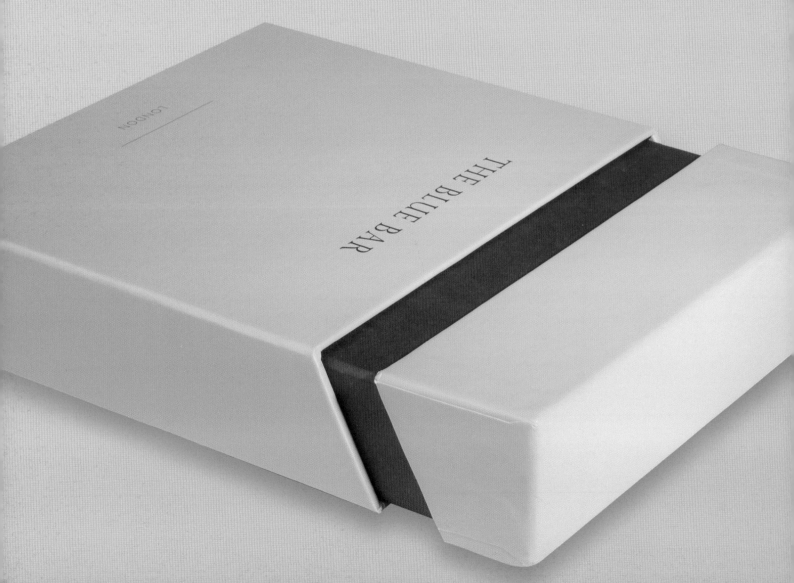

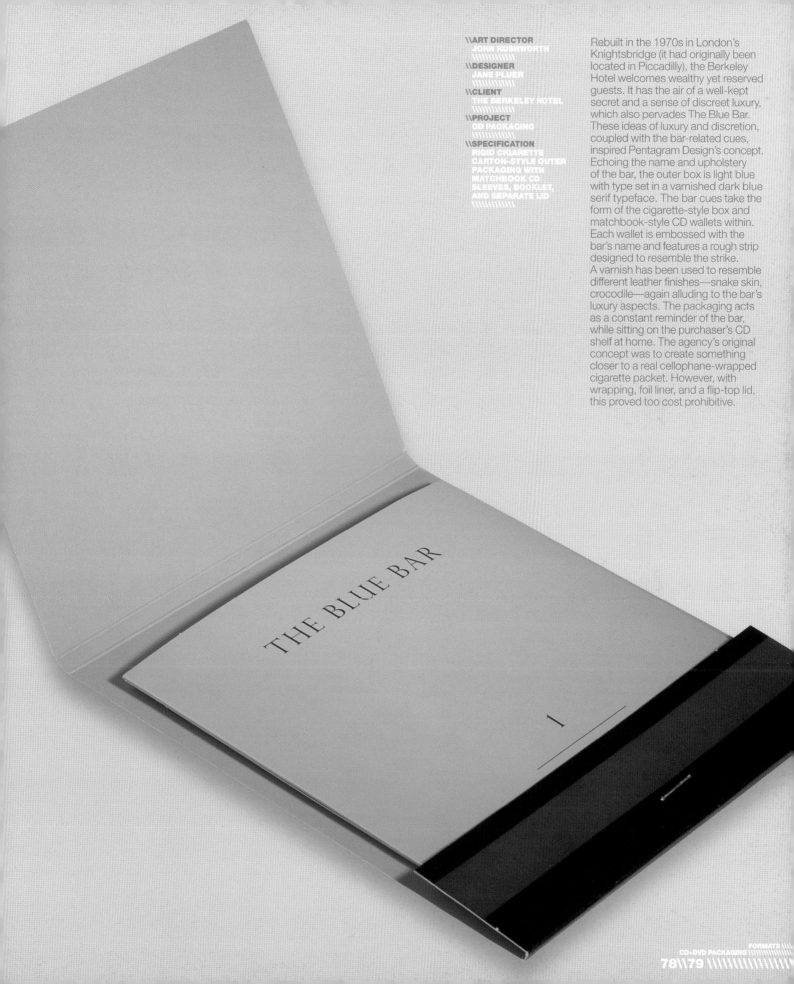

\\ART DIRECTOR
JOHN RUSHWORTH

\\DESIGNER
JANE PLUER

\\CLIENT
THE BERKELEY HOTEL

\\PROJECT
CD PACKAGING

\\SPECIFICATION
RIGID CIGARETTE CARTON-STYLE OUTER PACKAGING WITH MATCHBOOK CD SLEEVES, BOOKLET, AND SEPARATE LID

Rebuilt in the 1970s in London's Knightsbridge (it had originally been located in Piccadilly), the Berkeley Hotel welcomes wealthy yet reserved guests. It has the air of a well-kept secret and a sense of discreet luxury, which also pervades The Blue Bar. These ideas of luxury and discretion, coupled with the bar-related cues, inspired Pentagram Design's concept. Echoing the name and upholstery of the bar, the outer box is light blue with type set in a varnished dark blue serif typeface. The bar cues take the form of the cigarette-style box and matchbook-style CD wallets within. Each wallet is embossed with the bar's name and features a rough strip designed to resemble the strike. A varnish has been used to resemble different leather finishes—snake skin, crocodile—again alluding to the bar's luxury aspects. The packaging acts as a constant reminder of the bar, while sitting on the purchaser's CD shelf at home. The agency's original concept was to create something closer to a real cellophane-wrapped cigarette packet. However, with wrapping, foil liner, and a flip-top lid, this proved too cost prohibitive.

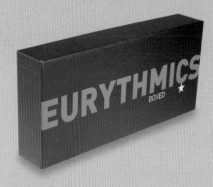

\\ART DIRECTOR
LAURENCE STEVENS
\\DESIGNER
LAURENCE STEVENS
\\CLIENT
SONY / BMG
\\PROJECT
SPECIAL-EDITION CD BOX
\\SPECIFICATION
2-PIECE BOX (BASE AND LID BOX) PRINTED MATTE BLACK WITH MATTE-SATIN FINISH. PANTONE 485C RED WITH SPECIAL SPOT UV VARNISH, PLUS PMS METALLIC SILVER; REMOVABLE 4-COLOR CMYK STICKER 6-PANEL DIGIPAK SLEEVES WITH DIE-CUT POCKET, 8 X 24-PAGE BOOKLET: CMYK, SATIN MATTE ART 240GSM

048
LSD STUDIO
EURYTHMICS: BOXED
UK

FEATURE
This is a very clean, uncomplicated way of packaging together a lot of material. The matte-black box is printed with silver and red text and a spot gloss varnish. The base is "wrapped" in the band's lyrics. Rather than using a flash format, the agency has let the music speak for itself.

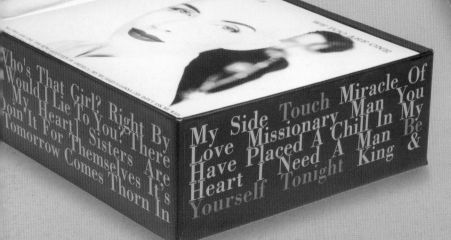

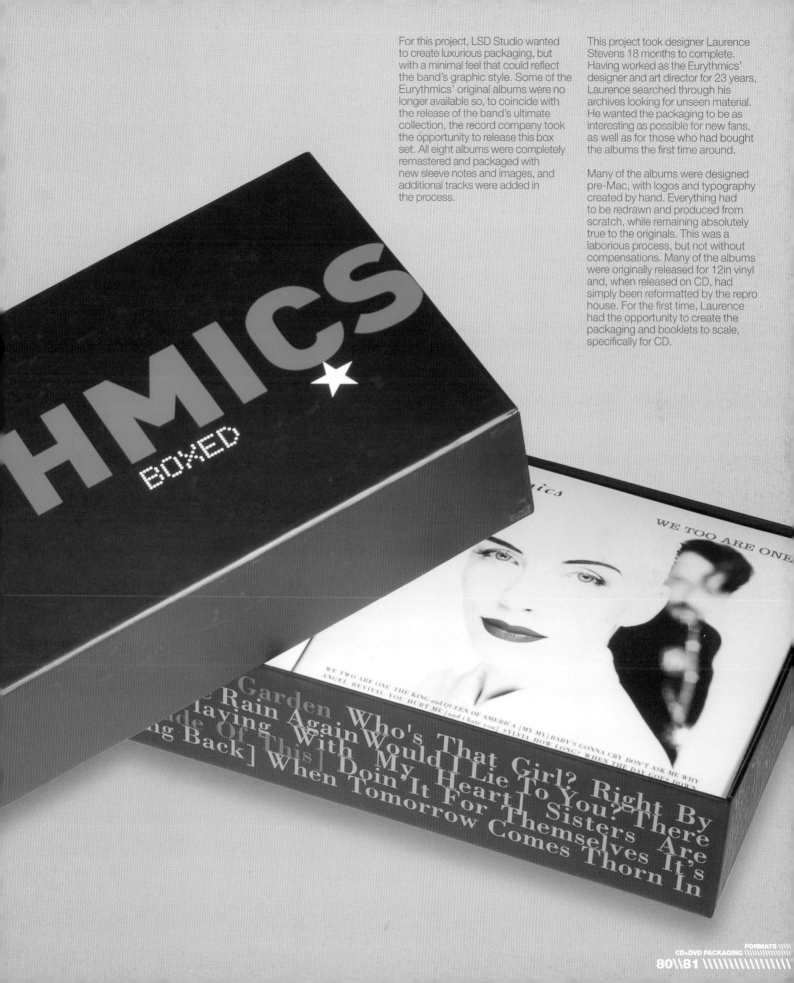

For this project, LSD Studio wanted to create luxurious packaging, but with a minimal feel that could reflect the band's graphic style. Some of the Eurythmics' original albums were no longer available so, to coincide with the release of the band's ultimate collection, the record company took the opportunity to release this box set. All eight albums were completely remastered and packaged with new sleeve notes and images, and additional tracks were added in the process.

This project took designer Laurence Stevens 18 months to complete. Having worked as the Eurythmics' designer and art director for 23 years, Laurence searched through his archives looking for unseen material. He wanted the packaging to be as interesting as possible for new fans, as well as for those who had bought the albums the first time around.

Many of the albums were designed pre-Mac, with logos and typography created by hand. Everything had to be redrawn and produced from scratch, while remaining absolutely true to the originals. This was a laborious process, but not without compensations. Many of the albums were originally released for 12in vinyl and, when released on CD, had simply been reformatted by the repro house. For the first time, Laurence had the opportunity to create the packaging and booklets to scale, specifically for CD.

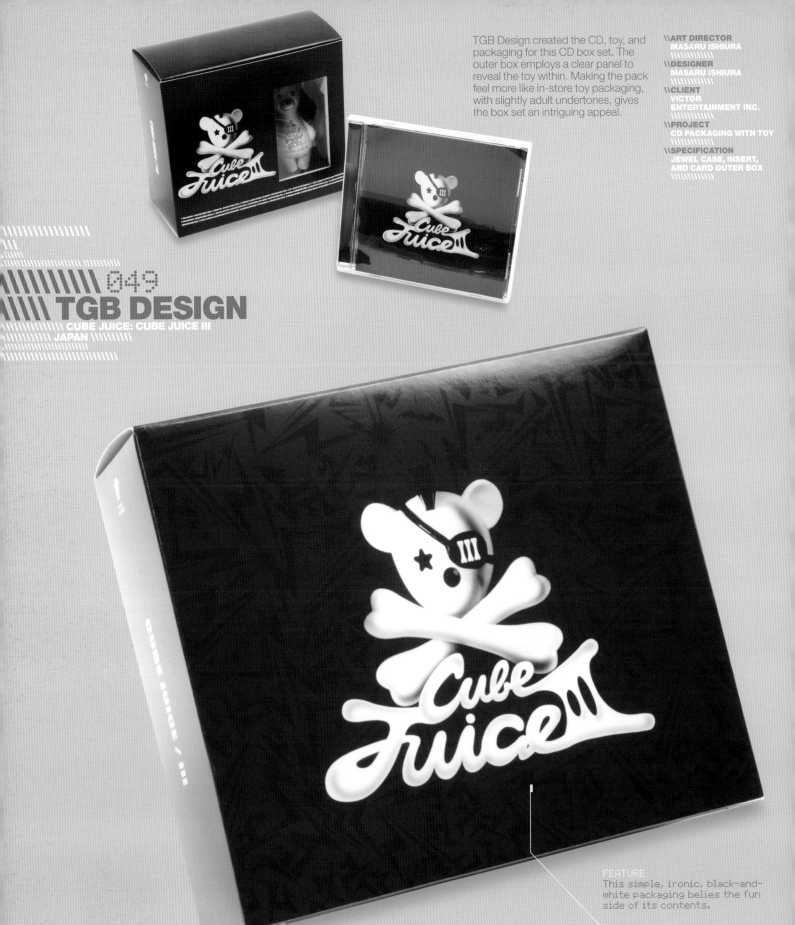

TGB Design created the CD, toy, and packaging for this CD box set. The outer box employs a clear panel to reveal the toy within. Making the pack feel more like in-store toy packaging, with slightly adult undertones, gives the box set an intriguing appeal.

\\ART DIRECTOR
MASARU ISHIURA
\\DESIGNER
MASARU ISHIURA
\\CLIENT
VICTOR ENTERTAINMENT INC.
\\PROJECT
CD PACKAGING WITH TOY
\\SPECIFICATION
JEWEL CASE, INSERT, AND CARD OUTER BOX

049
TGB DESIGN
CUBE JUICE: CUBE JUICE III
JAPAN

FEATURE
This simple, ironic, black-and-white packaging belies the fun side of its contents.

\\\\\\\\\ 050
\ TGB DESIGN
CUBE JUICE: CUBE WORLD: MUSIC IS OUR MESSAGE
JAPAN

Victor Entertainment wanted its Cube World DVD and toy to be sold together. Having also designed the toy, TGB Design decided to use a simple box with a clear window to enable purchasers to see the toy inside.

\\ART DIRECTOR
MASARU ISHIURA
\\DESIGNER
MASARU ISHIURA
\\CLIENT
VICTOR ENTERTAINMENT INC.
\\PROJECT
DVD WITH TOY PACKAGING
\\SPECIFICATION
JEWEL CASE, INSERT, CARD OUTER BOX WITH WINDOW, AND TOY

FEATURE
By utilizing some of the packaging tooling from a previous project, TGB managed to reduce production costs and develop a level of consistency for Cube Juice's packaging.

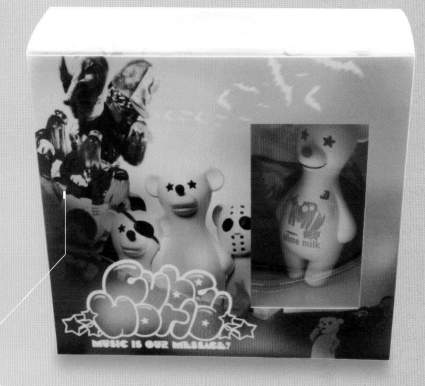

051
THE REPTILE HOUSE
HOTEL ST. TROPEZ
UK

FEATURE
This oversized inner tray is unusual in DVD packaging, creating immediate visual interest. Inside, the simple gatefold wallets use the die-cut holding slot to great effect, reflecting the packaging's vignettes in the colors on the CDs.

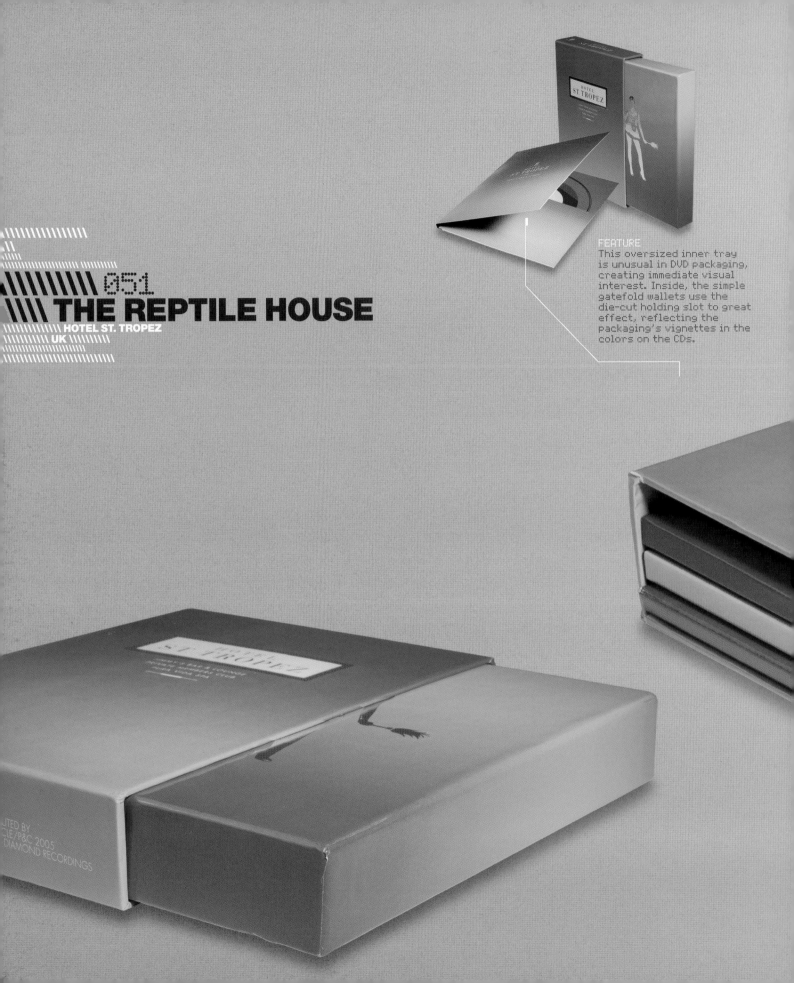

Working within a fairly tight budget, The Reptile House aimed to create packaging with a visual nod to perfume and cosmetic products. They applied the same vivid blues to the inner and outer box, and used the matte and gloss finishes to create contrast. The oversized inner box helped them to make the most of the different effects. Owing to budgetary constraints, the agency opted for flat graphics, spending money on foil blocking and individual CD wallets instead.

\\DESIGNER
RICHARD WELLAND
\\\\\\\\\\\\\
\\CLIENTS
THE HIT MUSIC COMPANY/CRAZY DIAMOND
\\\\\\\\\\\\\
\\PROJECT
3-CD BOX SET
\\\\\\\\\\\\\
\\SPECIFICATION
CUSTOM-MADE BOX WITH OVERSIZED INNER TRAY EXTERIOR: FOIL BLOCKING WITH MATTE UV FINISH INTERIOR: GLOSS UV FINISH
\\\\\\\\\\\\\

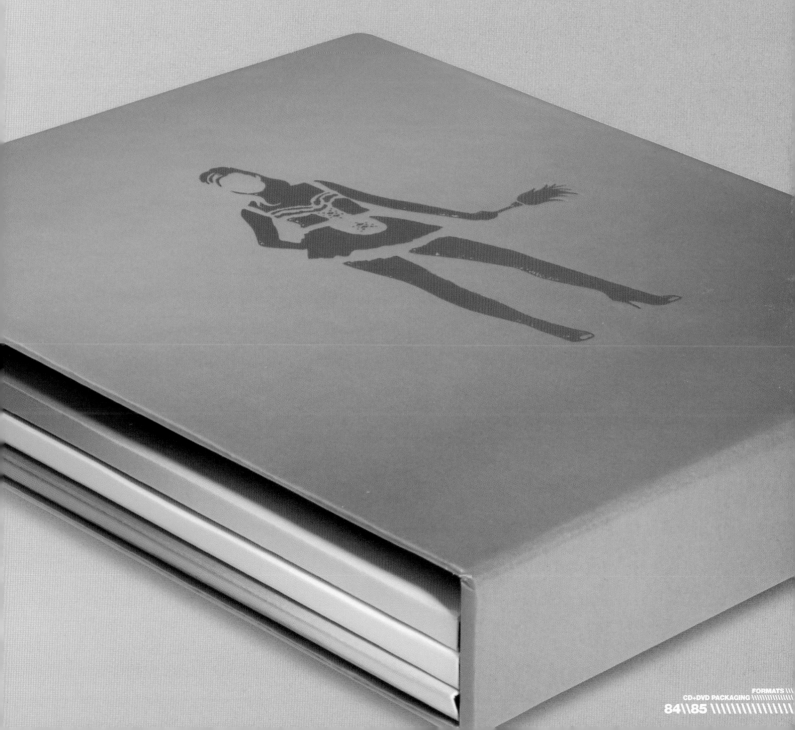

TGB Design collaborated with music company Play Label and retailer R. Newbold to produce this CD and T-shirt packaging series. Designed to be sold in sets, the T-shirts and CDs featured complementary designs—the Stone, Scissors, Paper theme echoed throughout. The agency decided on vacuum packing as a way of holding everything together, while the simple white, screen-printed front tells purchasers all about the three-way collaboration.

\\ART DIRECTOR
MASARU ISHIURA
\\DESIGNER
MASARU ISHIURA
\\CLIENTS
PLAY LABEL/
R. NEWBOLD
\\PROJECT
CD AND T-SHIRT
PACKAGING
\\SPECIFICATION
JEWEL CASE WITH
SCREEN-PRINTED INSERT,
VACUUM PACKED

052
TGB DESIGN
STONE SCISSORS PAPER
JAPAN

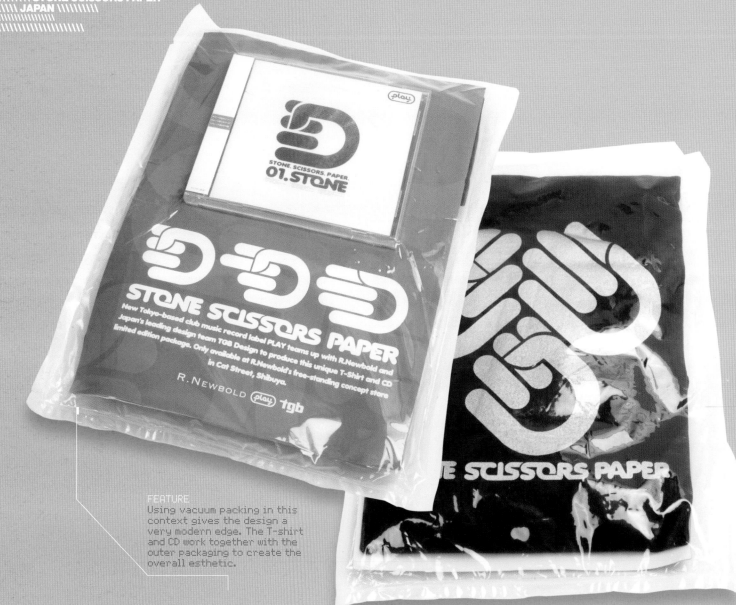

FEATURE
Using vacuum packing in this context gives the design a very modern edge. The T-shirt and CD work together with the outer packaging to create the overall esthetic.

This book/DVD packaging is based on the concept of a travel journal written by the album's main character. It features handwritten lyrics, photos, and additional notes from the character's point of view. The book was designed to fit into standard CD and DVD racks and, to keep costs down, its dimensions were built around a standard DVD tray—thus avoiding the need for a custom-made tray.

\\ART DIRECTOR
CHRIS BILHEIMER

\\DESIGNER
CHRIS BILHEIMER

\\CLIENT
REPRISE/WEA

\\PROJECT
LIMITED-EDITION DVD PACKAGING

\\SPECIFICATION
52-PAGE HARDCOVER BOOK WITH CD, MATTE FINISH

\\053
\\CHRONICTOWN
GREEN DAY: AMERICAN IDIOT
USA

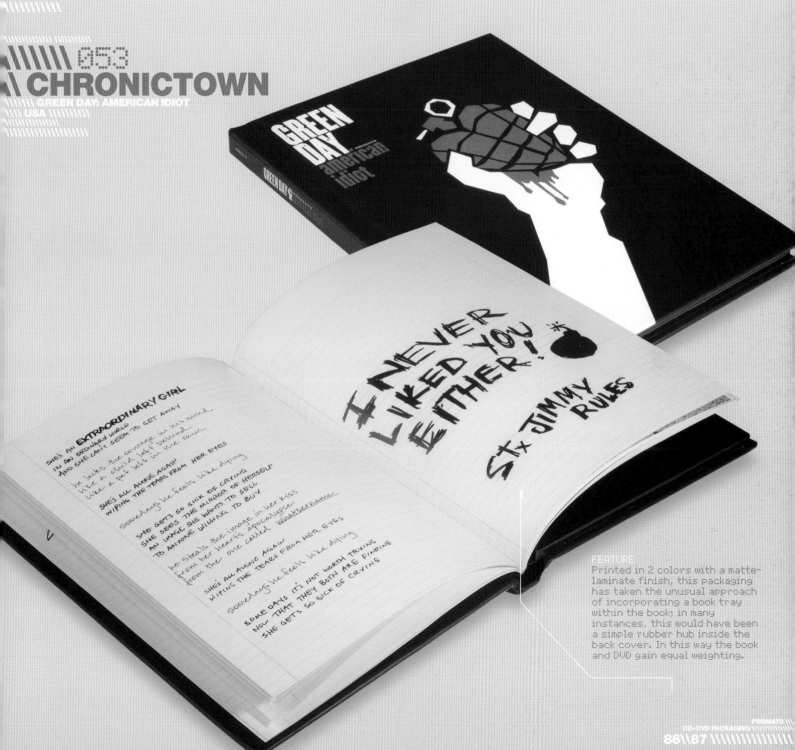

FEATURE
Printed in 2 colors with a matte-laminate finish, this packaging has taken the unusual approach of incorporating a book tray within the book; in many instances, this would have been a simple rubber hub inside the back cover. In this way the book and DVD gain equal weighting.

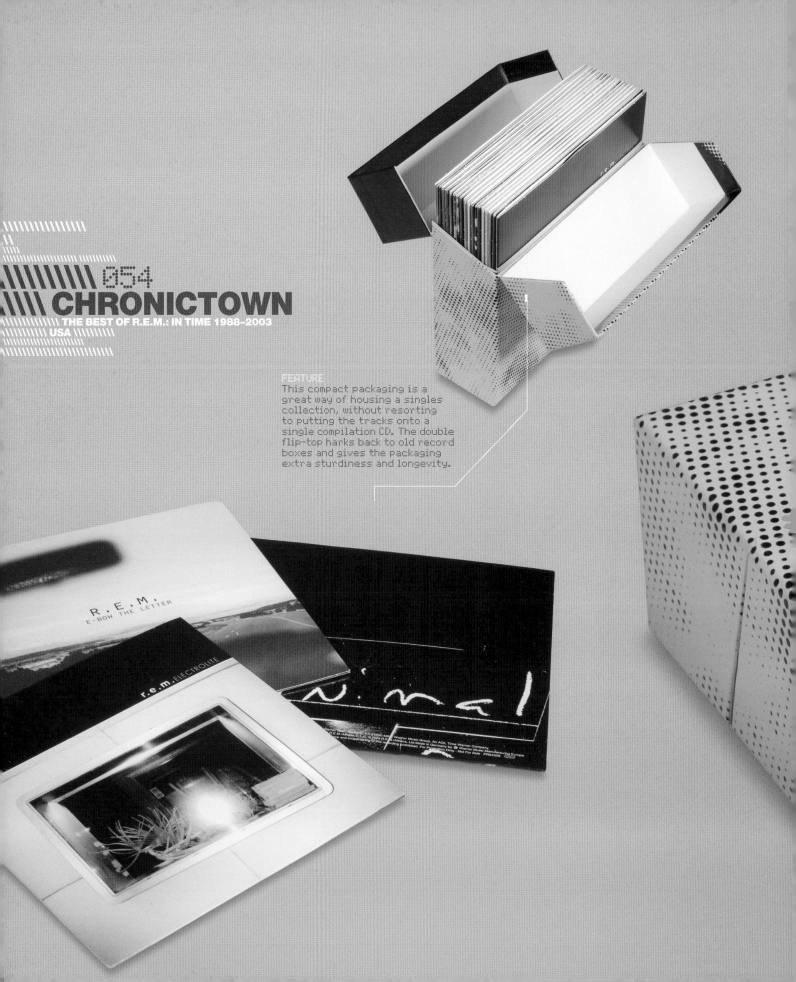

054
CHRONICTOWN
THE BEST OF R.E.M.: IN TIME 1988–2003
USA

FEATURE
This compact packaging is a great way of housing a singles collection, without resorting to putting the tracks onto a single compilation CD. The double flip-top harks back to old record boxes and gives the packaging extra sturdiness and longevity.

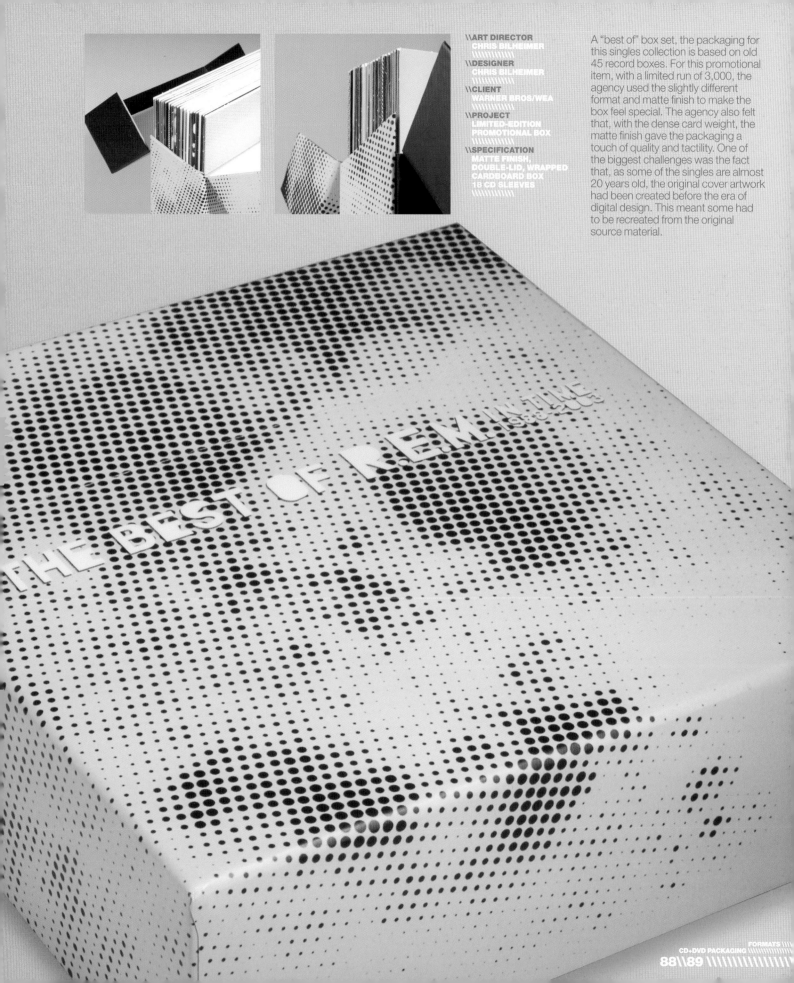

\\ART DIRECTOR
CHRIS BILHEIMER

\\DESIGNER
CHRIS BILHEIMER

\\CLIENT
WARNER BROS/WEA

\\PROJECT
LIMITED-EDITION
PROMOTIONAL BOX

\\SPECIFICATION
MATTE FINISH,
DOUBLE-LID, WRAPPED
CARDBOARD BOX
18 CD SLEEVES

A "best of" box set, the packaging for this singles collection is based on old 45 record boxes. For this promotional item, with a limited run of 3,000, the agency used the slightly different format and matte finish to make the box feel special. The agency also felt that, with the dense card weight, the matte finish gave the packaging a touch of quality and tactility. One of the biggest challenges was the fact that, as some of the singles are almost 20 years old, the original cover artwork had been created before the era of digital design. This meant some had to be recreated from the original source material.

\\DESIGN STUDIO
AIRSIDE

\\CLIENTS
LEMON JELLY/
XL RECORDINGS

\\PROJECT
CD AND DVD PACKAGING

\\SPECIFICATION
BOX SET WITH
DOUBLE-SIDED POSTER
AND POSTCARDS

When Airside was given the task of producing packaging for Lemon Jelly, part of the brief was the band's strong feeling that music packaging should feel special and feature a beautiful design. An element of this was that it shouldn't feature any text, as the band felt typography would detract from the design. The nine tracks on the album contain a sample or loop from songs from 1964 to 1995, making for a very eclectic album. This is reflected in the DVD's animations, all of which are created using different styles of illustration or photography. A snapshot from each animation was then incorporated into the '64–'95 logo. The piece includes the DVD, a series of postcards, and a large, double-sided poster.

FEATURE
This packaging is a novel twist on the standard slipcase + DVD approach. The inner box is cut at an angle, much like an office file box, holding its contents together and ensuring that an element of each is always on show. Keeping the spine free of design means it doesn't conflict with the outer slipcase–plus there's an element of surprise when the box slides out, revealing the pattern.

055 AIRSIDE
LEMON JELLY: '64–'95
UK

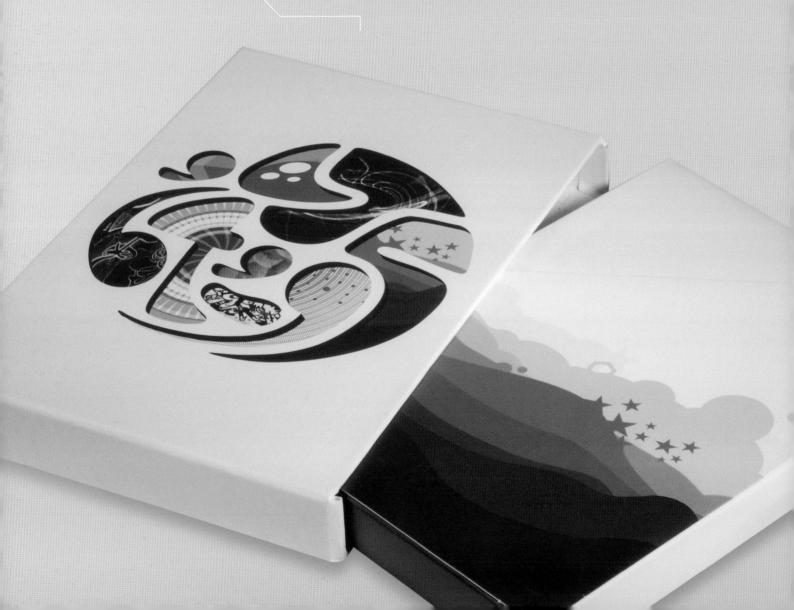

\\ART DIRECTOR
CARLOS SEGURA

\\DESIGNERS
CARLOS SEGURA
TNOP
CHRIS MAY

\\CLIENT
NYCO

\\PROJECT
CD PACKAGING

\\SPECIFICATION
SCREEN-PRINTED
POLYBAG OUTER,
4-COLOR POSTER,
HEAVYWEIGHT BOARD

The title of this album—*Two*—reflects the joining of the band's key members: lead singer Ted Atkatz from New York, and bass player Rob Kassinger from Colorado. On this first album by NYCO, every song is about two people and the different states their relationship may go through. Within the polybag outer, the packaging contains a 4-color poster and CD case, both featuring the same images, but represented in different ways. Heavyweight board ensures the piece retains its shape.

FEATURE
Screen printed with a wide white stripe, this polybag is an unusual way to hold multiple elements together.

056
SEGURA INC.
NYCO: TWO
USA

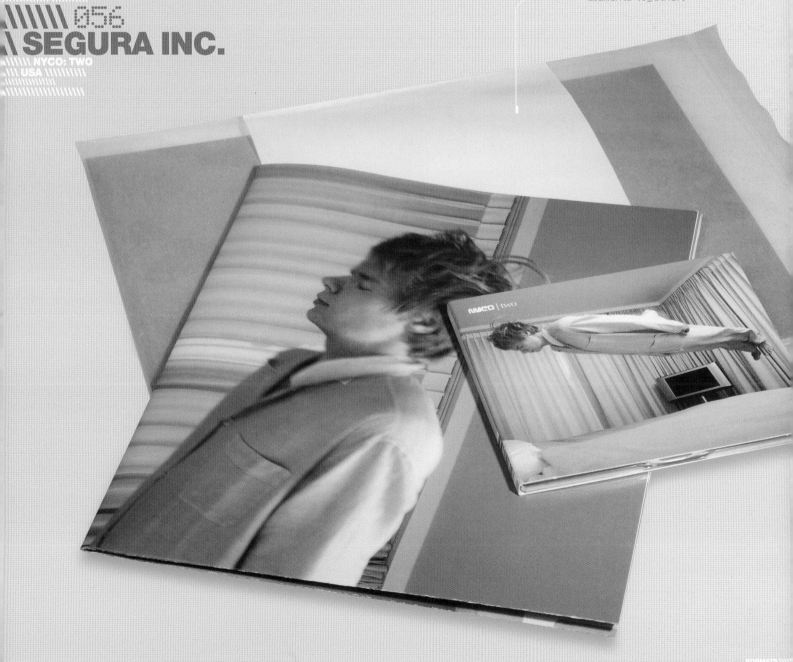

//// PRINT CD+DVD

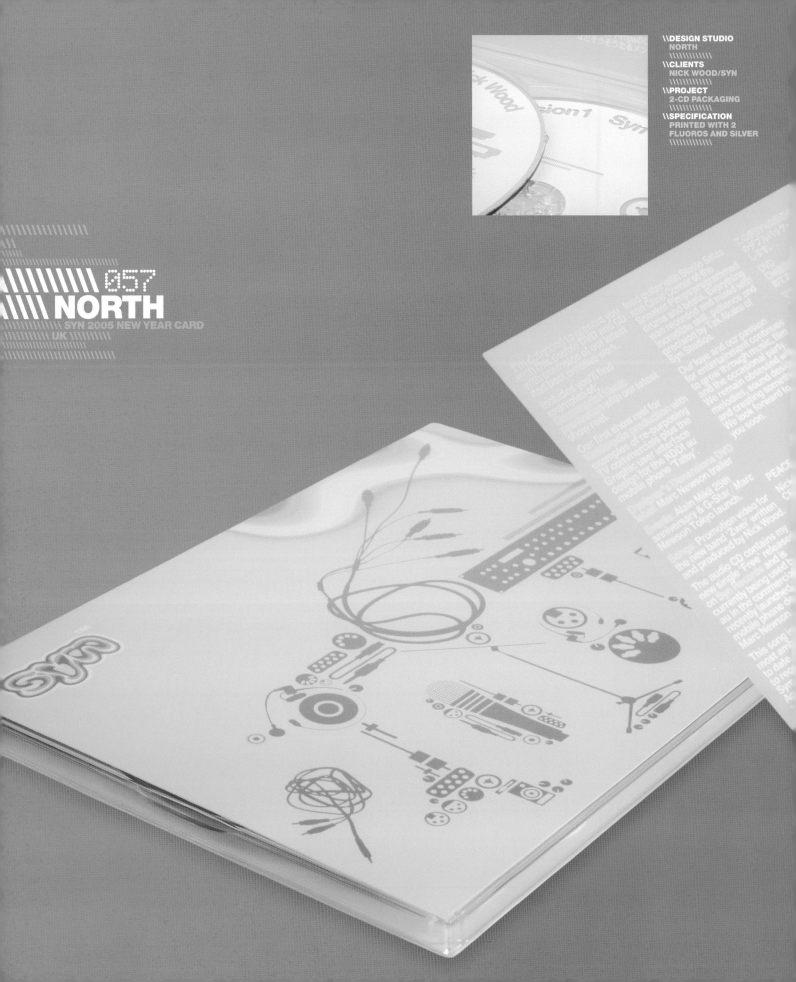

\\\\\\\\ 057
\\\\ **NORTH**
\\\ SYN 2005 NEW YEAR CARD
UK

\\DESIGN STUDIO
NORTH
\\CLIENTS
NICK WOOD/SYN
\\PROJECT
2-CD PACKAGING
\\SPECIFICATION
PRINTED WITH 2
FLUOROS AND SILVER

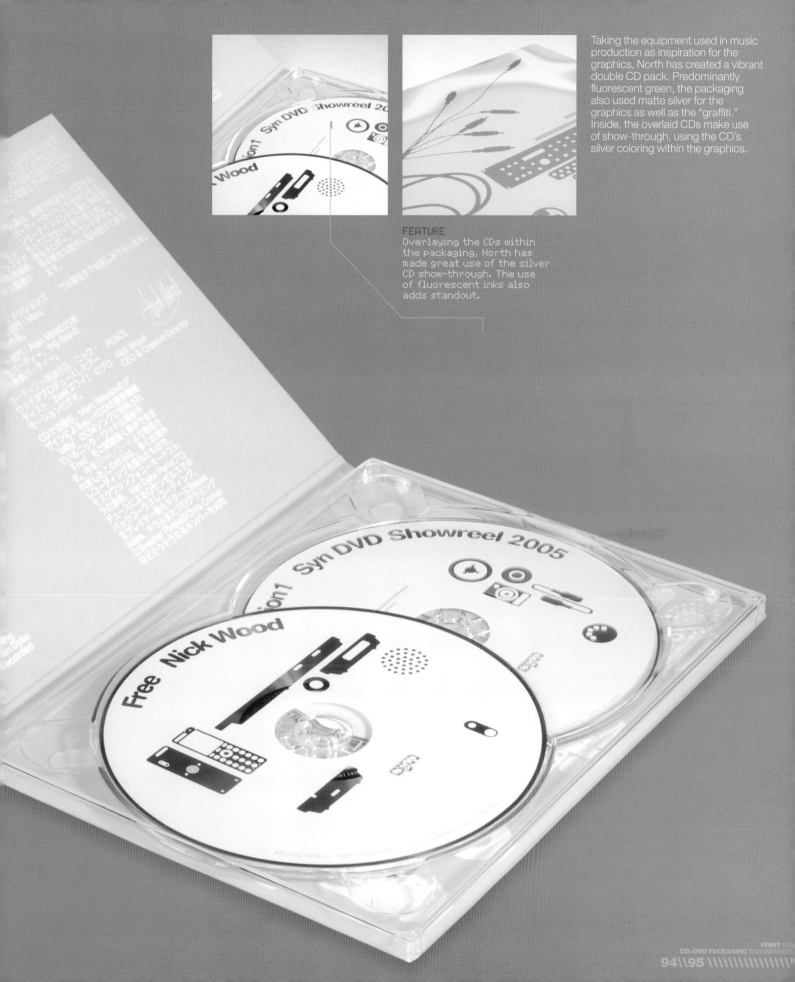

Taking the equipment used in music production as inspiration for the graphics, North has created a vibrant double CD pack. Predominantly fluorescent green, the packaging also used matte silver for the graphics as well as the "graffiti." Inside, the overlaid CDs make use of show-through, using the CD's silver coloring within the graphics.

FEATURE
Overlaying the CDs within the packaging, North has made great use of the silver CD show-through. The use of fluorescent inks also adds standout.

\\DESIGNER
KIM HIORTHØY

\\CLIENT
RUNE GRAMMOFON

\\PROJECT
CD PACKAGING

\\SPECIFICATION
6-PAGE DIGIPAK;
CARDBOARD WITH
MATTE VARNISH

A roll-fold CD pack, Kim Hiorthøy's packaging for this Spunk release features a simple 1-color print. The outside is predominantly white on black; the inside the reverse. And the CD within this monochrome packaging? Fluorescent orange, of course.

058 KIM HIORTHØY
SPUNK: EN ALDELES FORFERDELIG SYKDOM
NORWAY

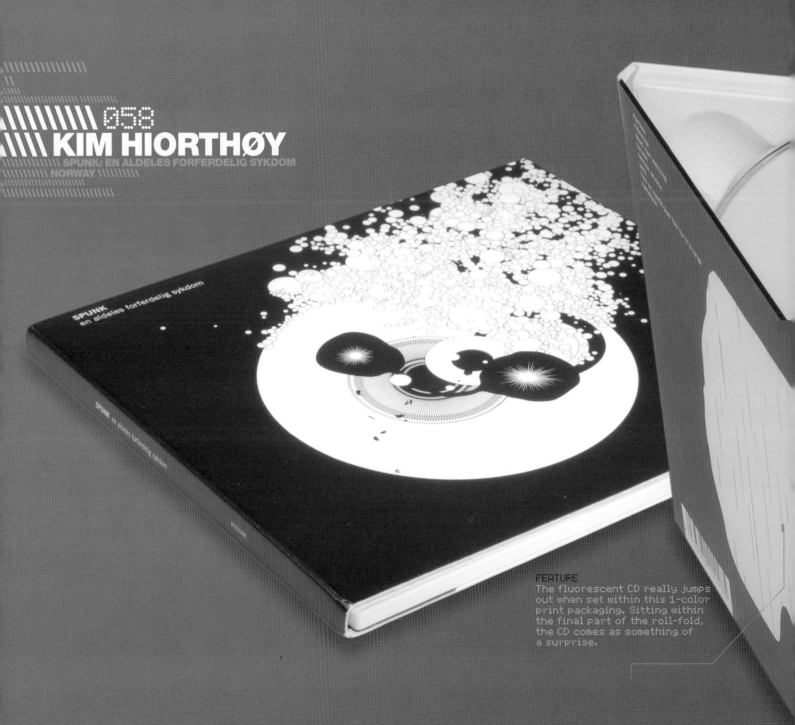

FEATURE
The fluorescent CD really jumps out when set within this 1-color print packaging. Sitting within the final part of the roll-fold, the CD comes as something of a surprise.

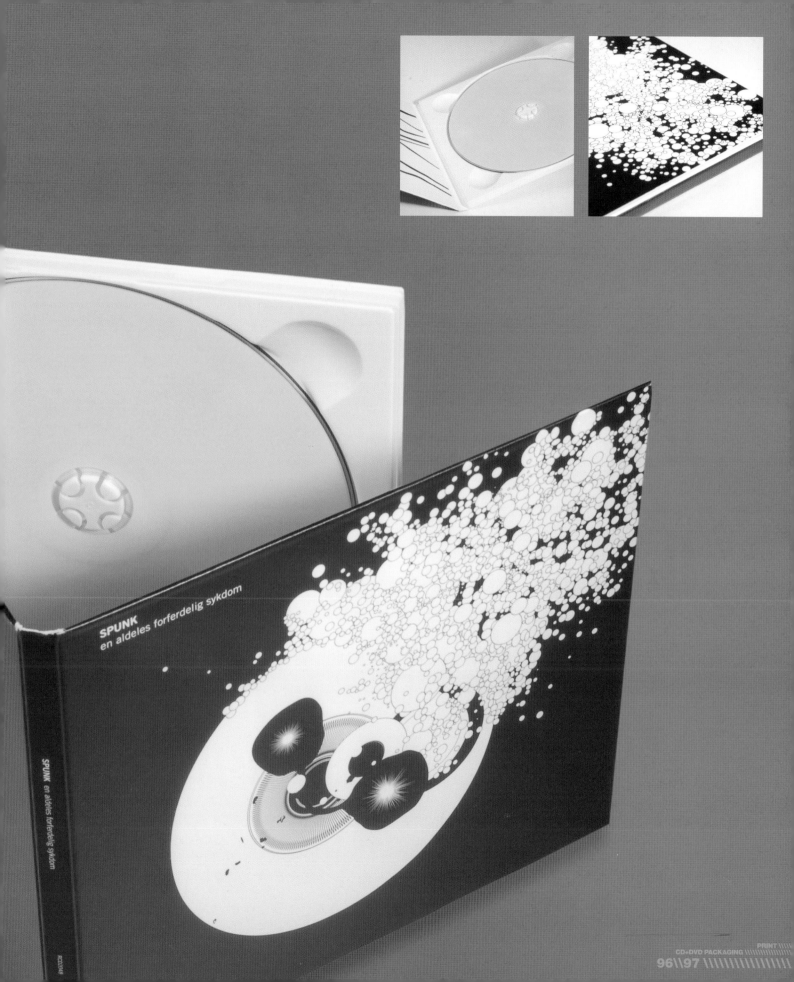

\\\\\\\\\\\
\\\\ 059
\\\\ TANK
\\\\\\\\\\\
DRAGONFLY: BLIND
USA \\\\\\\\\\

The CD packaging was produced for *Blind*, the second album released by US band Dragonfly. Combining a book and CD holder, the project had both physical and financial constraints: merchandising dictated that it should be the same size as a standard jewel case, and each unit had to cost no more than US$1. So Tank turned to India for production—and for design inspiration.

The album features Indian-style beats and rhythms and the design is a heavy montage, combining the Indian art of Barry Kumar with stills from the band's live footage. The overall feel is that of a scrapbook, where Indian pop culture meets rock and roll. The Indian images are rich in color, and there's strong use of colors including red, ocher, greens, blues, and blacks. Reflex blue has been used in the video images to boost the cyan content. Overlaid across all of this are words taken from the band's lyrics. They are matte silver, large, and scrolling, and hold the whole piece together.

\\ART DIRECTOR
DAVID WARREN
\\\\\\\\\\\
\\DESIGNERS
DAVID WARREN
ROB ALEXANDER
\\\\\\\\\\\
\\CLIENTS
DRAGONFLY/RED STAR ENTERTAINMENT
\\\\\\\\\\\
\\PROJECT
CD PACKAGING
\\\\\\\\\\\
\\SPECIFICATION
60-PAGE BOOK
COVER: 4-COLOR PROCESS + 1 SPECIAL MATTE LAMINATION
PAGES: 4-COLOR PROCESS + 2 SPECIALS AND GLOSS VARNISH
\\\\\\\\\\\

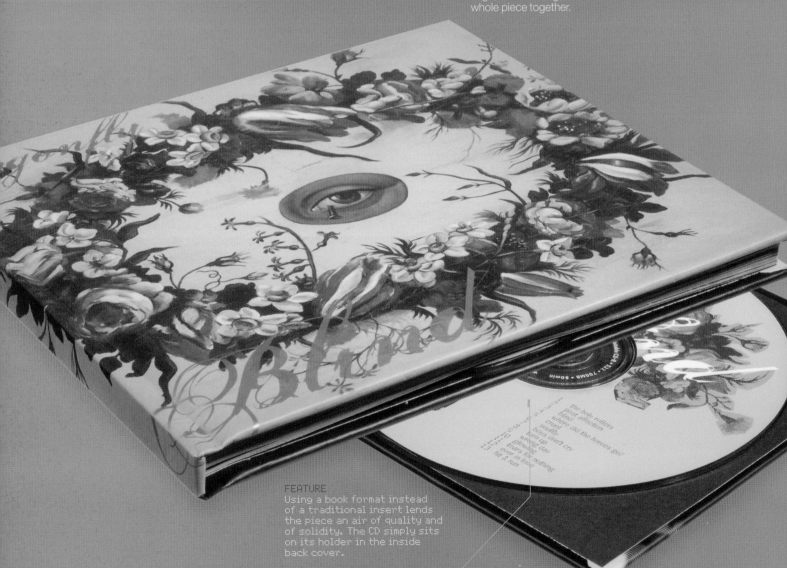

FEATURE
Using a book format instead of a traditional insert lends the piece an air of quality and of solidity. The CD simply sits on its holder in the inside back cover.

Produced on a very low budget, Walse Custom Design wanted Money Brother's album cover to have the feel of a religious icon. The heavy use of metallic gold, imagery, and graphic elements combine to create religious overtones. The album even features a sheep. So, any drawbacks to the project? Well, the budget was low, but this actually allowed the agency to demand more creative freedom.

\\ART DIRECTOR
HENRIK WALSE

\\DESIGNER
HENRIK WALSE

\\CLIENT
BURNING HEART RECORDS

\\PROJECT
CD PACKAGING

\\SPECIFICATION
A DOUBLE JEWEL CASE WITH CARD WRAPAROUND SLEEVE

\\ 060
\ WALSE CUSTOM DESIGN
MONEY BROTHER: TO DIE ALONE
SWEDEN

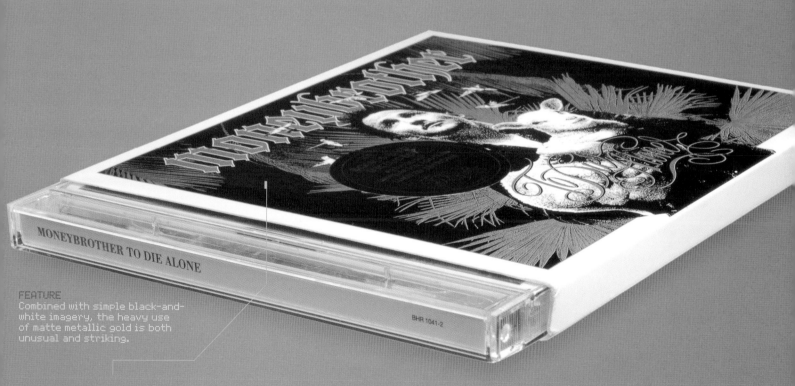

FEATURE
Combined with simple black-and-white imagery, the heavy use of matte metallic gold is both unusual and striking.

By printing directly onto the packaging's exterior, North has retained its transparent qualities. Inspired by the work of its client Marc Newson, a product designer, the graphics take his forms and incorporate them into the design. It was important to North that the packaging had a physical appeal, not just graphic. The forms are replicated on the CD itself, making use of the silver show-through.

\\ART DIRECTOR
STEPHEN GILMORE

\\DESIGN STUDIO
NORTH

\\CLIENTS
NICK WOOD/
MARC NEWSON

\\PROJECT
DVD PACKAGING

\\SPECIFICATION
SCREEN-PRINTED
CLEAR DVD CASE

061 NORTH
MARC NEWSON: DESIGNERS DIMENSIONS
UK

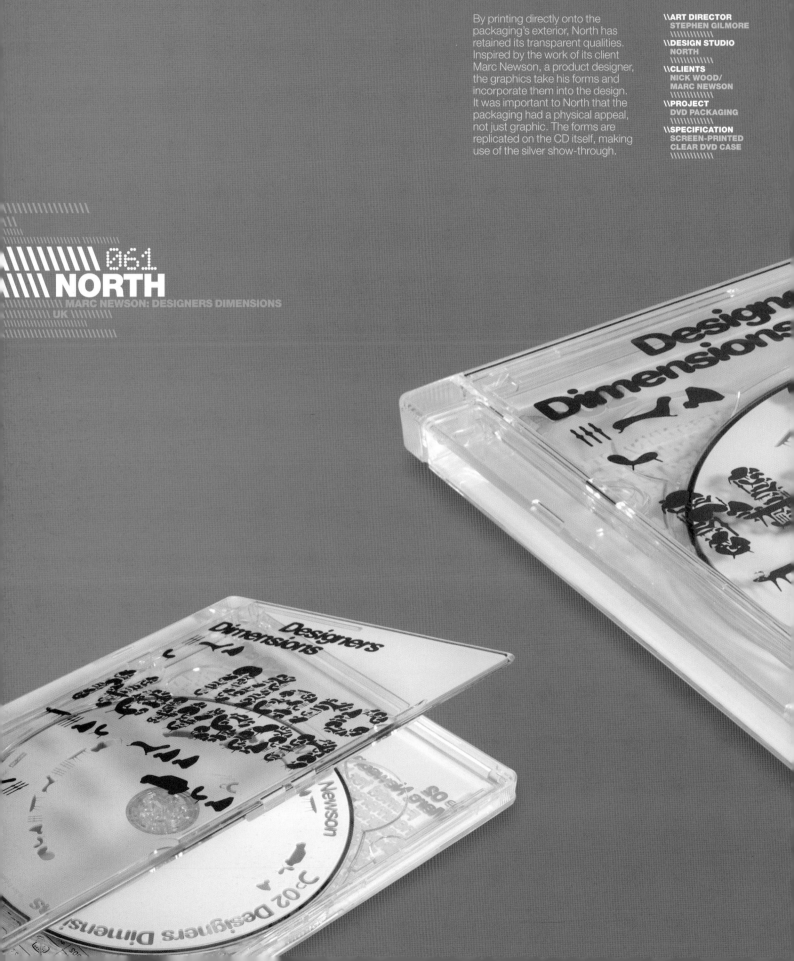

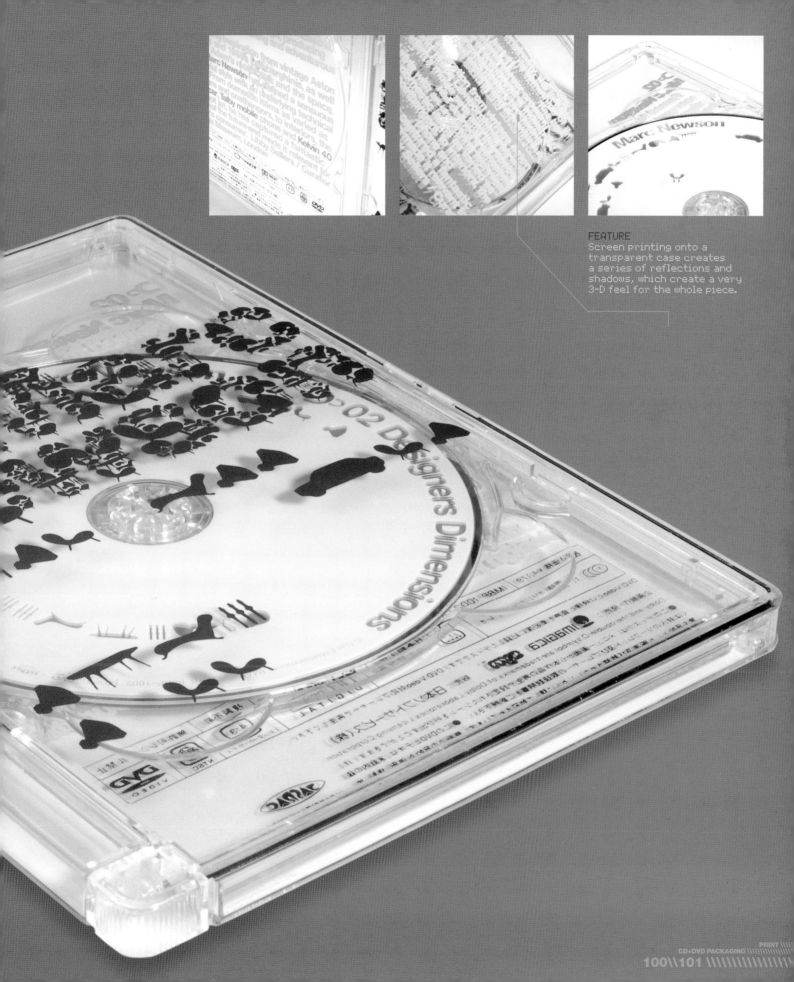

FEATURE
Screen printing onto a transparent case creates a series of reflections and shadows, which create a very 3-D feel for the whole piece.

062 THE REDROOM
THE ALIENS: ALIENOID STARMONICA
UK

The Aliens band was looking for punchy and beautiful packaging for its first release; something that would stand out and announce it. The band provided examples of the kind of thing it was looking for, as well as the illustrations and the logo, which the members designed themselves. Working in close conjunction with the band, The Redroom chose unfinished stock for the inner wallet and fold-out insert because of the more tactile finish. For the cover, however, it opted for mirror board "because, quite frankly, it looks amazing."

\\ART DIRECTORS
THE ALIENS:
ROBIN JONES
JOHN MACLEAN
GORDON ANDERSON

\\DESIGNERS
CHRIS PEYTON/
THE ALIENS

\\CLIENT
EMI RECORDS

\\PROJECT
CD PACKAGING AND
SLEEVE DESIGN

\\SPECIFICATION
CAPACITY WALLET
INNER POCHETTE, FOLD-OUT POSTER MIRROR BOARD WITH SPOT COLORS AND VARNISH; INNER BAG AND POSTER ON UNFINISHED BOARD

FEATURE
As The Redroom discovered, printing onto mirror board is a specialist process. White cannot be printed onto the stock so the whole thing—including the tiny text on the slim spine—has been screen printed. This effect is reversed on the CD, with a matte print and silver show-through on the logo.

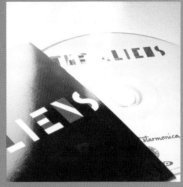

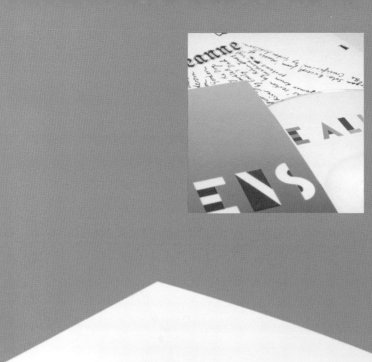
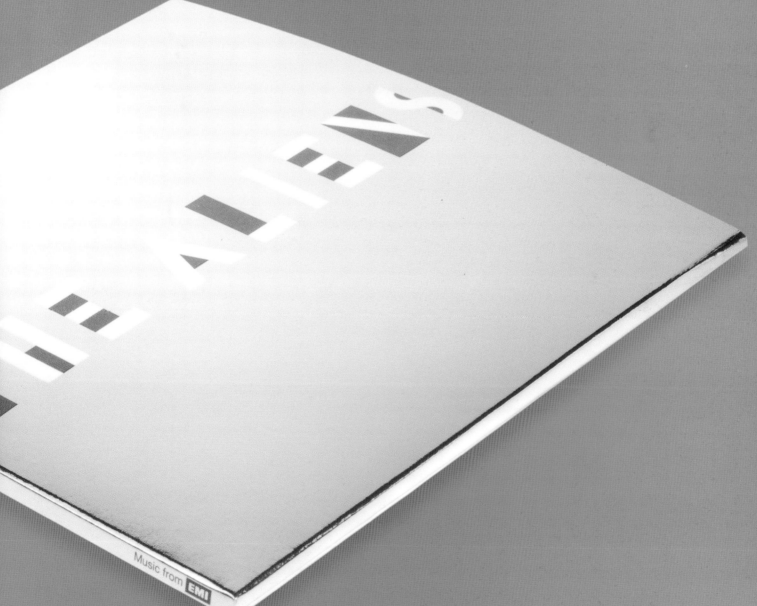

Rather than selecting higher-budget packaging formats, karlssonwilker selected simple jewel-case packaging and a shrink-wrap outer printed in 3-colors.

\\ART DIRECTORS
JAN WILKER
HJALTI KARLSSON

\\DESIGNER
JAN WILKER

\\CLIENT
CAPITOL RECORDS

\\PROJECT
CD PACKAGING

\\SPECIFICATION
JEWEL CASE WITH
3-COLOR PRINT
SHRINK-WRAP

063
KARLSSONWILKER INC.
THE VINES: HIGHLY EVOLVED
USA

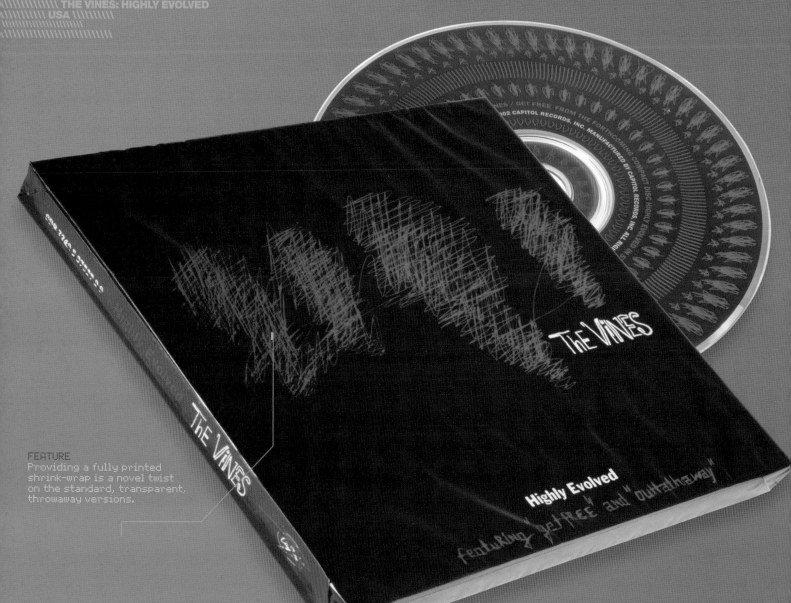

FEATURE
Providing a fully printed shrink-wrap is a novel twist on the standard, transparent, throwaway versions.

Creating new packaging for record company Skirl Records, karlssonwilker has taken a regular-sized design and applied it to DVD packaging, creating bands of white space at the top and bottom. This is an unusual approach. Each case is printed in just 2 spot colors, which are also in the disc's design.

\\ART DIRECTORS
JAN WILKER
HJALTI KARLSSON

\\DESIGNERS
FABIENNE HESS
JAN WILKER
HJALTI KARLSSON

\\CLIENT
SKIRL RECORDS

\\PROJECT
NEW PACKAGING DESIGN FOR FUTURE SKIRL RECORDS RELEASES

\\SPECIFICATION
DVD-SIZED DIGIPAK
2-SPOT COLOR PRINT

\\ 064
\ KARLSSONWILKER INC.
SKIRL RECORDS CD SERIES
USA

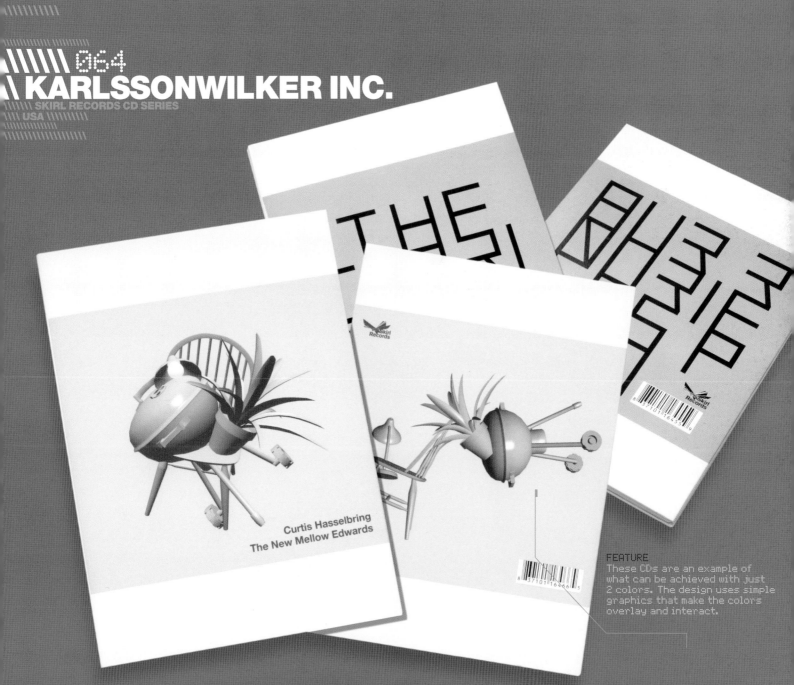

FEATURE
These CDs are an example of what can be achieved with just 2 colors. The design uses simple graphics that make the colors overlay and interact.

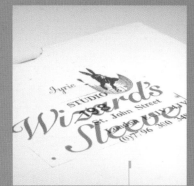

\\ART DIRECTOR
ADAM WHITAKER

\\DESIGNER
ADAM WHITAKER

\\CLIENT
IYRIE!

\\PROJECT
CD COVERS FOR
REGULAR IYRIE!
CD RELEASES

\\SPECIFICATION
PRINTED LETTERPRESS

065 IYRIE!
IYRIE! MIX CDS
UK

FEATURE
With this packaging, iyrie! has understood and played to the imperfections of the letterpress. Ink will often be irregular, blurred, or smudged, but this is part of the charm. The letterpress causes indentations when it prints, so the agency has selected card sleeves that complement this effect, with highly tactile results.

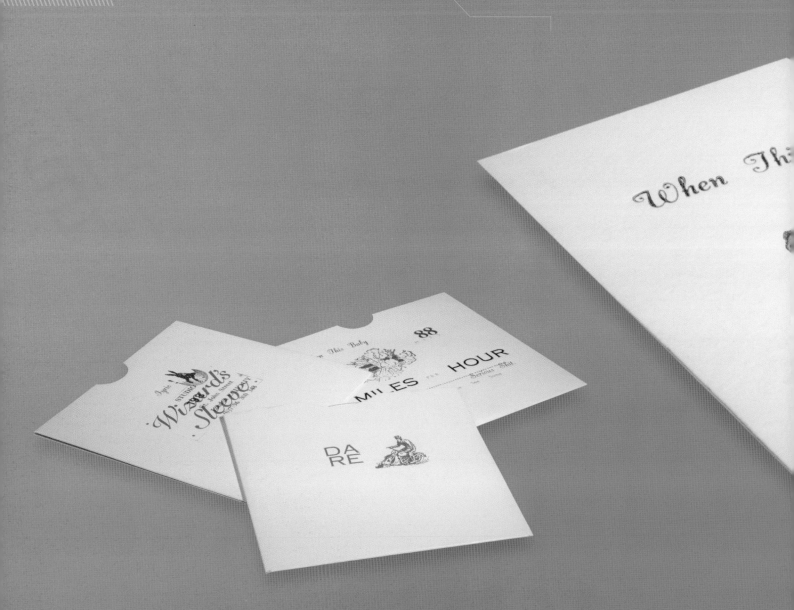

Over the years, iyrie!'s music mailing list has steadily grown to around 200 recipients. From a financial standpoint, it wasn't viable to have covers professionally printed each time. What's more, the time involved in just producing and burning the CDs was already a heavy burden on resources, so turning to its ink-jet printer was not an option either. The agency wanted to create an individual yet consistent look for the series, so, with an aversion to traditional jewel cases, eventually settled on cardboard cases and a good, old-fashioned letterpress.

Ironically, the agency discovered that a technology generally regarded as slow and tedious comes into its own in this context. Instead of being a laborious chore, the covers became a fun, hands-on project that didn't involve hours sitting in front of the computer. The number produced in any one stint is limited to the amount of drying space. And the limitations of the letterpress mean that decisions have to be made well in advance: blocks are made and cannot be altered; colors are based on what can be found on eBay. And if you decide to print in yellow next, it involves cleaning and drying the equipment. So, as the agency says, "sometimes you just think 'it wasn't what I had in mind, but maybe that will look good in green instead'."

So basically, it's still time-consuming work, but feels worth the effort. And the results are cost-effective, tactile, and unique covers that reflect the eclectic cut-and-paste nature of the music within.

North's inspiration for both these designs comes from client Syn's own morphing, dynamic identity. Created as a soundtrack for the 2002 World Cup in Japan, *Passion* takes a simple foil-block, soccer-pitch graphic, and then "melts" the stripes of a freshly mown soccer pitch. The circular insert mirrors the shape of the CD and reinforces the soccer theme. *Sound Virus* takes the idea of morphing and applies it to a virus—music being something that is passed on and can be caught.

\\ART DIRECTOR
STEPHEN GILMORE
\\DESIGN STUDIO
NORTH
\\CLIENTS
NICK WOOD/SYN/KIRIN
\\PROJECT
CD PACKAGING
\\SPECIFICATION
CARDBOARD WITH FLUORO GREENS AND SILVER FOIL BLOCKING

066 NORTH
NICK WOOD: PASSION/SOUND VIRUS
UK

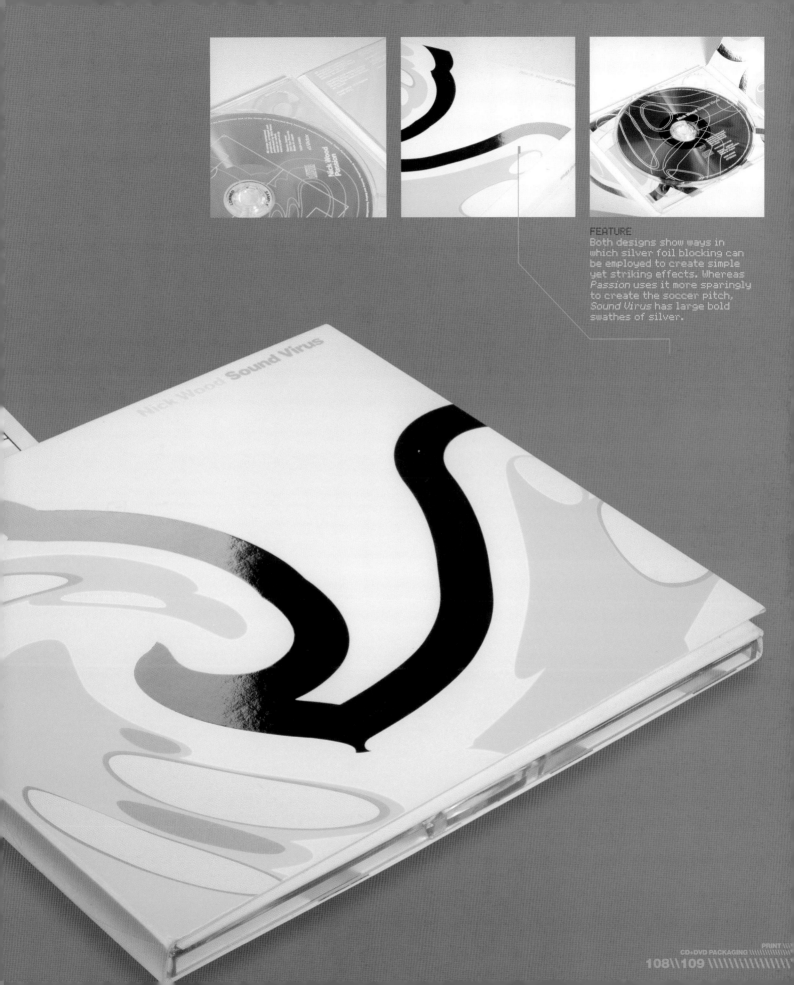

FEATURE
Both designs show ways in which silver foil blocking can be employed to create simple yet striking effects. Whereas *Passion* uses it more sparingly to create the soccer pitch, *Sound Virus* has large bold swathes of silver.

067 ZIP DESIGN
SOUL HEAVEN: MASTERS AT WORK/
PRESENTS BLAZE
UK

Taking inspiration from soulful women, each release within the *Soul Heaven* series features a different model and wood-texture effect. The uncoated stock adds to the "wooden" feel of the packaging, and the gold foil blocking creates something of a retro 1970s feel.

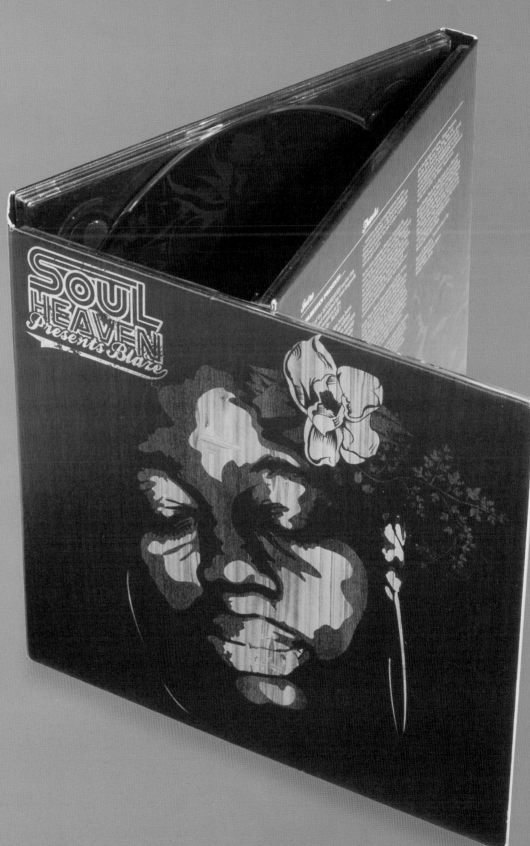

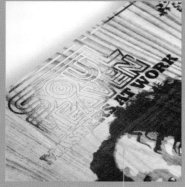

\\ART DIRECTOR
PETER CHADWICK

\\DESIGNER
DAVID BOWDEN

\\CLIENT
DEFECTED RECORDS

\\PROJECT
PACKAGING FOR
2 TRIPLE-CDS

\\SPECIFICATION
DIGIBOX: 3 ONBODIES
UNCOATED STOCK WITH
GOLD FOIL BLOCKING

FEATURE
As well as the unusual packaging, Zip has employed interesting print techniques on the CDs themselves. *Masters at Work* features a soft and textured print, whereas *Presents Blaze* has a very light print, allowing a minimal amount of show-through so the gray elements have a silvery shine.

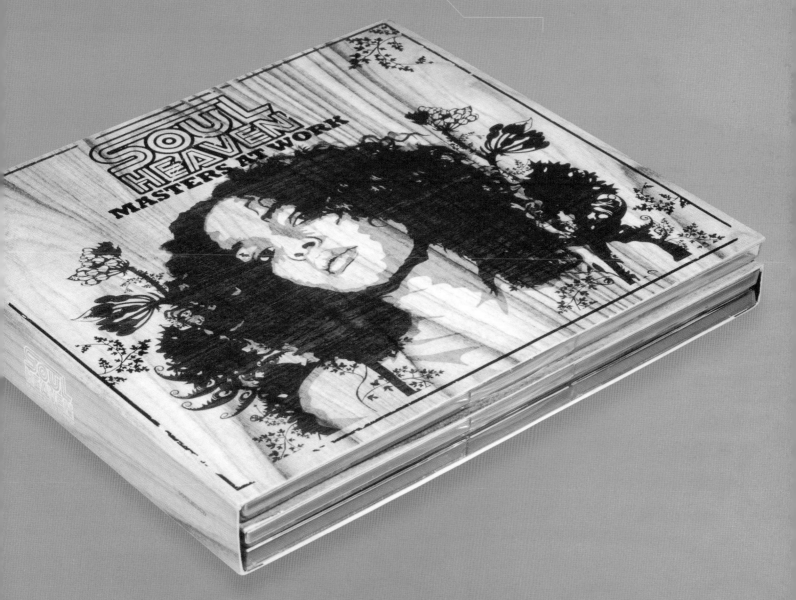

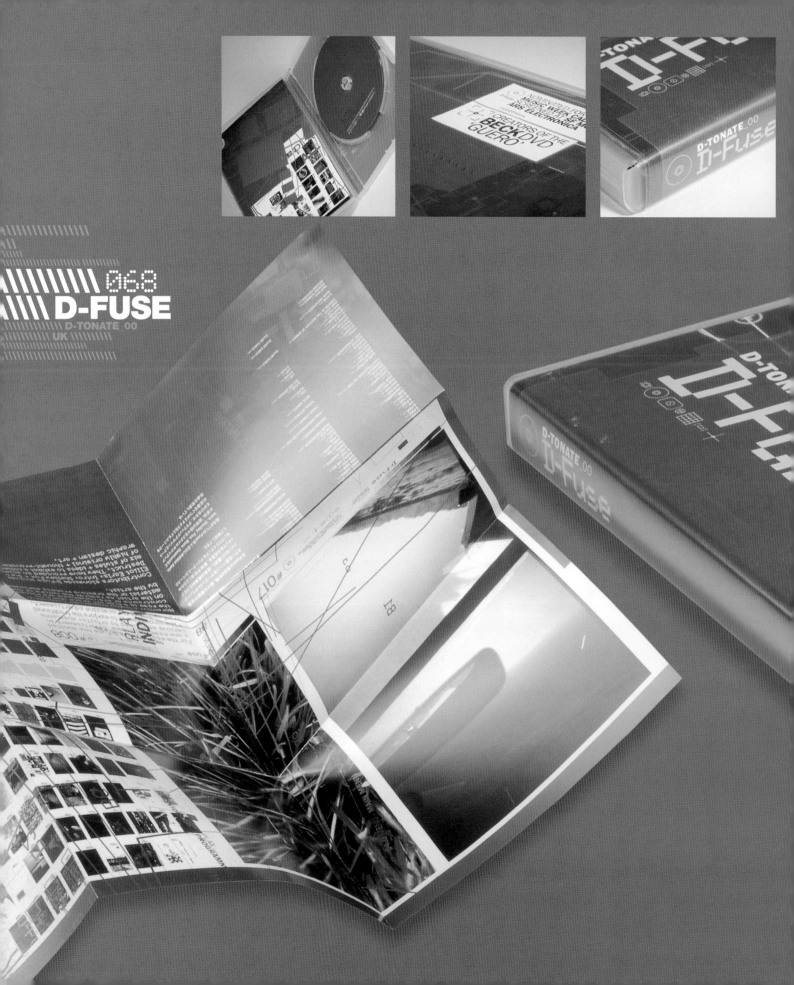

068 D-FUSE
D-TONATE_00
UK

ART DIRECTOR
MICHAEL FAULKNER
DESIGNER
MICHAEL FAULKNER
CLIENT
D-FUSE
PROJECT
NTSC DVD AND POSTER
SPECIFICATION
DVD LABEL: GLOSS
AND MATTE FINISHES
POSTER AND SLEEVE:
METALLIC

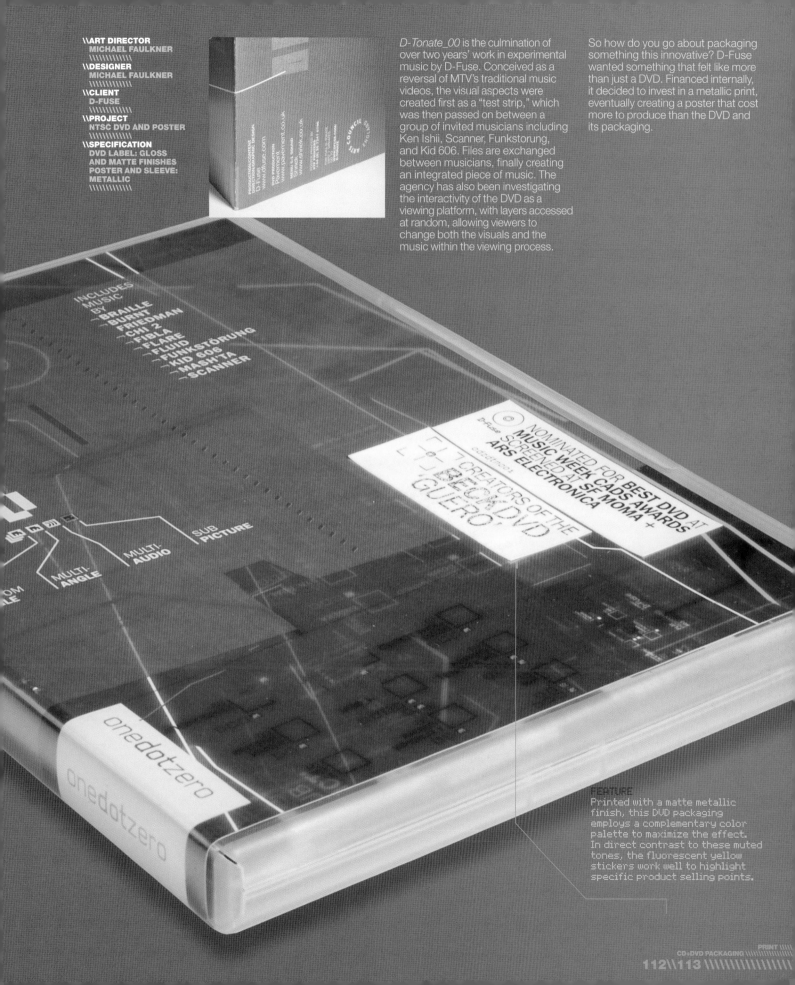

D-Tonate_00 is the culmination of over two years' work in experimental music by D-Fuse. Conceived as a reversal of MTV's traditional music videos, the visual aspects were created first as a "test strip," which was then passed on between a group of invited musicians including Ken Ishii, Scanner, Funkstorung, and Kid 606. Files are exchanged between musicians, finally creating an integrated piece of music. The agency has also been investigating the interactivity of the DVD as a viewing platform, with layers accessed at random, allowing viewers to change both the visuals and the music within the viewing process.

So how do you go about packaging something this innovative? D-Fuse wanted something that felt like more than just a DVD. Financed internally, it decided to invest in a metallic print, eventually creating a poster that cost more to produce than the DVD and its packaging.

FEATURE
Printed with a matte metallic finish, this DVD packaging employs a complementary color palette to maximize the effect. In direct contrast to these muted tones, the fluorescent yellow stickers work well to highlight specific product selling points.

From the front, this appears to be a standard CD package. Turn it over though and we discover how madebygregg has played with the CD's 3in (76mm) sputter to its full effect. Featuring just three songs, the music obviously doesn't require as much CD storage space as a standard album. So instead of using a standard CD, the agency has opted for this semitransparent CD with the music centered on the core sputter. The CD design plays with this—overprinting the silver element of the CD, and also printing onto the transparent areas.

\\ART DIRECTOR
GREGG BERNSTEIN
\\DESIGNER
GREGG BERNSTEIN
\\CLIENTS
POLYVINYL RECORDS/
THE RED HOT
VALENTINES
\\PROJECT
SLIMLINE CD PACKAGING
\\SPECIFICATION
SLIMLINE JEWEL CD
CASE CMYK PRINT ON
UNCOATED STOCK

069
MADEBYGREGG
THE RED HOT VALENTINES: CALLING OFF TODAY
USA

FEATURE
By using the transparency at the back of the packaging, the transparent CD can be seen without having to open the packaging, and the insert's text can be read through it.

With the luxury of a fairly lavish budget, madebygregg set forth with this 6-color CD packaging. Darker than previous Hey Mercedes releases, the design takes inspiration from the content of *Loses Control*; the concept that, in certain situations, forces beyond our control may be at work. With this theme in mind, the agency applied a spot varnish graphic to every second page. Only visible when hit by the light in a certain way, it implies that more is happening than meets the eye. The agency wanted the packaging to have a "distressed" feel, so all type was printed, hand-distressed, then rescanned. To bolster this effect further, the lyrics were reversed and blurred.

\\ART DIRECTOR
GREGG BERNSTEIN

\\DESIGNER
GREGG BERNSTEIN

\\CLIENTS
VAGRANT RECORDS/
HEY MERCEDES

\\PROJECT
CD PACKAGING

\\SPECIFICATION
STANDARD JEWEL CASE
CMYK ON UNCOATED
STOCK, WITH SPOT
VARNISH AND MATTE
COATING

070
\MADEBYGREGG
HEY MERCEDES: LOSES CONTROL
USA

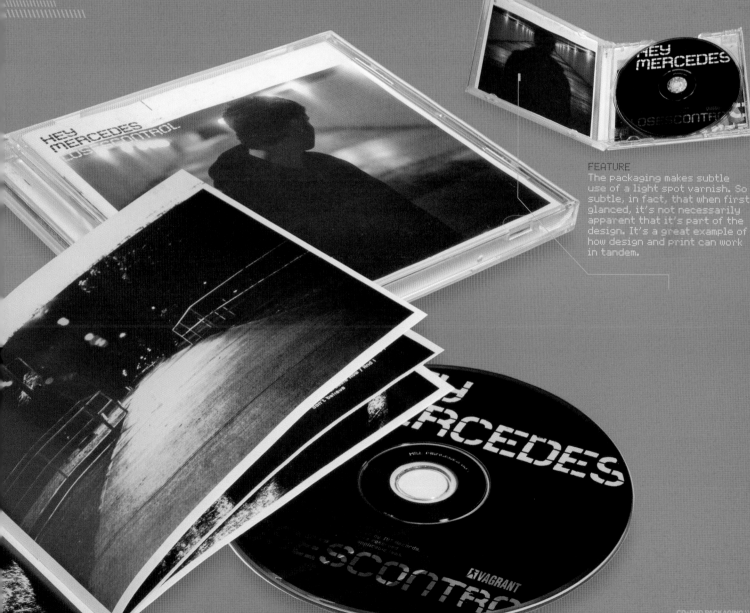

FEATURE
The packaging makes subtle use of a light spot varnish. So subtle, in fact, that when first glanced, it's not necessarily apparent that it's part of the design. It's a great example of how design and print can work in tandem.

Red Design was tasked with creating a "special" design for the *We Are Skint* retrospective. As this was a compilation album, the agency struggled to find a single image that it felt would represent the entire content. Instead it chose to remove all imagery from the exterior and—using a clear double case—let the materials speak for themselves. All text is screen printed in a bold red on the case's exterior, with the CDs always visible and forming part of the overall esthetic. The elongated star is a consistent graphic throughout the packaging. Screen printed on the outside of the case, it also appears in matte UV on the CDs and as a high spot gloss on the poster/insert.

\\\DESIGN STUDIO
RED DESIGN

\\\CLIENT
SKINT RECORDS

\\\PROJECT
DOUBLE JEWEL CASE WITH POSTER

\\\SPECIFICATION
CLEAR JEWEL CASE + 1 COLOR SCREEN PRINT. CDS: 2 COLORS + MATTE UV POSTER: 4-COLOR + SPOT GLOSS 2-COLOR BELLYBAND

071 RED DESIGN
WE ARE SKINT
UK

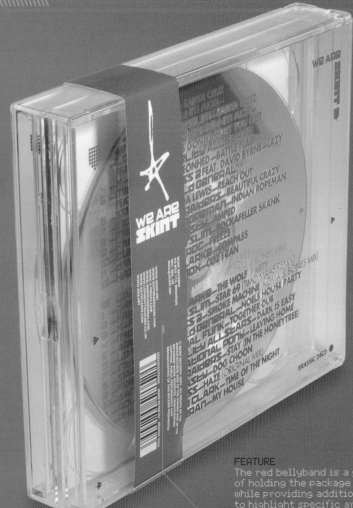

FEATURE
The red bellyband is a great way of holding the package together, while providing additional space to highlight specific artists, and removing the need for the case itself to feature a bar code.

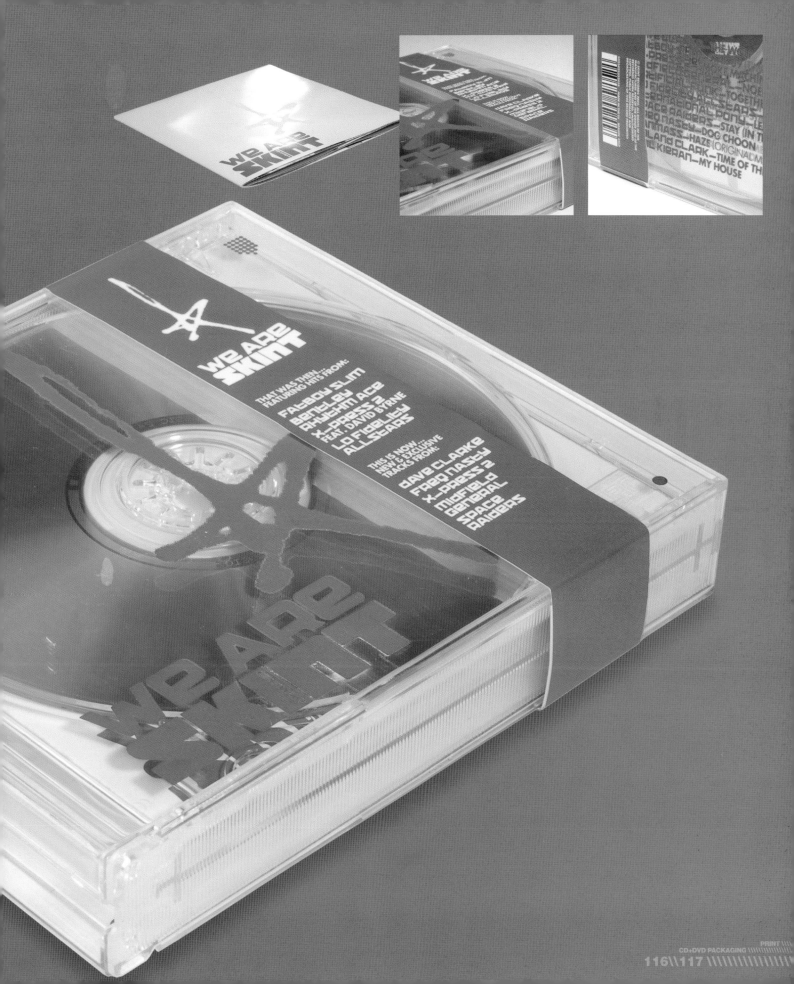

Flashman—whose diverse influences include everything from computer games and Manga comic books, to classic sci-fi film references—was an unsigned artist, and split the album's release costs with his manager. Therefore, Kukusi created low-cost packaging that could be produced on a small print run. As the design incorporated diagrams and illustrations from eminent architects including Frank Lloyd Wright, Le Corbusier, Mies van der Rohe, and Walther Gropius, the agency felt Futura was the natural font choice for the packaging.

\\DESIGNERS
ANDREW DAY
CHRIS PEYTON

\\CLIENT
FLASHMAN

\\PROJECT
CD PACKAGING

\\SPECIFICATION
TRACING-PAPER COVER,
CLEAR PLASTIC WALLET

072 KUKUSI
FLASHMAN
UK

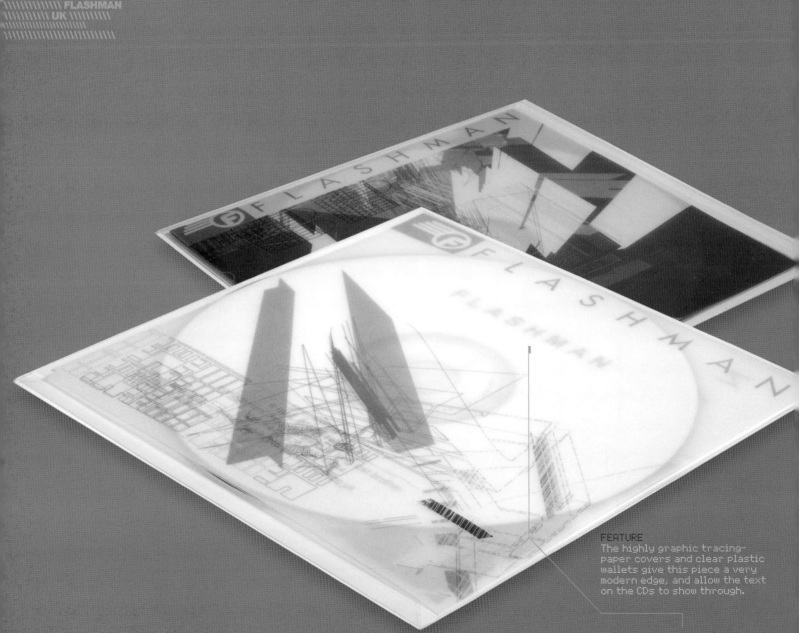

FEATURE
The highly graphic tracing-paper covers and clear plastic wallets give this piece a very modern edge, and allow the text on the CDs to show through.

Looking to create a recognizable compilation series that could express the obscurity and positive weirdness of the music, Syrup Helsinki found no better source of inspiration than the music itself. Using the 2-color print to full effect, the agency has created a series of fun black-and-white characters that appear on vibrant, flat-color backgrounds.

\\ART DIRECTOR
TEEMU SUVIALA

\\DESIGNERS
TEEMU SUVIALA
ANTTI HINKULA
SOFIA ØSTERHUS

\\CLIENT
ESCALATOR RECORDS
(JAPAN)

\\PROJECT
7-CD BOX SET

\\SPECIFICATION
JEWEL CASE WITH
4-COLOR BOX
LABEL AND SLEEVE:
2-COLOR PRINT,
UNCOATED STOCK

\\ 073
\\ SYRUP HELSINKI
\\\\\\ WE ARE ESCALATOR RECORDS: COMPILATION SERIES
\\\\ FINLAND

FEATURE
Another great use of 2-color printing, this packaging uses simplicity to its complete advantage. Adding other elements to this packaging would detract from it.

This CD was produced to promote *Free* by Nick Wood—a cell phone theme tune. *Free* takes its name from the Talby phone mnemonic and, to pick up on this, North deconstructed the phone to use as graphics for the CD's title.

\\DESIGN STUDIO
NORTH

\\CLIENTS
NICK WOOD/
MARC NEWSON

\\PROJECT
PACKAGING FOR CELL
PHONE SOUNDTRACK

\\SPECIFICATION
SCREEN-PRINTED
JEWEL CASE

\\\\\\\\ 074
\\\\NORTH
NICK WOOD: FREE
UK

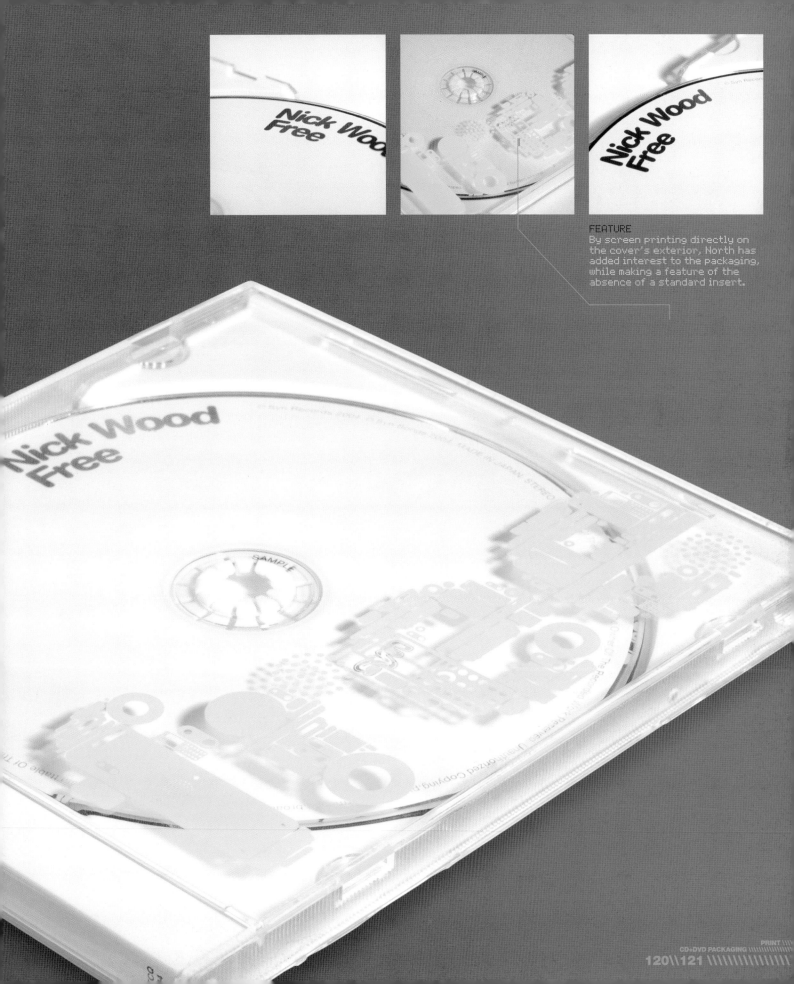

FEATURE
By screen printing directly on the cover's exterior, North has added interest to the packaging, while making a feature of the absence of a standard insert.

This brightly colored Christmas CD packaging makes fun and modern use of gold foil blocking. As well as the children's round faces, the gold is used for extra detail, such as the little gold snowflakes. This starry effect is replicated on the CD itself, with cut-throughs on the CD creating a twinkling snowflake effect.

\\DESIGN STUDIO
NORTH

\\CLIENTS
NICK WOOD/
STARBUCKS

\\PROJECT
CD PACKAGING

\\SPECIFICATION
GOLD FOIL BLOCKING

FEATURE
The simple design on the CD creates a pretty Christmas feel. Cut-throughs have been used to great effect, picking out a minimal number of snowflakes to glint in the light.

075 NORTH
NICK WOOD: STARBUCKS KIDS CHRISTMAS
UK

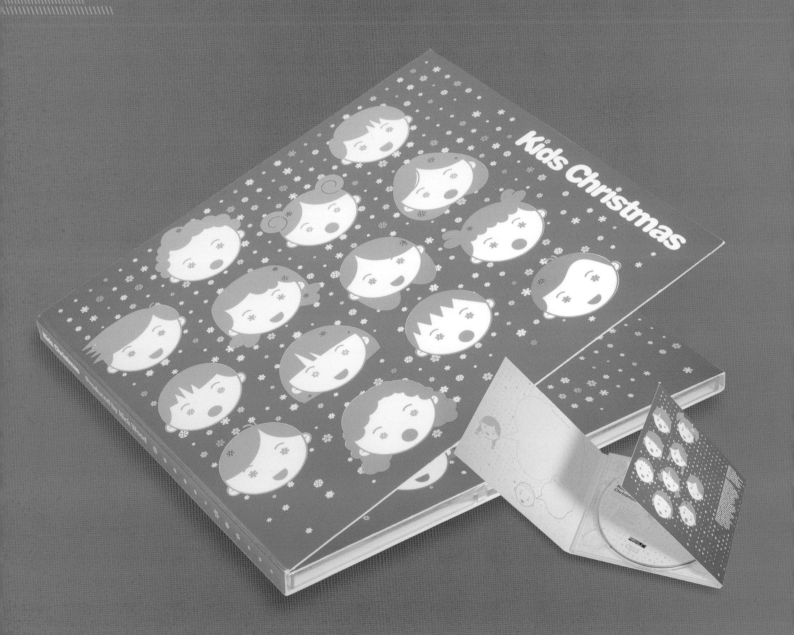

Webb & Webb set out to produce packaging that reflected the quality of Robert Dowling's photography and moviemaking. The agency opted to use typography to achieve this. Limited to paper stock held by the printers, it decided letterpressing a classic typeface would produce a timeless and tactile solution. The simple roll-fold packaging also has an innovative twist, with a half-moon die-cut holding the CD in place.

\\DESIGN STUDIO
WEBB & WEBB DESIGN

\\CLIENT
ROBERT DOWLING

\\PROJECT
DVD PACKAGING FOR PHOTOGRAPHER'S MOVIE AND PHOTOGRAPHY PORTFOLIOS

\\SPECIFICATION
6-PAGE FOLDED CARD, LETTERPRESS PRINTED, FABRIANO 5 SMOOTH 350GSM

076
\\WEBB & WEBB DESIGN
ROBERT DOWLING SHOWREEL AND PORTFOLIO PACKS
UK

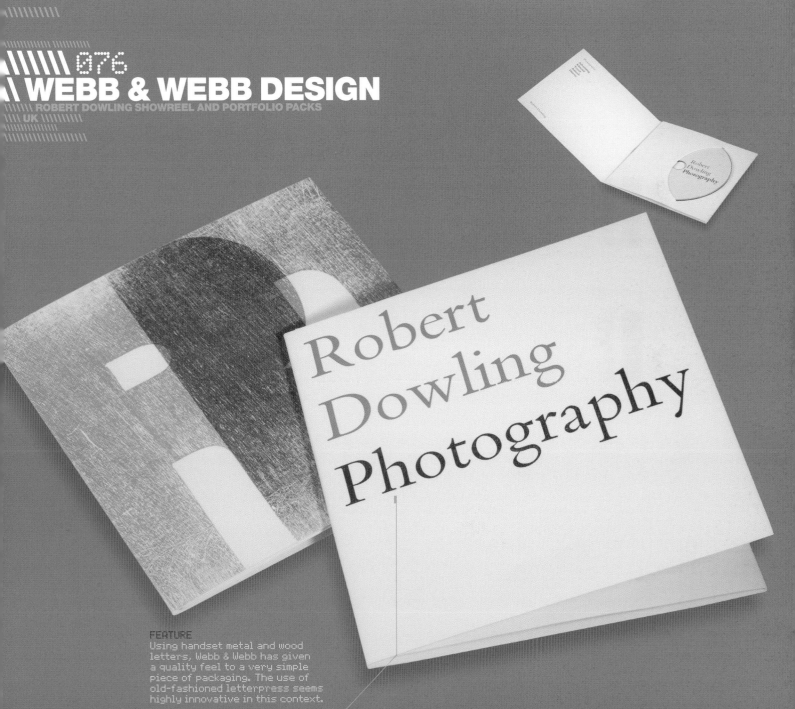

FEATURE
Using handset metal and wood letters, Webb & Webb has given a quality feel to a very simple piece of packaging. The use of old-fashioned letterpress seems highly innovative in this context.

\\\\\\\\\\\ 077
\\\\\ KARLSSONWILKER INC.
CRI/BLUESHIFT RECORDINGS
USA

Opting to print the inserts in black and white, and with print runs at a maximum of 1,500, karlssonwilker saved enough of the budget to screen print on the outside of the jewel cases. Each case is printed in 1 vibrant color that interplays with the black-and-white inserts. The result is highly dynamic packaging.

FEATURE
This is a great example of the way the cover and insert design work brilliantly together. In this instance, the screen print has been used playfully to obscure the text beneath.

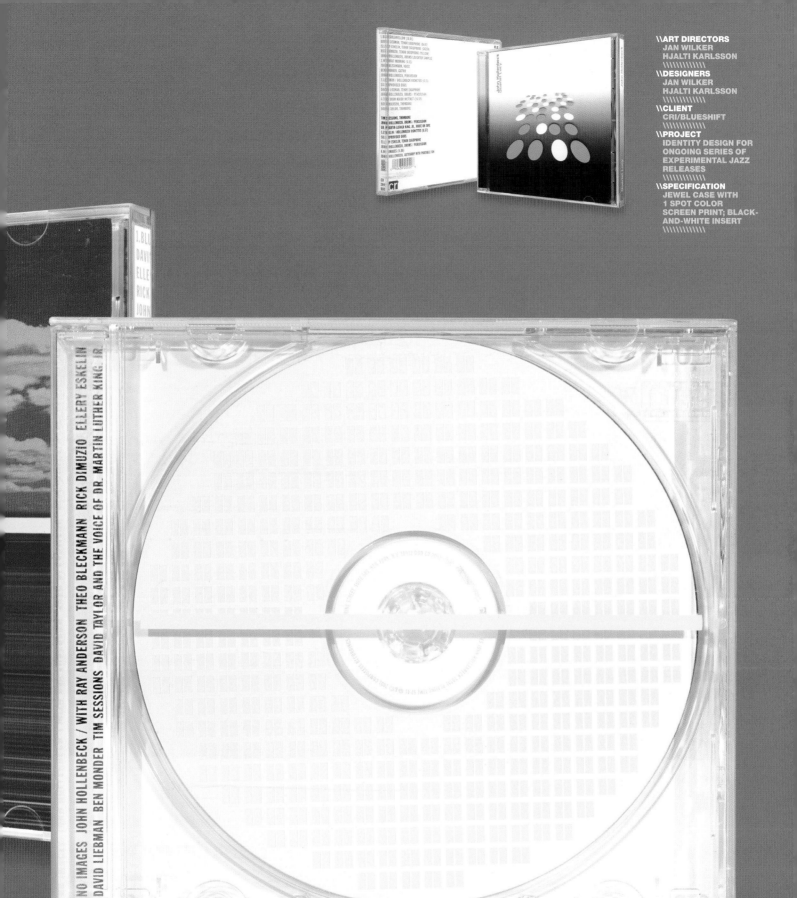

\\ART DIRECTORS
JAN WILKER
HJALTI KARLSSON

\\DESIGNERS
JAN WILKER
HJALTI KARLSSON

\\CLIENT
CRI/BLUESHIFT

\\PROJECT
IDENTITY DESIGN FOR ONGOING SERIES OF EXPERIMENTAL JAZZ RELEASES

\\SPECIFICATION
JEWEL CASE WITH 1 SPOT COLOR SCREEN PRINT; BLACK-AND-WHITE INSERT

078
GIULIO TURTURRO
THE TONY WILLIAMS LIFETIME: SPECTRUM: THE ANTHOLOGY
USA

Inspired by the music of Tony Williams, who drummed for the likes of Miles Davis, Giulio Turtorro's primary aim was to produce a slipcase that simulated the skin of a drum. The budget was slightly above average, but Giulio chose to hold back on color in the booklet so that he could splurge on the slipcase. In addition, having the insert in black-and-white meant it didn't detract from the slipcase, the main focal point of the packaging. The only color is on the inner tray at the back, which you glimpse through the transparent areas of the slipcase print. The drumming theme is echoed in the back cover and inner tray, with overlaid circles representing the floor plan of a drum kit. Retro touches such as the graphics, fonts, and the concentric circles on the CD—resembling old-fashioned vinyl—allude to the artist's 1970s music.

\\ART DIRECTOR
GIULIO TURTURRO

\\DESIGNER
GIULIO TURTURRO

\\CLIENT
VERVE RECORDS

\\PROJECT
2-CD SET

\\SPECIFICATION
2-CD JEWEL CASE;
CLEAR VINYL SLIPCASE
PRINTED IN 2 COLORS
16-PAGE SADDLE-
STITCHED BOOKLET ON
UNCOATED STOCK

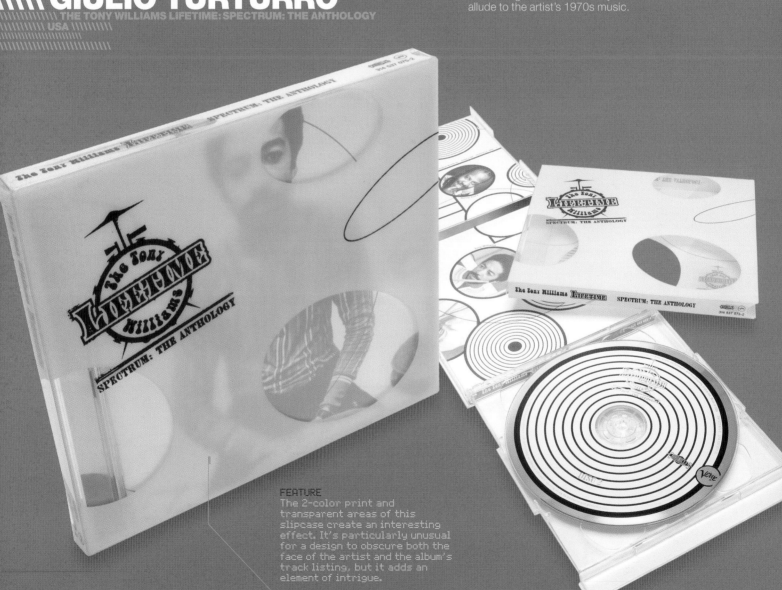

FEATURE
The 2-color print and transparent areas of this slipcase create an interesting effect. It's particularly unusual for a design to obscure both the face of the artist and the album's track listing, but it adds an element of intrigue.

Wanting to find an interesting way to reflect the album's title *Chromeo*, Chris Bolton took inspiration from the old-fashioned typography used in perfume packaging. The designer created his own typography based on Herb Lubalin's 1970s work. Cost issues limited the number of colors Bolton could use, but he feels this adds to the design's simple elegance.

\\ART DIRECTOR
CHRIS BOLTON

\\DESIGNER
CHRIS BOLTON

\\CLIENT
ESKIMO RECORDS
(BELGIUM)

\\PROJECT
CD PACKAGING

\\SPECIFICATION
CD WITH SLIPCASE,
AND FOLD-OUT POSTER
PRINTED PANTONE
SILVER, BLACK,
AND WHITE

079
\ CHRIS BOLTON
CHROMEO PRESENT "UN JOLI MIX POUR TOI"
FINLAND

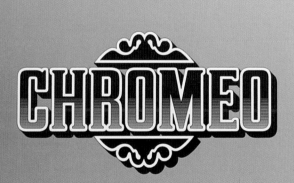

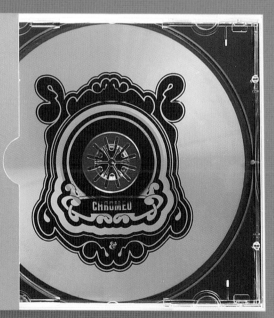

FEATURE
Printed in just 2 colors, Bolton used Pantone silver not only for the background, but also within the lettering, thus adding an element of shine, and playing on the album's title.

Iwant Design has been responsible for developing artwork for Buzzin' Fly Records since the label's 2003 inception. The agency designed the label's fly logo and font which, initially inspired by Pablo Ferro, has since taken on an identity all of its own. Taking layers of typography and graphic elements, the agency worked to create manic layers of color across the reverse board. For this release the budget was limited, but the agency stretched the processes where possible. This included the incorporation of a bespoke blue tray, designed to complement the blue foil blocking used throughout, and with indents replicating the diagonal cross used throughout the design.

\\ART DIRECTOR
JOHN GILSENAN

\\DESIGNER
JOHN GILSENAN

\\CLIENT
BUZZIN' FLY

\\PROJECT
CD PACKAGING

\\SPECIFICATION
6-PAGE DIGIPAK: HEAVYWEIGHT BOARD AND BESPOKE BLUE TRAY. MATTE BLUE FOIL BLOCK THROUGHOUT

080
IWANT DESIGN
BUZZIN' FLY VOLUME 3
UK

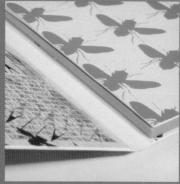
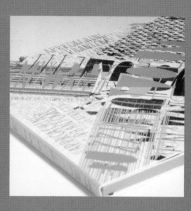
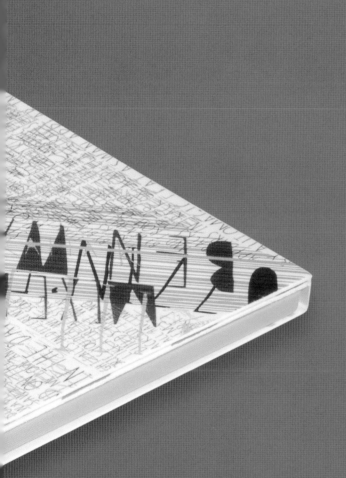
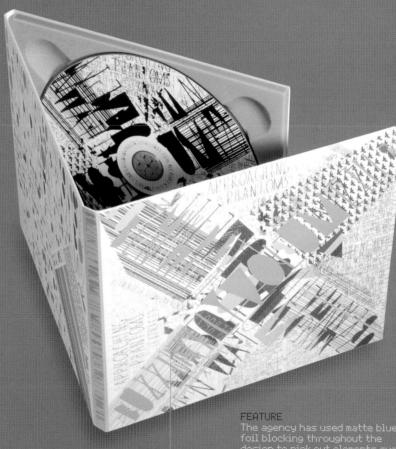

FEATURE
The agency has used matte blue foil blocking throughout the design to pick out elements such as the title and the musician's name. The color contrasts well with the reverse board and plays with the slight embossing inherent in foil blocking to create another level and texture within the design.

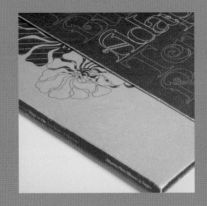
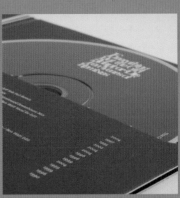

081
IWANT DESIGN
UK
EVERYTHING BUT THE GIRL: ADAPT OR DIE: TEN YEARS OF REMIXES

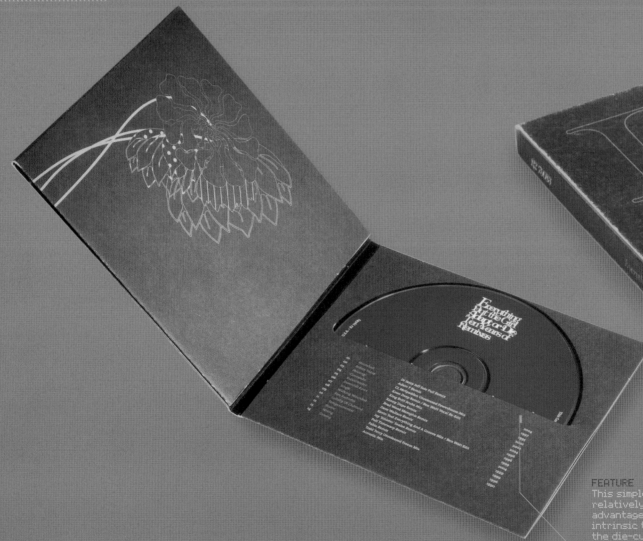

FEATURE
This simple packaging uses a relatively low budget to its advantage. The 2-color print is intrinsic to the design, and the die-cut CD slot keeps the packaging fresh and compact.

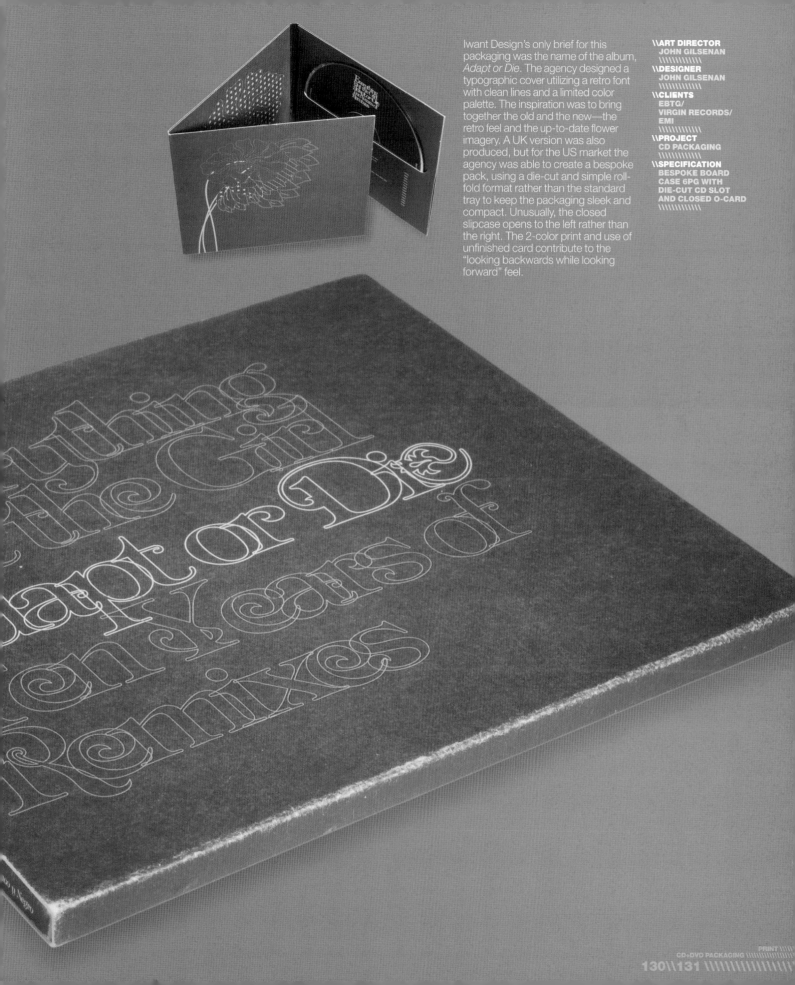

Iwant Design's only brief for this packaging was the name of the album, *Adapt or Die*. The agency designed a typographic cover utilizing a retro font with clean lines and a limited color palette. The inspiration was to bring together the old and the new—the retro feel and the up-to-date flower imagery. A UK version was also produced, but for the US market the agency was able to create a bespoke pack, using a die-cut and simple roll-fold format rather than the standard tray to keep the packaging sleek and compact. Unusually, the closed slipcase opens to the left rather than the right. The 2-color print and use of unfinished card contribute to the "looking backwards while looking forward" feel.

\\ART DIRECTOR
JOHN GILSENAN

\\DESIGNER
JOHN GILSENAN

\\CLIENTS
EBTG/
VIRGIN RECORDS/
EMI

\\PROJECT
CD PACKAGING

\\SPECIFICATION
BESPOKE BOARD
CASE 6PG WITH
DIE-CUT CD SLOT
AND CLOSED O-CARD

As the label's second compilation release, Iwant Design attempted to capture something of the evolving beauty of the record. The newly introduced "fly" font—inspired by Pablo Ferro's movie titles—was used to suggest spiky undertones. Using the solid color of the reverse card, everything inside the covers—including the pull-out poster—is printed entirely in black. So while being full of information, the pull-out poster feels very clean. The unfinished stock used throughout adds to this feel. Nothing detracts from the simplicity of the design.

\\ART DIRECTOR
JOHN GILSENAN

\\DESIGNER
JOHN GILSENAN

\\CLIENT
BUZZIN' FLY RECORDS

\\PROJECT
CD PACKAGING

\\SPECIFICATION
BESPOKE CARD WALLET:
4-PAGE, 2 POCKETS,
PULL-OUT POSTER
BOOKLET REVERSE
BOARD THROUGHOUT;
DIE-CUT FINGER HOLES;
5-COLOR PRINT OF
CARD WALLETS

082
IWANT DESIGN
BUZZIN' FLY VOLUME 2
UK

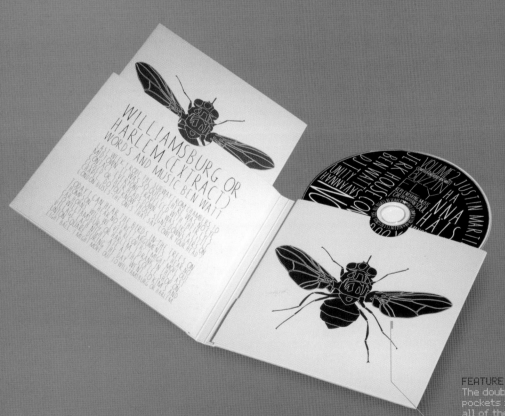

FEATURE
The double gatefold with die-cut pockets is a great way of holding all of the necessary information, without detracting from the clean simplicity of the graphics and font.

When commissioned by Etiquette Recordings to produce DVD packaging for *A Breach of Etiquette Vol 1*, TGB's initial inspirations were noise and sound. Rather than using a standard-sized DVD case, the agency chose a jewel case with slipcase—traditionally the domains of CD packaging. Alongside simple black-and-white illustrations, it added vibrancy with fluorescent orange.

\\ART DIRECTOR
MASARU ISHIURA

\\DESIGNER
MASARU ISHIURA

\\CLIENT
ETIQUETTE RECORDINGS
(OUTSIDE INC)

\\PROJECT
DVD WITH SLIPCASE

\\SPECIFICATION
JEWEL CASE PRINTED
BLACK-AND-WHITE +
1 SPECIAL

083
TGB DESIGN
A BREACH OF ETIQUETTE VOL 1
JAPAN

FEATURE
Rather than shying away from a limited color palette, TGB has used it positively with these tongue-in-cheek, 1980s-style illustrations. It has allocated its budget well by using a special color sparingly, thus not detracting from the "medical" theme.

iyrie's remix CDs take the tunes and imagery from all the releases produced in the past year. The covers are therefore printed over the course of the year, with a new layer added from a different cover with each new release. In this way, each and every CD cover is unique. The agency also produced a promotional poster, telling people a little bit of the story of the packaging's creation.

\\ART DIRECTOR
ADAM WHITAKER

\\DESIGNER
ADAM WHITAKER

\\CLIENT
IYRIE!

\\PROJECT
COVERS FOR CD SERIES

\\SPECIFICATION
LETTERPRESS AND SCREEN PRINTING

084 \ IYRIE!
IYRIE! MIX CDS
UK

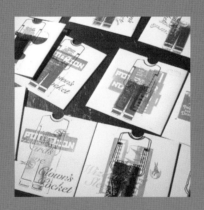

FEATURE
Overlaying letterpress and screen-printed images and colors produces a fantastically haphazard effect. There is something decidedly undeliberate about this packaging—almost accidental. It's a great way of reflecting the "remixed" aspect of the music.

CD+DVD PACKAGING
134\\135
PRINT

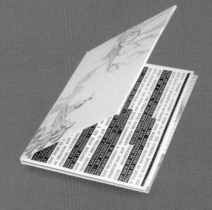

\\\\\\\ 085
\\\\\ CREATEANDCONSUME
\\\\\ MOTIVESOUNDS
\\\\\ UK

Working on packaging for a double CD that featured so many different styles of music, createandconsume was faced with the challenge of creating a fairly nonspecific design. Focusing on the relative youth of the record label, and the home production of many of the bands, the agency took elements such as photocopier and typewriter keys as a starting point for an experiment in pattern and type. The design uses an intricate typography system where track listings merge with a halftone pattern. This is then chopped up and manipulated to form part of the cover image. The original design had actually been far more ambitious than the finished product, but was scaled back and modified to stay within budget. In this incarnation, metallic black ink has been used for the package's surface graphics. The gatefold packaging has two A4 (8¼ x 11¾in) 1-color print insert sheets, folded so that half fits into a pocket behind the CD, with the other half sticking out to create a "booklet" effect.

\\\ART DIRECTOR
BARRY SMITH
\\\\\\\\\\\
\\\DESIGNER
BARRY SMITH
\\\\\\\\\\\
\\\CLIENT
MOTIVESOUNDS
RECORDINGS
\\\\\\\\\\\
\\\PROJECT
BESPOKE CD
SLEEVE DESIGN
\\\\\\\\\\\
\\\SPECIFICATION
CUSTOM DIE-CUT.
4-PANEL CD SLEEVE
AND SPINE.
COATED REVERSE
BOARD. METALLIC
BLACK INK
\\\\\\\\\\\

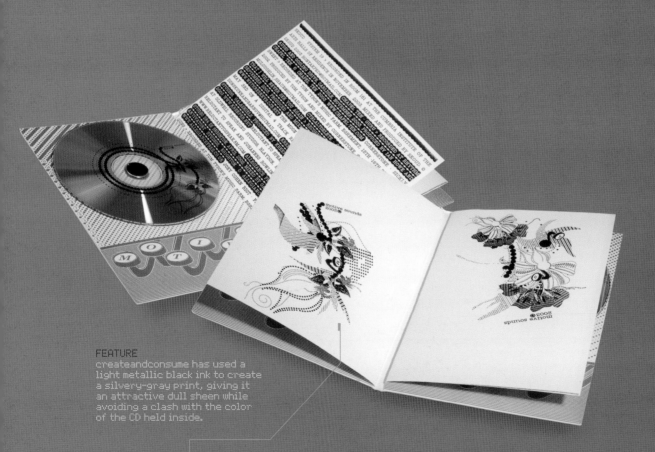

FEATURE
createandconsume has used a light metallic black ink to create a silvery-gray print, giving it an attractive dull sheen while avoiding a clash with the color of the CD held inside.

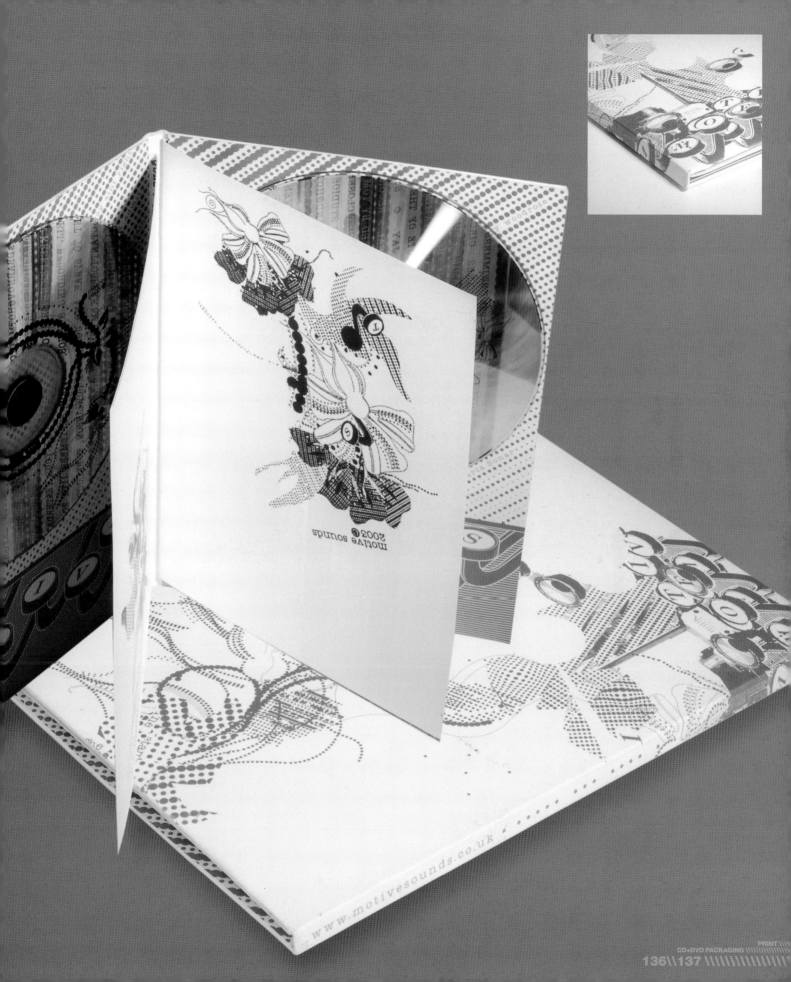

\\DESIGNER
KIM HIORTHØY

\\CLIENT
RUNE GRAMMOFON

\\PROJECT
DVD PACKAGING

\\SPECIFICATION
4-PAGE DIGIPAK;
CARDBOARD WITH
MATTE VARNISH

Created by Kim Hiorthøy, this understated packaging is mainly printed in 1 color, with the blue-gray and white of the cover replicated on the CD inside. A transparent pack holds the CD in place within the cardboard cover.

086
KIM HIORTHØY
SUPERSILENT: 7
NORWAY

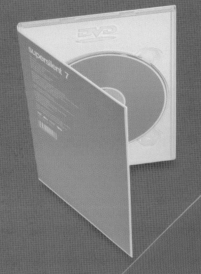

FEATURE
This packaging's charm lies in its simplicity. Apart from the spine, it is printed in just 1 color. The title, Supersilent, is echoed in the design, which is completely blank apart from the bar code and other information that would usually appear almost hidden away on the back.

Taking an architectural theme as its basic inspiration, Coast created CD packaging for a jewel case with a closed slipcase. The slipcase graphics feature a spot gloss varnish that is echoed on the CD itself with the simple use of show-through.

\\ART DIRECTOR
FREDERIC VANHORENBEKE
\\DESIGNER
FREDERIC VANHORENBEKE
\\CLIENT
CULTURE CLUB
\\PROJECT
CD PACKAGING
\\SPECIFICATION
SPOT GLOSS VARNISH

087
\\COST
CULTURE CLUB VOLUME 4
BELGIUM

FEATURE
The agency has used spot gloss on a matte card as a cost-effective way of giving the packaging a little standout.

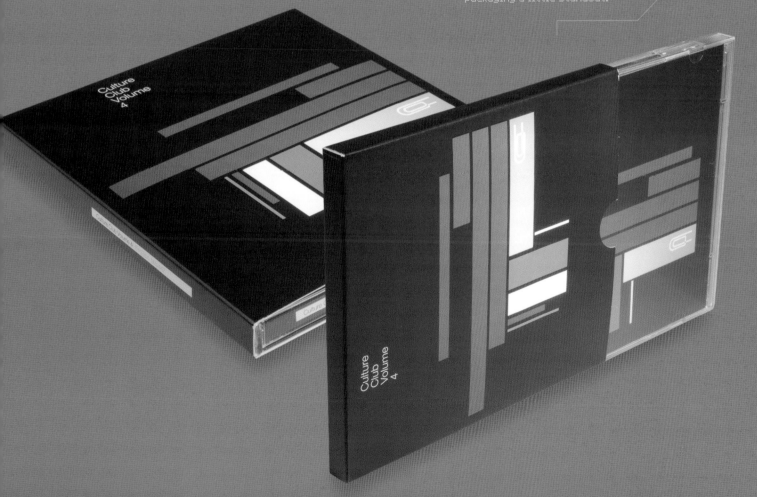

\\\\\\\\\\ 088
\\\\ CREATEANDCONSUME
SKOUD: SYSTEMS AND DRAFTS
UK

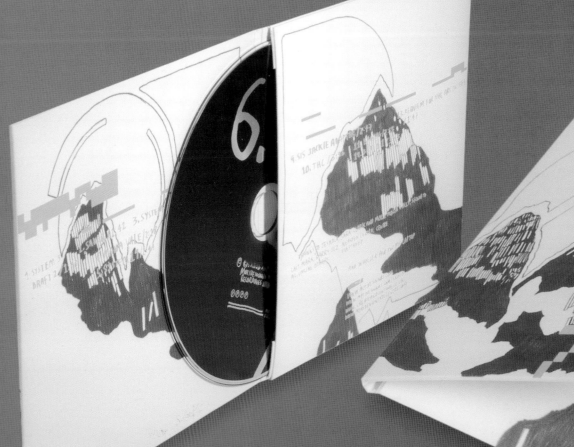

FEATURE
Working to a tight budget, the agency selected two contrasting spot colors to give the piece presence. Prinaeen is still incredibly bright, but without being gaudy.

\\ART DIRECTOR
BARRY SMITH

\\DESIGNER
BARRY SMITH

\\CLIENTS
MOTIVESOUNDS
RECORDINGS / SKOUD

\\PROJECT
CD SLEEVE DESIGN

\\SPECIFICATION
4-PANEL GATEFOLD
CD WITH SPINE—
PRINTED ON REVERSE
OF 535 MICRON FOLDING
BOARD IN BLACK AND
PANTONE 802

Taking the contradictory elements of man and machine, createandconsume used imagery based on a logotype designed specifically for this sleeve. Although mainly electronic in nature, the music still has a very human feel. The artwork was rendered in pencil across three A3 (11¾ x 16½in) sheets, then scaled down to fit the cover. The type from the inner pages has then been enlarged until pixelated and applied in this subverted form in the back and front covers, overlaid in a bright Day-Glo green.

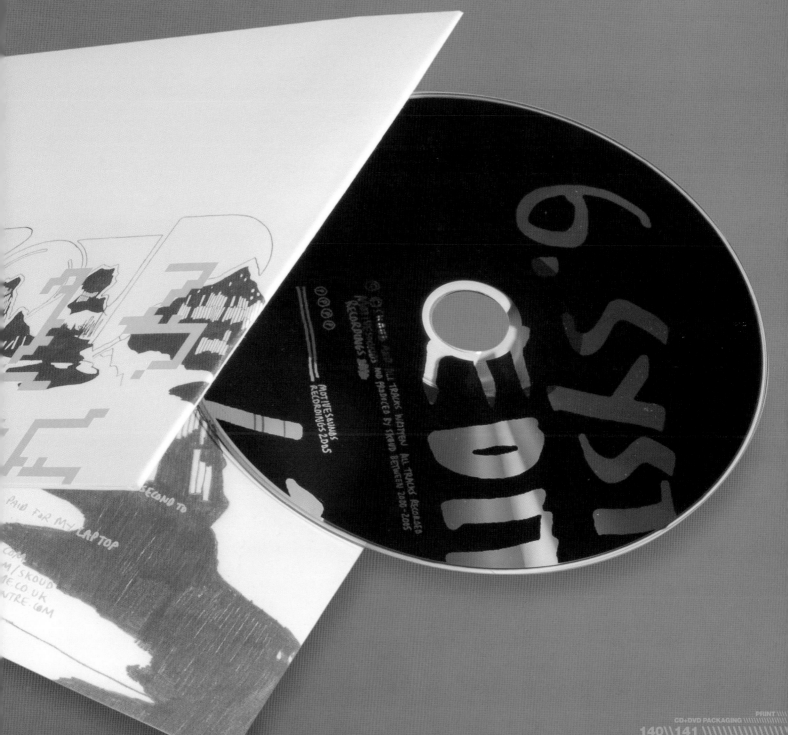

\\ART DIRECTOR
CHRIS BILHEIMER

\\DESIGNER
CHRIS BILHEIMER

\\CLIENT
CAPITOL

\\PROJECT
LIMITED-EDITION DVD PACKAGING

\\SPECIFICATION
CARDBOARD O-CARD AND JEWEL CASE
4-COLOR PROCESS + SILVER, CLEARCOAT AND GOLD FOIL

Wanting to differentiate the limited-edition version of Yellowcard's *Lights and Sounds* from its standard counterpart, Chronictown created a slipcover for the jewel case. The agency selected a metallic finish and gold foil stamp as a way to make the packaging special. However, as it was using a metallic ink with a foil stamp, the packaging had to be foil stamped first then printed on top, making registration difficult.

FEATURE
Using black alongside the metallic silver ink has given the packaging a dull sheen, allowing the gold cross to stand out further. The CD appears to reverse this effect, with matte white used to create areas of high-shine silver show-through.

089 CHRONICTOWN
YELLOWCARD: LIGHTS AND SOUNDS
USA

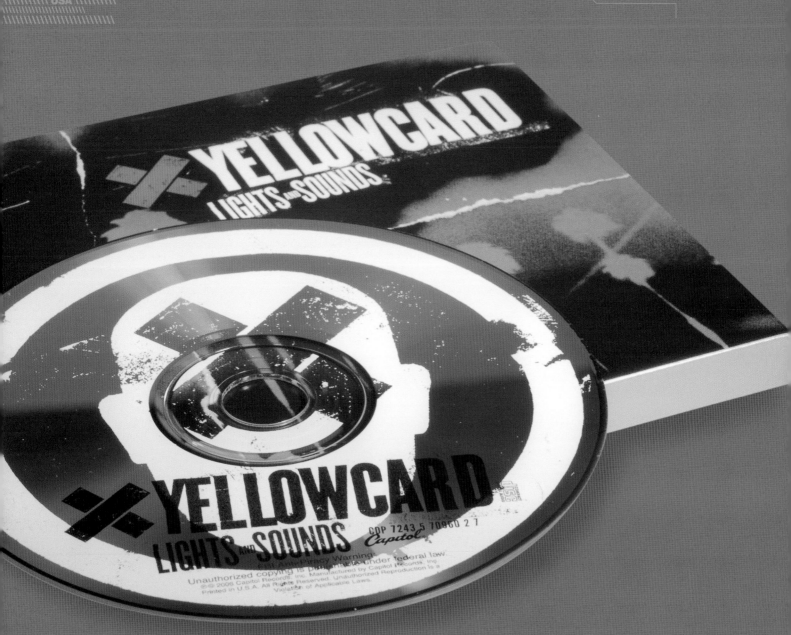

Produced for an initial print run only, this Green Day packaging by Chronictown has a clear acetate sleeve that uses the inner red Digipak to complete the picture with dramatic effect. The front cover sees the musician performing to a cheering crowd. However, when the pack is removed, the packaging's transparency works to build up in layers, with the crowd from the back of the packaging visible through the front. It takes us immediately from a smaller concert to a large, open-air festival.

\\ART DIRECTOR
CHRIS BILHEIMER

\\DESIGNER
CHRIS BILHEIMER

\\PROJECT
CD AND DVD PACKAGING

\\CLIENT
REPRISE/WEA

\\SPECIFICATION
ACETATE O-CARD IN 4-COLOR AND SPOT WHITE PRINT. DOUBLE DIGIPAK

090
\ CHRONICTOWN
GREEN DAY: BULLET IN A BIBLE
USA

FEATURE
The slipcase has been screen printed on the reverse, using black ink for the crowd and to create an atmospheric "darkening sky," and thus retains its outer glossiness.

\\\ART DIRECTOR
SAM HODGSON
\\\\\\\\\\\\

\\\DESIGNER
SAM HODGSON
\\\\\\\\\\\\

\\\CLIENT
MOTIVESOUNDS
RECORDINGS
\\\\\\\\\\\\

\\\PROJECT
CD PACKAGING

\\\SPECIFICATION
GATEFOLD CD:
PANTONE 300C
PRINTED ON REVERSE
OF 535 MICRON FOLDING
BOXBOARD
\\\\\\\\\\\\

091 SAM HODGSON
LET AIRPLANES CIRCLE OVERHEAD
UK

FEATURE
This piece maximizes the impact of 1-color print. The graphics wrap around from front to back and, by printing on the card's reverse, the designer has achieved a soft, muted look, which may otherwise have appeared rather flat.

Having no image to work with and wanting to avoid clichéd shots of the band, freelance designer Sam Hodgson looked to nonobvious ways he could reference the band's name, Let Airplanes Circle Overhead. He eventually set on old Airfix kits and their instructional leaflets, and with these in mind created graphics through deconstructions of the logo he had designed. Sam had developed the logo using Helvetica Neue, bloating the type then altering the characters, using the letters A and V to mimic the tail fin of an airplane. The type was then chopped up using various weights of strokes and dashes to create visual hierarchy. For a natural feel, Sam used a photograph of the sky in the background, avoiding too much of the digital appearance of a gradient.

The only constraints on this project were that, first, the packaging had to adhere to standard CD packaging dimensions, avoiding the risk of retailers not wanting to stock it. Second, the budget wasn't vast. As such, Sam had to find new ways of enhancing the packaging, so decided to print on the reverse of the card.

Looking to client Mikkel Bache's style of photography for inspiration, MRDS wanted to create simple, elegant, and unique CD packaging. Understated and printed in just 1 color—matte black—throughout, it maintains a distance from the photographer's work, thus avoiding any sense of conflict.

\\ART DIRECTOR
MUGGIE RAMADANI

\\DESIGNER
MUGGIE RAMADANI

\\CLIENT
MIKKEL BACHE

\\PROJECT
CORPORATE IDENTITY

\\SPECIFICATION
COVER: MUNKEN LYNX 400GSM; 1+1 PANTONE BLACK U
CD-ROM: PRINTED BLACK BOTH SIDES

092 MUGGIE RAMADANI DESIGN STUDIO
MIKKEL BACHE: PHOTOGRAPHER
DENMARK

FEATURE
The CD is printed in matte black on both sides, eliminating any silver show-through that would otherwise clash with the simplicity of the monochrome packaging.

\\ART DIRECTOR
CARLOS SEGURA

\\DESIGNERS
CARLOS SEGURA
TNOP
CHRIS MAY

\\CLIENT
GABRIELLA MUSIC

\\PROJECT
CD PACKAGING

\\SPECIFICATION
DIGIPAK WITH CARD-
BOARD, GATEFOLD
SLEEVE, PRINTED
1 COLOR

One of several releases designed by Segura for Lesley Spencer, this packaging is based on a simple CD Digipak with a cardboard gatefold sleeve. The CD is printed in just 1 color, with show-through used to create the CD's title. The CD overlays the silver type printed inside the back cover, partly obscuring it.

093
SEGURA INC.
LESLEY SPENCER: A MOVEABLE FEAST
USA

FEATURE
The design for this packaging wraps around from back to front. The information falls within the same "band," which runs across the front, spine, and back, with a colorful vignette creating unity.

CD+DVD

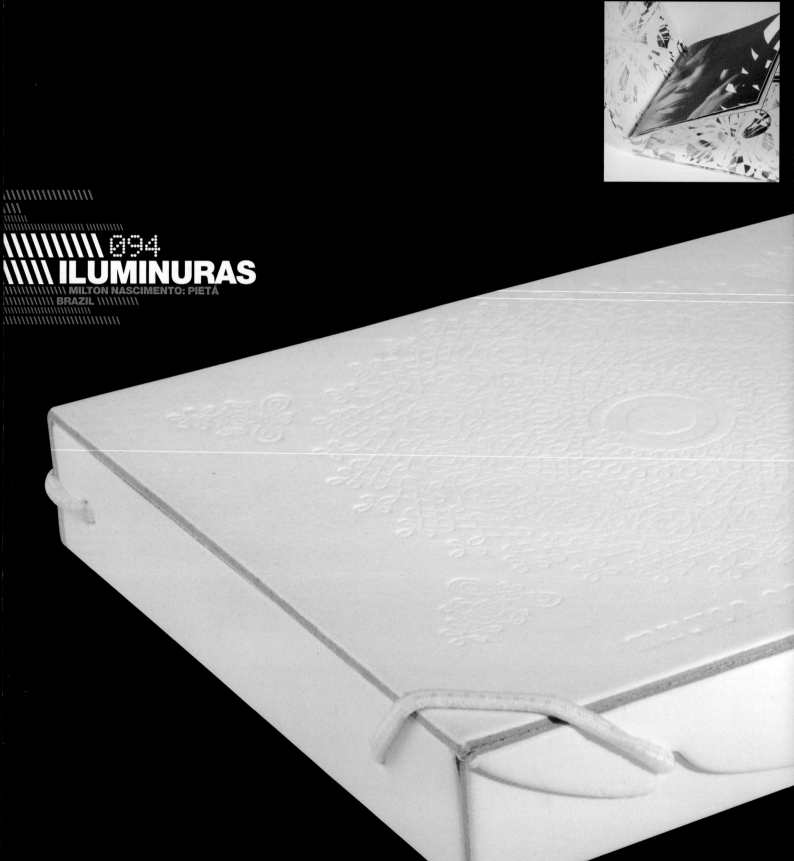

094 ILUMINURAS
MILTON NASCIMENTO: PIETÁ
BRAZIL

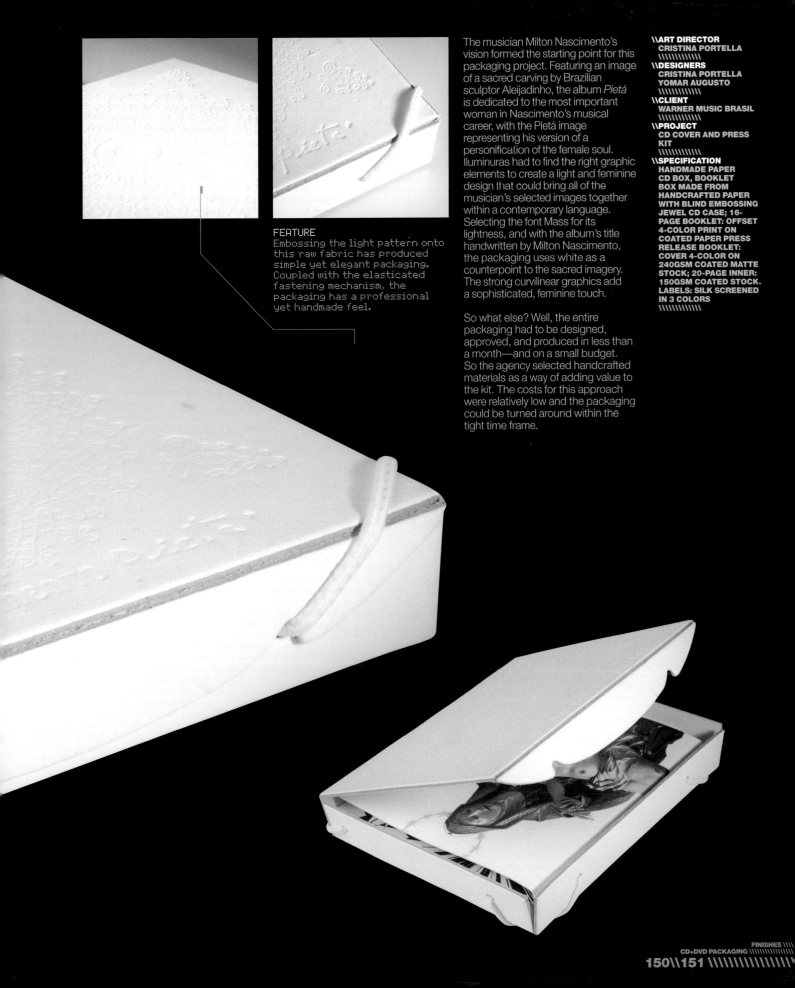

FEATURE
Embossing the light pattern onto this raw fabric has produced simple yet elegant packaging. Coupled with the elasticated fastening mechanism, the packaging has a professional yet handmade feel.

The musician Milton Nascimento's vision formed the starting point for this packaging project. Featuring an image of a sacred carving by Brazilian sculptor Aleijadinho, the album *Pietá* is dedicated to the most important woman in Nascimento's musical career, with the Pietá image representing his version of a personification of the female soul. Iluminuras had to find the right graphic elements to create a light and feminine design that could bring all of the musician's selected images together within a contemporary language. Selecting the font Mass for its lightness, and with the album's title handwritten by Milton Nascimento, the packaging uses white as a counterpoint to the sacred imagery. The strong curvilinear graphics add a sophisticated, feminine touch.

So what else? Well, the entire packaging had to be designed, approved, and produced in less than a month—and on a small budget. So the agency selected handcrafted materials as a way of adding value to the kit. The costs for this approach were relatively low and the packaging could be turned around within the tight time frame.

\\ART DIRECTOR
CRISTINA PORTELLA

\\DESIGNERS
CRISTINA PORTELLA
YOMAR AUGUSTO

\\CLIENT
WARNER MUSIC BRASIL

\\PROJECT
CD COVER AND PRESS KIT

\\SPECIFICATION
HANDMADE PAPER CD BOX, BOOKLET BOX MADE FROM HANDCRAFTED PAPER WITH BLIND EMBOSSING JEWEL CD CASE; 16-PAGE BOOKLET: OFFSET 4-COLOR PRINT ON COATED PAPER PRESS RELEASE BOOKLET: COVER 4-COLOR ON 240GSM COATED MATTE STOCK; 20-PAGE INNER: 150GSM COATED STOCK. LABELS: SILK SCREENED IN 3 COLORS

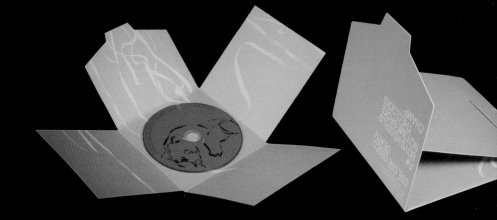

095
CREATEANDCONSUME
CAPULET: THE WORLD IS A TRAGIC PLACE, BUT THERE IS GRACE ALL AROUND US, SO ATTEND TO THE GRACE
UK

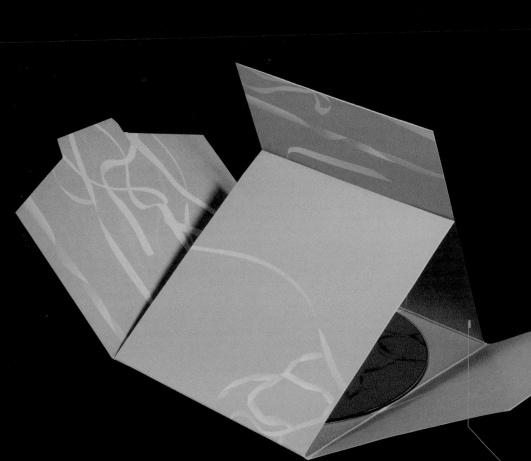

FEATURE
This packaging's format works well with the clean design. The intriguing four-way gatefold houses the CD at its center, and is held together itself with a simple flap and die-cut mechanism.

As a relatively small record label, this motivesounds release had to have strong presence. As ever, there were budgetary constraints, so createandconsume chose to use 1 spot color—metallic silver—to maximum effect. Inspired by the CD's title and paying homage to pop artist Ed Ruscha, who used ribbon and paper to create words, the design features a graphic ribbon that has been used to form the shape of a bear.

\\ART DIRECTOR
BARRY SMITH
//////////////
\\DESIGNER
BARRY SMITH
//////////////
\\CLIENTS
MOTIVESOUNDS
RECORDINGS/CAPULET
//////////////
\\PROJECT
CD SLEEVE DESIGN
//////////////
\\SPECIFICATION
CUSTOM DIE-CUT.
10-PANEL CD SLEEVE
DOUBLE-SIDED 400GSM
GENERATION SKY. 1 SPOT
COLOR BOTH SIDES.
PANTONE 877 SILVER
//////////////

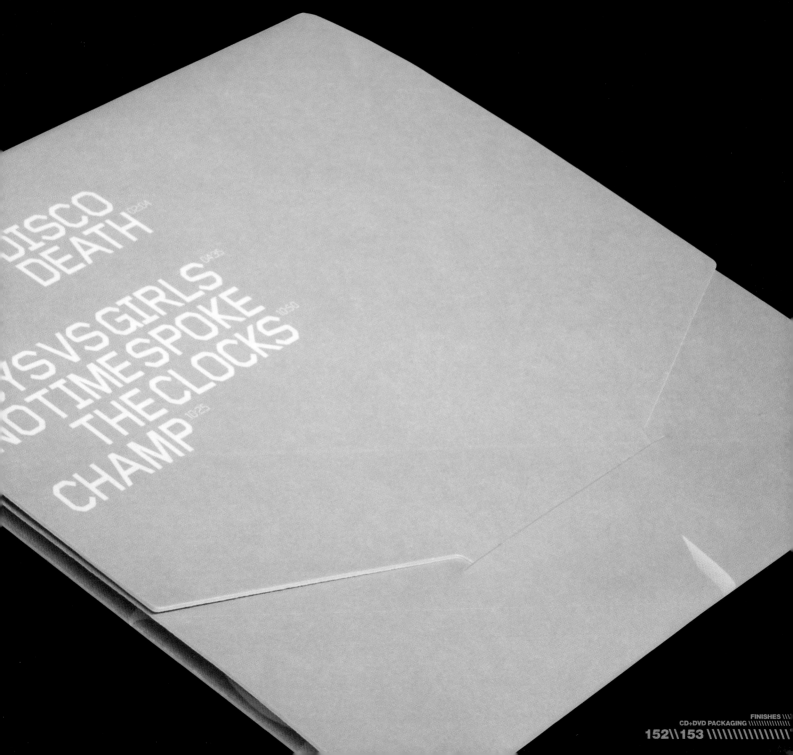

\\DESIGN STUDIO
WEWORKFORTHEM

\\CLIENT
YOUWORKFORTHEM

\\PROJECT
DVD AND MANIFESTO

\\SPECIFICATION
2/2PMS WITH DIE-CUT

096
WEWORKFORTHEM
NOTES FOR THOSE BEGINNING THE DISCIPLINE OF ARCHITECTURE:
ALTERNATE ENDING 1: THE GLIMMERING NOISE
USA

FEATURE
Two die-cut slots hold the DVD in place within this simple packaging, allowing parts of the disc to be seen at the back of the packaging. An additional flap folds over, protecting the disc and anchoring it in place.

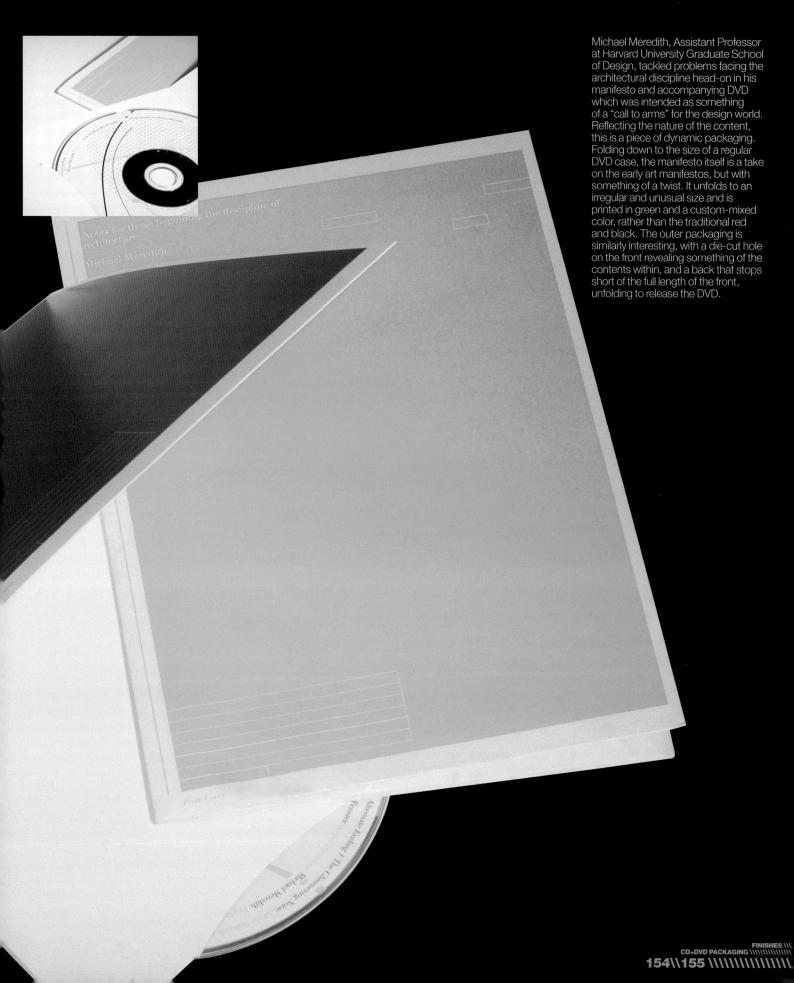

Michael Meredith, Assistant Professor at Harvard University Graduate School of Design, tackled problems facing the architectural discipline head-on in his manifesto and accompanying DVD which was intended as something of a "call to arms" for the design world. Reflecting the nature of the content, this is a piece of dynamic packaging. Folding down to the size of a regular DVD case, the manifesto itself is a take on the early art manifestos, but with something of a twist. It unfolds to an irregular and unusual size and is printed in green and a custom-mixed color, rather than the traditional red and black. The outer packaging is similarly interesting, with a die-cut hole on the front revealing something of the contents within, and a back that stops short of the full length of the front, unfolding to release the DVD.

\\ART DIRECTOR
MUGGIE RAMADANI

\\DESIGNER
MUGGIE RAMADANI

\\CLIENT
PETER KRASILNIKOFF

\\PROJECT
CD PACKAGING WITHIN
CORPORATE IDENTITY

\\SPECIFICATION
STANDARD TRANSPARENT
CD CASE WITH MINIATURE
CD-ROM LABELS PRINTED
IN 2 METALLIC COLORS
(PANTONE 877C + 8221C)

097
MUGGIE RAMADANI DESIGN STUDIO
PETER KRASILNIKOFF: PHOTOGRAPHER
DENMARK

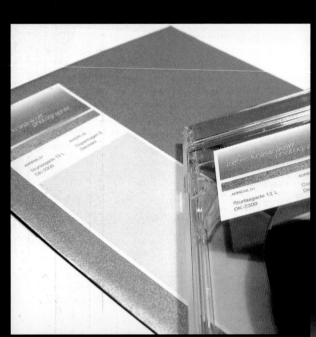

FEATURE
There is a simple elegance to this packaging. The metallic labels contain all the necessary contact information and, applied as a separate layer to the packaging, play on the overall transparency.

The client Peter Krasilnikoff's photographic style is very simple, elegant, and minimalistic. MRDS wanted to create a corporate identity and CD packaging that would reflect this. Taking a transparent case, the agency selected a transparent CD with a mini, 3in (76mm) sputter for standout. Stickers with the photographer's details are applied to the outside. These were created by blending 2 metallic colors.

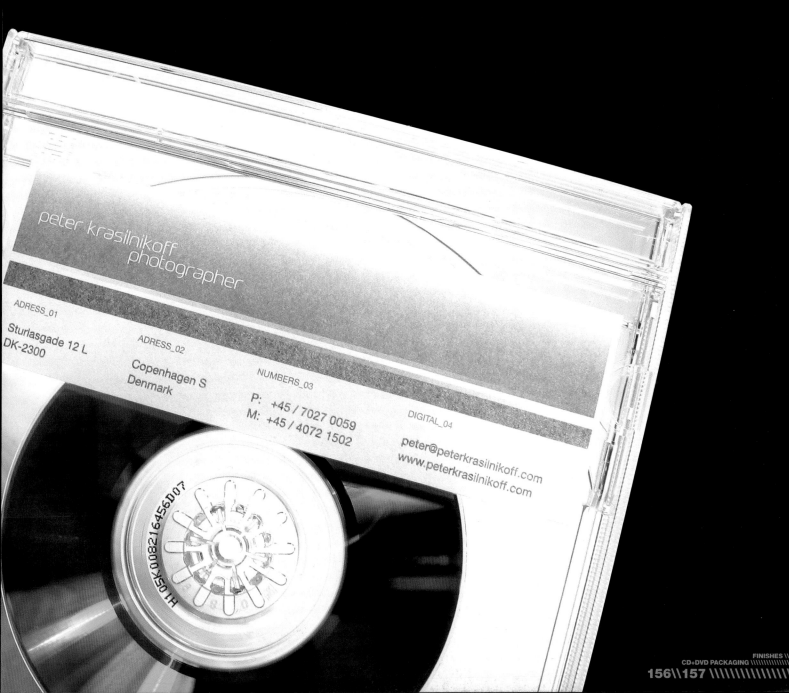

Owing to a limited budget, 1-color printing was essential for this packaging. However, Rinzen used this to the project's advantage, creating distinctive and memorable packaging. The simple graphics reflect the minimalism of the music, and the die-cut and matte-celloglazing form part of a recognizable "house style" for the client. Owing to the CD's limited distribution in niche and boutique record stores, the alternative packaging was very much embraced.

\\DESIGN STUDIO
RINZEN
\\CLIENT
ROOM 40
\\PROJECT
CD PACKAGING
\\SPECIFICATION
DIE-CUT, LOOSE INSERTS
MATTE-CELLOGLAZED,
1-COLOR PMS

098 RINZEN
ROOM 40: VARIOUS ARTISTS
AUSTRALIA

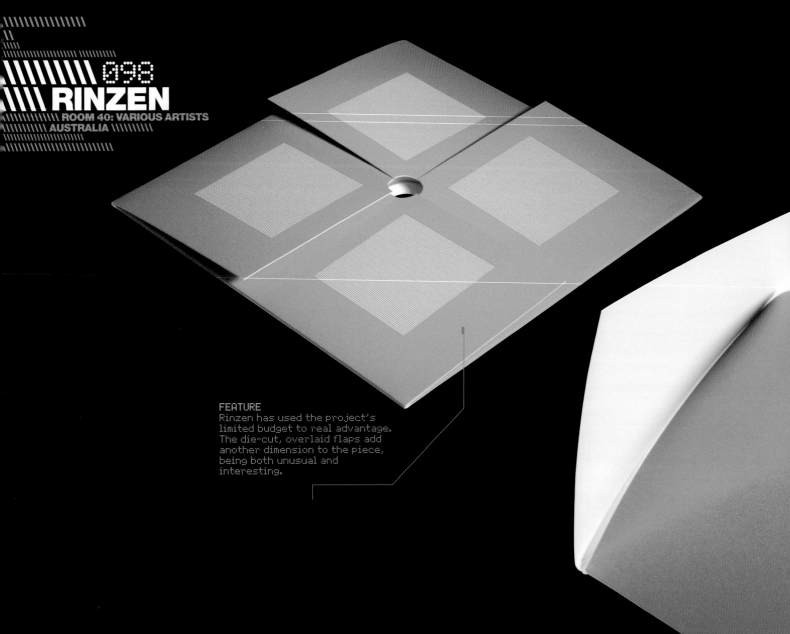

FEATURE
Rinzen has used the project's limited budget to real advantage. The die-cut, overlaid flaps add another dimension to the piece, being both unusual and interesting.

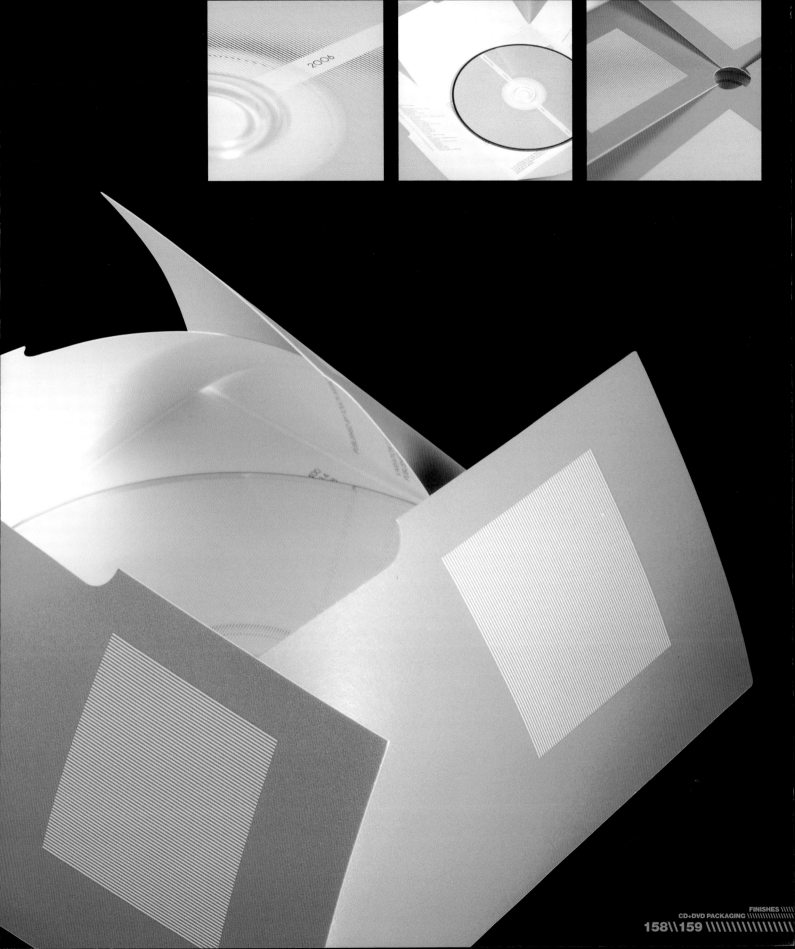

FINISHES
CD+DVD PACKAGING

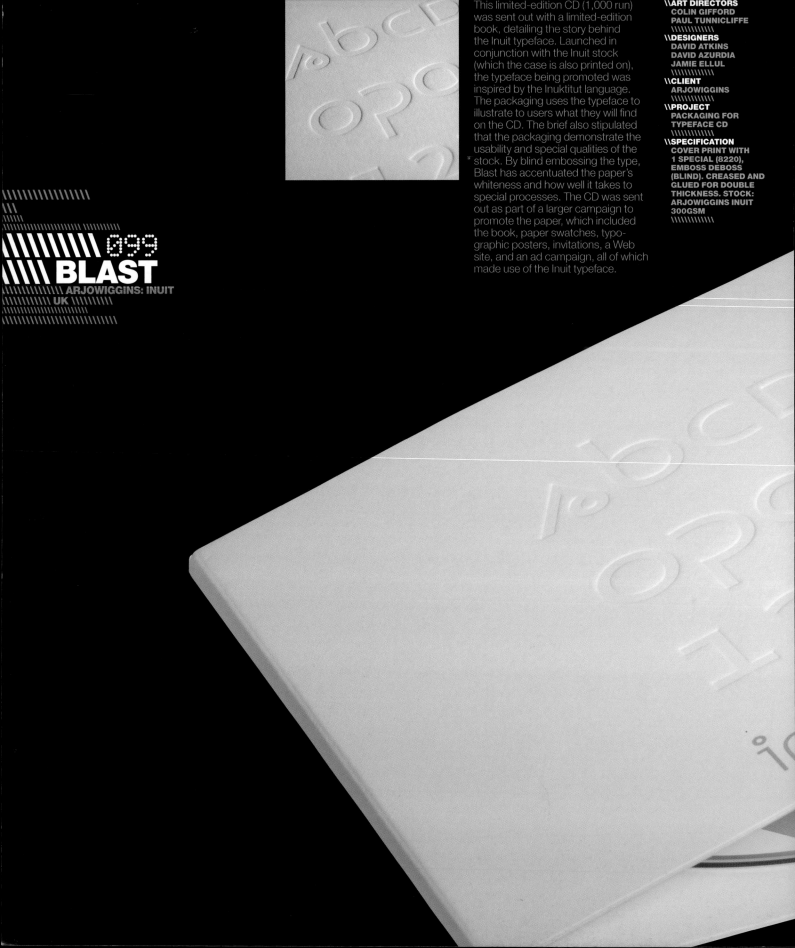

///////////////
\\\
//////
///////// 099
\\\\ BLAST
\\\\\\\\\\ ARJOWIGGINS: INUIT
\\\\\\\\ UK \\\\\\\\\

This limited-edition CD (1,000 run) was sent out with a limited-edition book, detailing the story behind the Inuit typeface. Launched in conjunction with the Inuit stock (which the case is also printed on), the typeface being promoted was inspired by the Inuktitut language. The packaging uses the typeface to illustrate to users what they will find on the CD. The brief also stipulated that the packaging demonstrate the usability and special qualities of the stock. By blind embossing the type, Blast has accentuated the paper's whiteness and how well it takes to special processes. The CD was sent out as part of a larger campaign to promote the paper, which included the book, paper swatches, typographic posters, invitations, a Web site, and an ad campaign, all of which made use of the Inuit typeface.

\\ART DIRECTORS
COLIN GIFFORD
PAUL TUNNICLIFFE

\\DESIGNERS
DAVID ATKINS
DAVID AZURDIA
JAMIE ELLUL

\\CLIENT
ARJOWIGGINS

\\PROJECT
PACKAGING FOR
TYPEFACE CD

\\SPECIFICATION
COVER PRINT WITH
1 SPECIAL (8220),
EMBOSS DEBOSS
(BLIND). CREASED AND
GLUED FOR DOUBLE
THICKNESS. STOCK:
ARJOWIGGINS INUIT
300GSM

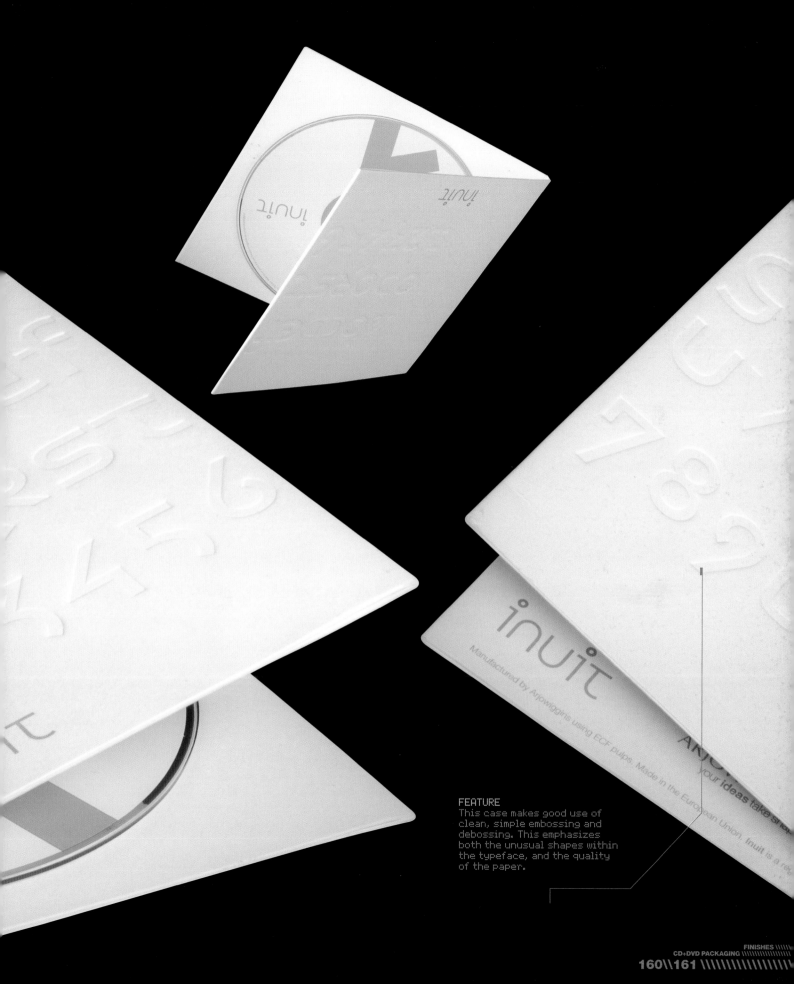

FEATURE
This case makes good use of clean, simple embossing and debossing. This emphasizes both the unusual shapes within the typeface, and the quality of the paper.

Teedot's new corporate identity was designed to play to the senses—sight, sound, and touch. With a monochrome look applied throughout, the black dot has a dominant role. The die-cut CD sleeve sits within the plain white slipcase which, in turn, sits inside the fabric outer case, also featuring the black dot. The outer case makes use of several interesting materials, from fabric through to a feather-like uncoated stock.

\\ART DIRECTOR
MUGGIE RAMADANI

\\DESIGNER
MUGGIE RAMADANI

\\CLIENT
TEEDOT

\\PROJECT
CD PACKAGING WITHIN CORPORate IDENTITY

\\SPECIFICATION
DIE-CUT COVER, 400GSM GALLERY SILK, MATTE FOIL BOTH SIDES, 1 + 1
COLORS: PANTONE BLACK U ON THE INSIDE

100
MUGGIE RAMADANI DESIGN STUDIO
TEEDOT: CORPORATE IDENTITY
DENMARK

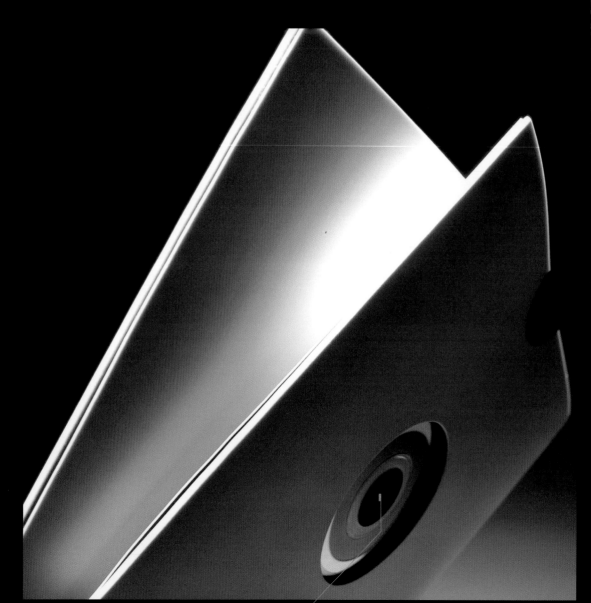

FEATURE
The large central die-cut within the inner sleeve echoes the black dot theme, with the sleeve's black insides visible through the CD's central hole.

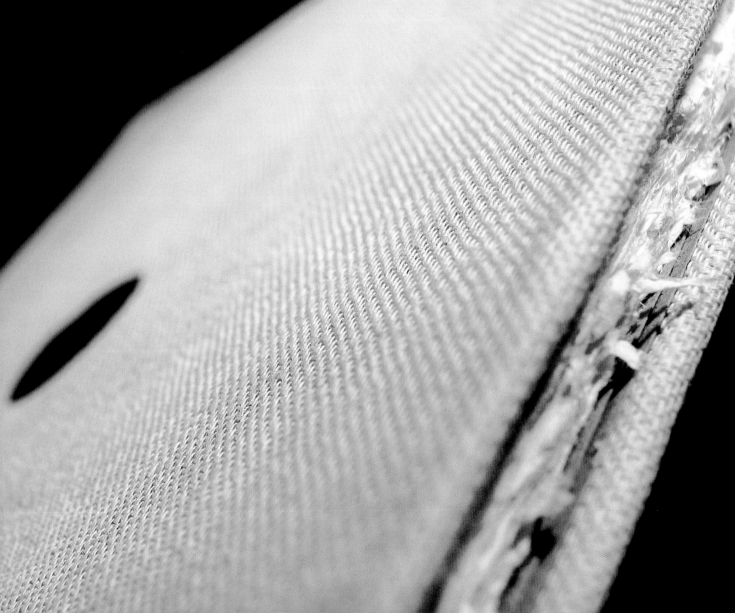

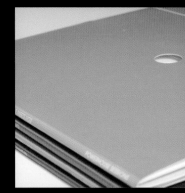

\\DESIGN STUDIO
RINZEN
\\\\\\\\\\\
\\CLIENT
ROOM 40
\\\\\\\\\\\
\\PROJECT
CD SERIES PACKAGING
\\\\\\\\\\\
\\SPECIFICATION
DIE-CUT, LOOSE INSERTS
MATTE-CELLOGLAZED,
1-COLOR PMS
\\\\\\\\\\\

1.01
RINZEN
JASON CHANTLER: MONOKE
AUSTRALIA

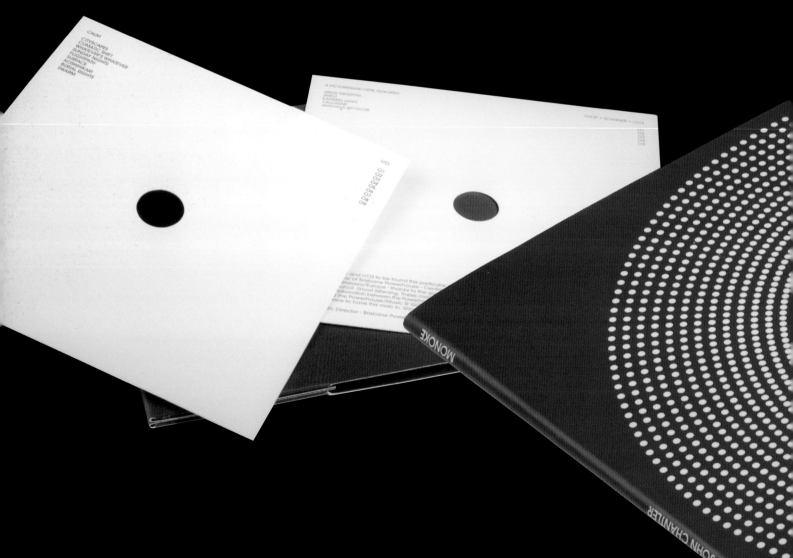

With budget restrictions limiting print to 1-color per CD, Rinzen has created a strong and distinctive series of CDs for the client, Room 40. Each case features a central circular die-cut, and opens up to reveal two internal pockets—one of which houses the CD, the other the inserts. On the outside each case features a striking graphic, making use of simple elements such as lines and dots. Inside, the CDs reflect this external design, whereas the inserts feature images that give a feel for the CD's general content.

FEATURE
The template for each CD in the series uses a simple format very effectively, with pockets to hold both the CD and inserts, and a die-cut hole running through the entire piece.

\\ART DIRECTOR
JUSTIN AHRENS
\\DESIGNERS
JUSTIN AHRENS
KERRI LIK
JOSH JENSEN
DAN HASSENPLUG
\\CLIENT
O'NEIL PRINTING
\\PROJECT
PROMOTIONAL MAILER
\\SPECIFICATION
4/4 STOCHASTIC
SCREENING; DIE-CUTS;
HAND ASSEMBLY;
NEENAH PAPER EAMES
PAPER LINE

102
RULE 29
MR CATO: BARE N' BLUE
USA

Rule 29 set out to create a self-promotional piece that would be memorable and could be used to promote partner services and companies. And so Mr Cato was born—his name being derived from "Staccato," meaning short and abrupt. Mr Cato's story takes us through Americana, profiling the work of the design company, photographers, and printers, as well as paper and music companies. The story culminates with Mr Cato's CD of relaxing music, which he encourages us to listen to while we discover what "it" is that he and his friends can help us with.

Typography is primarily handwritten, adding to the sense of fun and adventure, and graphics are a combination of hand-drawn images and commissioned photography. A pocket full of cards ensures the information for each company in the promotion is easily identified, and by covering the piece with color, Rule 29 has shown the effectiveness of stochastic screening.

FEATURE
This piece is a great showcase for design, print, and paper. Combining die-cut show-throughs, pockets, and additional external packaging, it's incredibly interactive. The use of a number of interesting materials means that it is also very tactile.

Hucklebuck's lead singer and guitarist Sam Hare took a roadtrip across America's southern states. While there he visited "Sam's Town" casino, and the gambling dice inspired the name of this album and the themes for its artwork. The *Sam's Town* die logo is revealed through the die-cut outer sleeve, and is also replicated on the CD itself.

\\ART DIRECTOR
NEIL HEDGER

\\DESIGNER
NEIL HEDGER

\\CLIENTS
SAM HARE/HUCKLEBUCK

\\PROJECT
CD PACKAGING

\\SPECIFICATION
JEWEL CASE, 4-PAGE BOOKLET; GRAYBOARD OUTER, DIE-CUT, AND RUBBER-STAMPED

FEATURE
The grayboard die-cut outer sleeve adds rawness and interest to this simple CD packaging. By hand-finishing every sleeve with the Hucklebuck rubber stamp, the agency has ensured that no two packages appear the same.

103
\ CARTER WONG TOMLIN
HUCKLEBUCK: SAM'S TOWN
UK

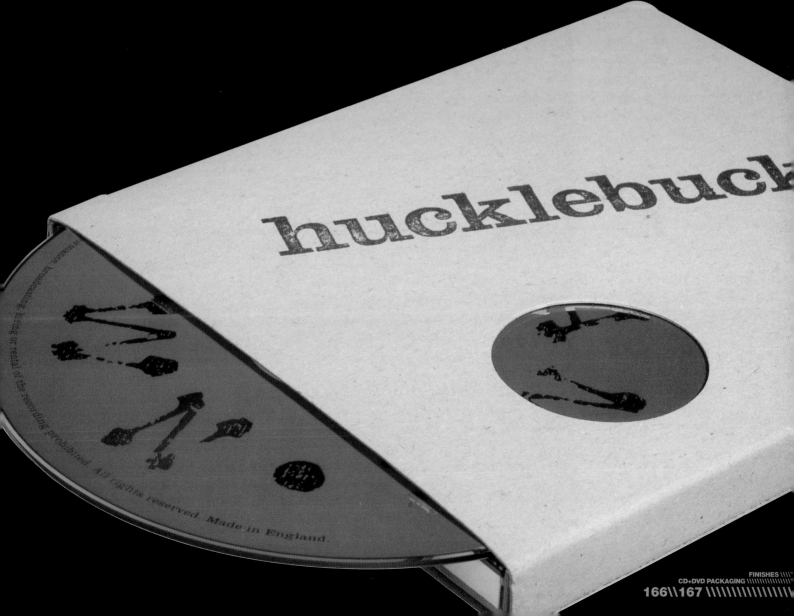

1.04
KUKUSI
DURAN DURAN: ASTRONAUT: THE TOUR
UK

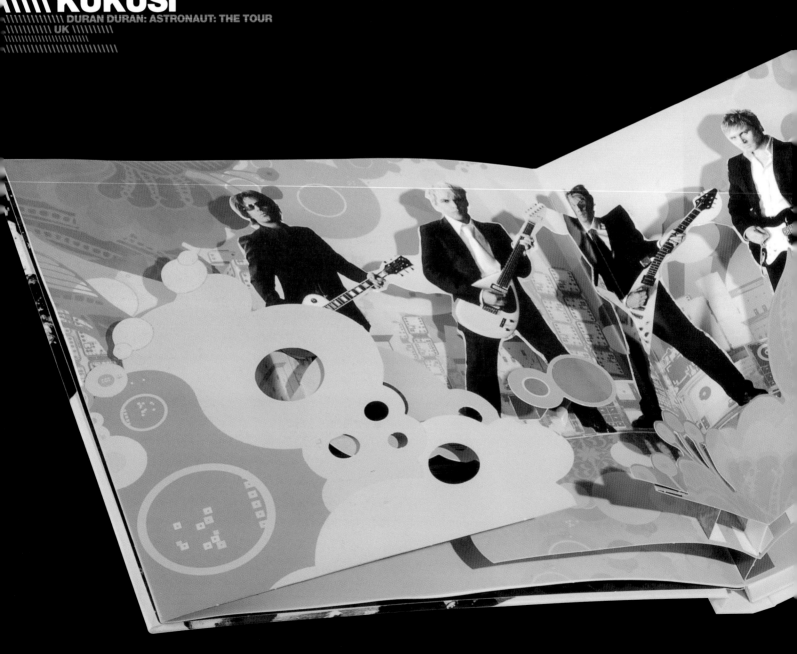

A tour program and CD package like no other, this project by Kukusi has broken new ground in the number of print and production techniques it employs. However, by printing in China, the agency still managed to keep production costs "ridiculously low." The lighting rig on the Astronaut tour set new standards in stage lighting, so the agency's challenge was to create a piece that reflected this, albeit on a "more modest scale." The program also had to hold elements and mementos from the live show for fans to take away and remember it by.

So, utilizing never-used-before pop-up techniques created by pop-up engineer David Hawcock of Hawcock Books, the book features a pop-up lighting rig (decorated with holographic silver foil and a fifth color) and a pop-up of the band on stage. Look inside the drawer and you'll find a more traditional program, a Manga-style comic printed on newsprint and—relatively sober by comparison—a CD of the live Wembley show.

\\DESIGNER
ANDREW DAY
\\\\\\\\\\\\\\\
\\CLIENTS
DURAN DURAN / DREWE ISSUE
\\\\\\\\\\\\\\\
\\PROJECT
TOUR PROGRAM AND DVD PACKAGING
\\\\\\\\\\\\\\\
\\SPECIFICATION
POP-UP BOOK WITH DRAWER CONTAINING 48-PAGE BOOK, MANGA-STYLE COMIC AND LIVE DVD OF WEMBLEY GIG POP-UP ENGINEERING; HOLOGRAPHIC SILVER FOIL PAPER; 2 SPECIAL COLORS; GLOSS UV; NEWSPRINT PAPER
\\\\\\\\\\\\\\\

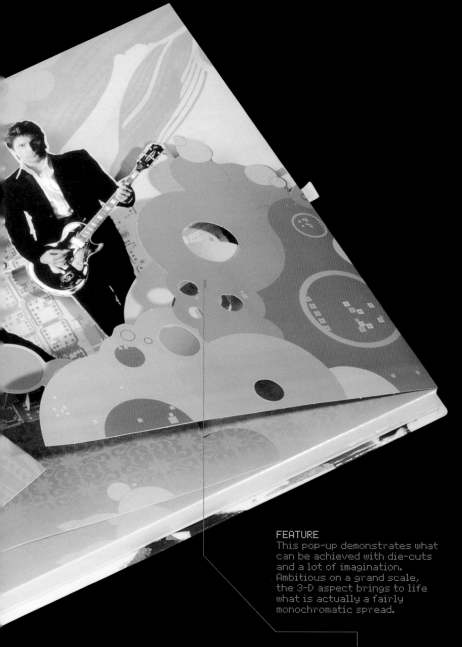

FEATURE
This pop-up demonstrates what can be achieved with die-cuts and a lot of imagination. Ambitious on a grand scale, the 3-D aspect brings to life what is actually a fairly monochromatic spread.

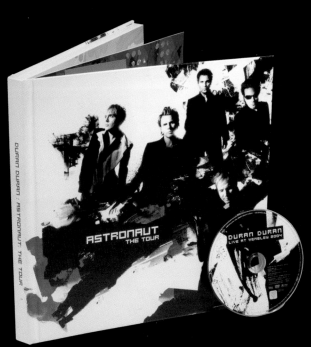

Produced as a piece of marketing collateral, this direct mailer combines CD packaging with a poster. DESQ specializes in producing entertaining applications for the education sector as a way to foster and promote learning. Therefore, as well as delivering the company's showreel to potential clients, the mailer had to convey a real sense of its "edutainment" ethos. This idea not only dominates the layout and imagery, but is also carried through to the format, which is both innovative and interactive. Unconventional and cost-effective, it positions the company as one that doesn't just take a standard approach. These ideas are reflected in the fluorescent orange CD and straightforward data sheets, both of which sit in interesting die-cut slots.

1.05 PETER AND PAUL
DESQ MAILER
UK

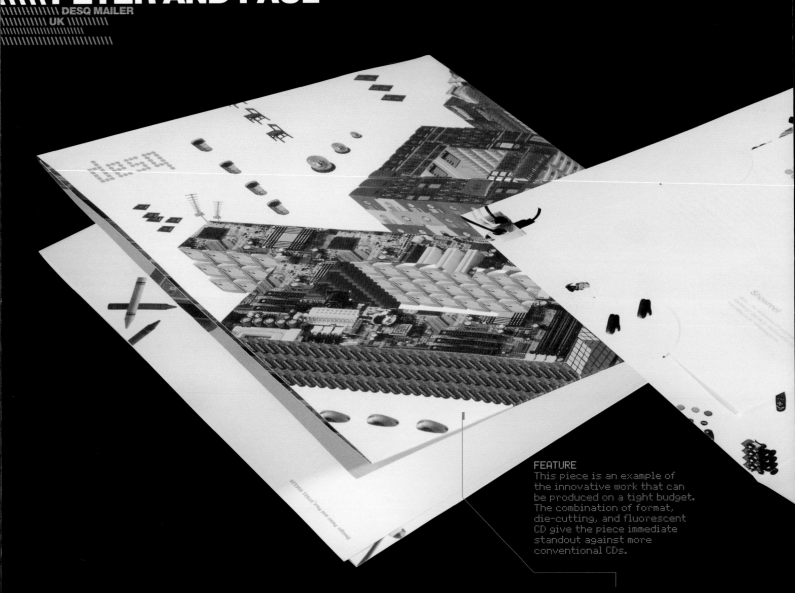

FEATURE
This piece is an example of the innovative work that can be produced on a tight budget. The combination of format, die-cutting, and fluorescent CD give the piece immediate standout against more conventional CDs.

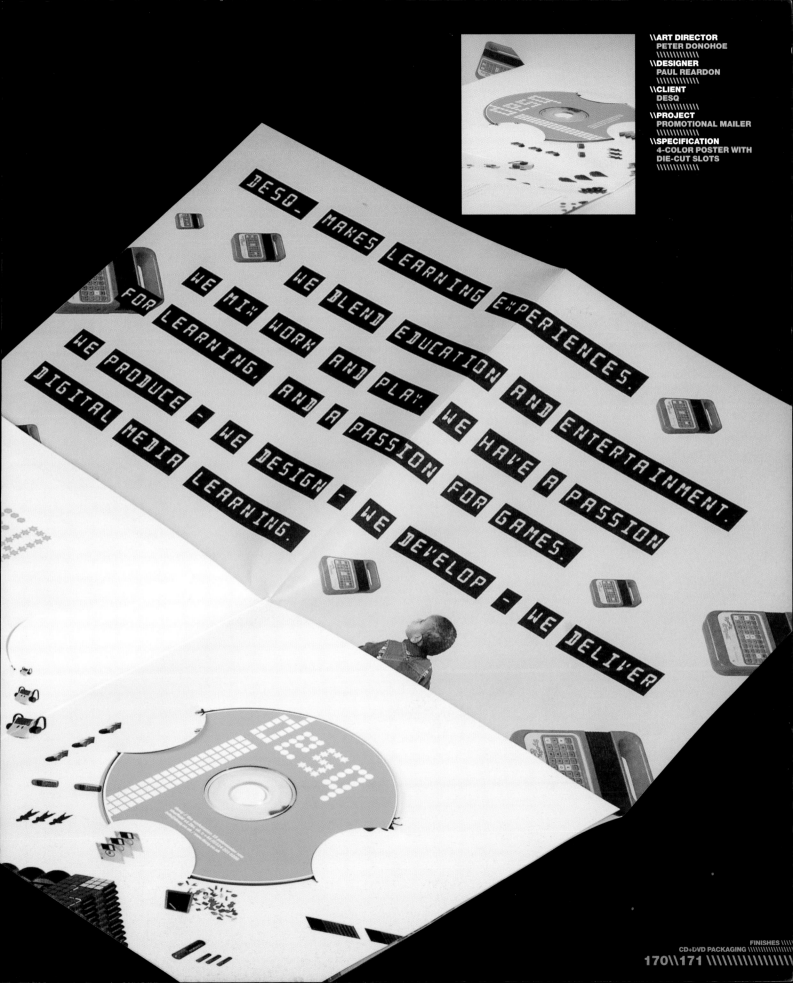

\\ART DIRECTOR
PETER DONOHOE
\\DESIGNER
PAUL REARDON
\\CLIENT
DESQ
\\PROJECT
PROMOTIONAL MAILER
\\SPECIFICATION
4-COLOR POSTER WITH DIE-CUT SLOTS

106
CRUSH DESIGN
DA LATA: REMIXES
UK

FEATURE
There's a rough-and-ready authenticity to this packaging. The most obvious example of this is the die-cut logo on the front. Rather than smooth edges, the agency has gone for an effect that plays to the material's rough texture.

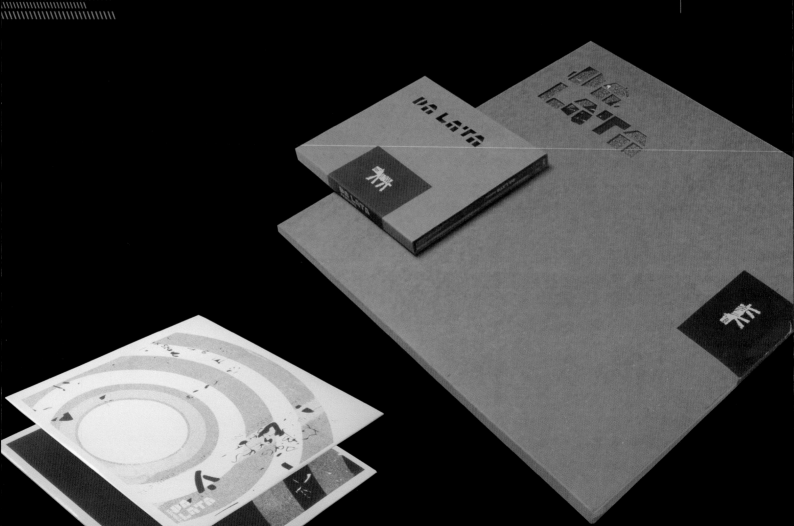

Commissioned to produce packaging for Da Lata, Crush Design created a generic outer sleeve to cover releases by any of the label's artists. The print budget was tight, but by not opting for a 4-color print the agency saved money for more interesting elements such as the die-cuts. Crush wanted the design to reflect the blend of Afro-Brazilian influences and modern sensibilities that the label is famous for. Taking a rough reverse board, die-cut to reveal elements of the 2-color albums within, the agency feels it has created packaging with "credibility." The packaging is sealed shut with a simple sticker.

\\ART DIRECTOR
CARL RUSH
\\\\\\\\\\\\\\
\\DESIGNER
CARL RUSH
\\\\\\\\\\\\\\
\\CLIENT
PALM PICTURES
\\\\\\\\\\\\\\
\\PROJECT
CD PACKAGING
\\\\\\\\\\\\\\
\\SPECIFICATION
DIE-CUT REVERSE
BOARD; STICKERS
\\\\\\\\\\\\\\

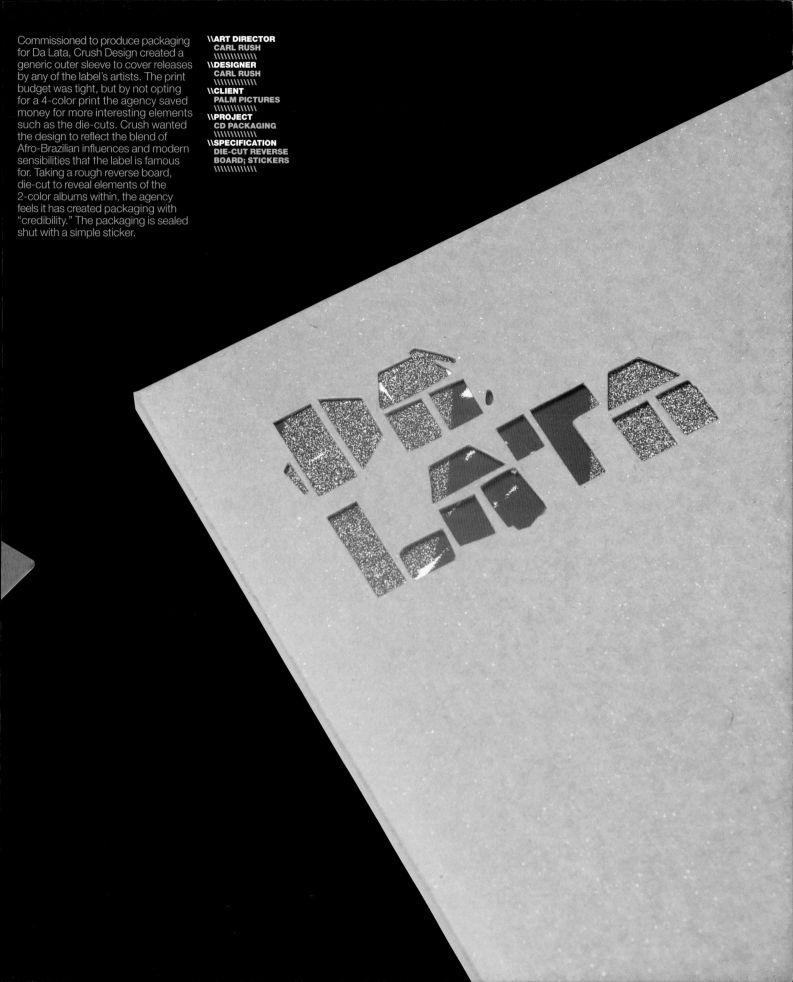

FEATURE
The subtle die-cuts inject a touch of elegance, intrigue, and color into this design.

\\ART DIRECTOR
MUGGIE RAMADANI
\\\\\\\\\\\\\
\\DESIGNERS
MUGGIE RAMADANI
CLAUS RYSSER
\\\\\\\\\\\\\
\\CLIENT
ELI DIGITAL IMAGING
\\\\\\\\\\\\\
\\PROJECT
CD WITHIN CORPORATE IDENTITY
\\\\\\\\\\\\\
\\SPECIFICATION
COVER WITH DIE-CUT LOGO; MICHA MATTE 400GSM, 2+1-COLORS: PANTONE BLACK 7U ON FRONT, 3 SEPARATE COLORS INSIDE: PANTONE 121U, 151U, AND 180U. CD-ROMS PRINTED IN 3 COLORS
\\\\\\\\\\\\\

107
MUGGIE RAMADANI DESIGN STUDIO
ELI DIGITAL IMAGING
DENMARK

Working alongside the client Eli, Muggie Ramadani wanted to convey a sense of his "digital magic" in the packaging it created for him. Part of an overall corporate identity, this set of three CD sleeves is printed in just 1 color on the outside, and in 1 of 3 vibrant colors—orange, red, or yellow—on the inside. The idea is that the die-cut type provides a glimpse of the color within, thus providing a hint of magic. The CDs are printed in the same 3 colors, so the CDs and sleeves can coordinate or mix and match. The most important element in this project was the die-cutting. The agency had to work closely with the printer to ensure it was 100% accurate. To get it even slightly wrong would have ruined the desired effect.

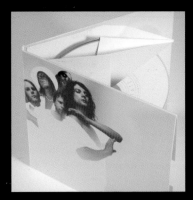

\\ART DIRECTOR
RICKY TILLBLAD
\\DESIGNER
RICKY TILLBLAD
\\CLIENT
EMI MUSIC
\\PROJECT
CD PACKAGING
\\SPECIFICATION
SPECIAL CARDBOARD;
UV VARNISHED

108
ZION GRAPHICS
THE ARK: STATE OF THE ARK
SWEDEN

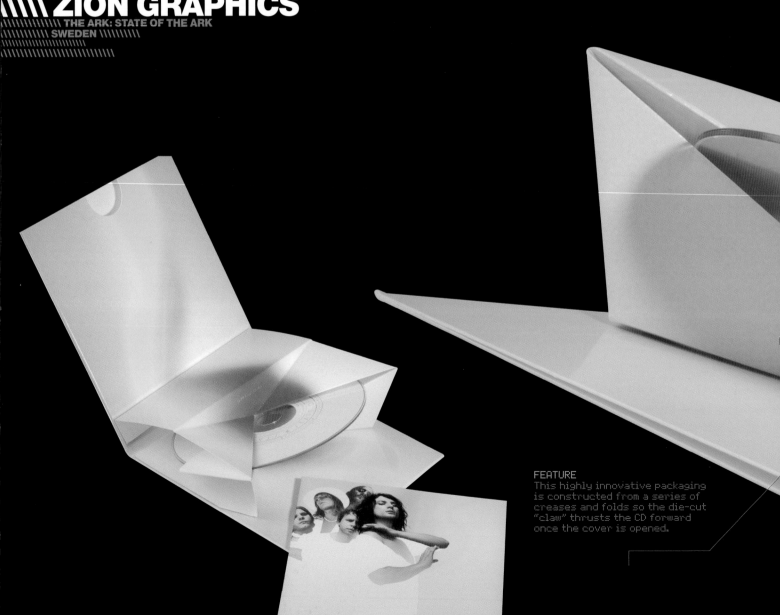

FEATURE
This highly innovative packaging is constructed from a series of creases and folds so the die-cut "claw" thrusts the CD forward once the cover is opened.

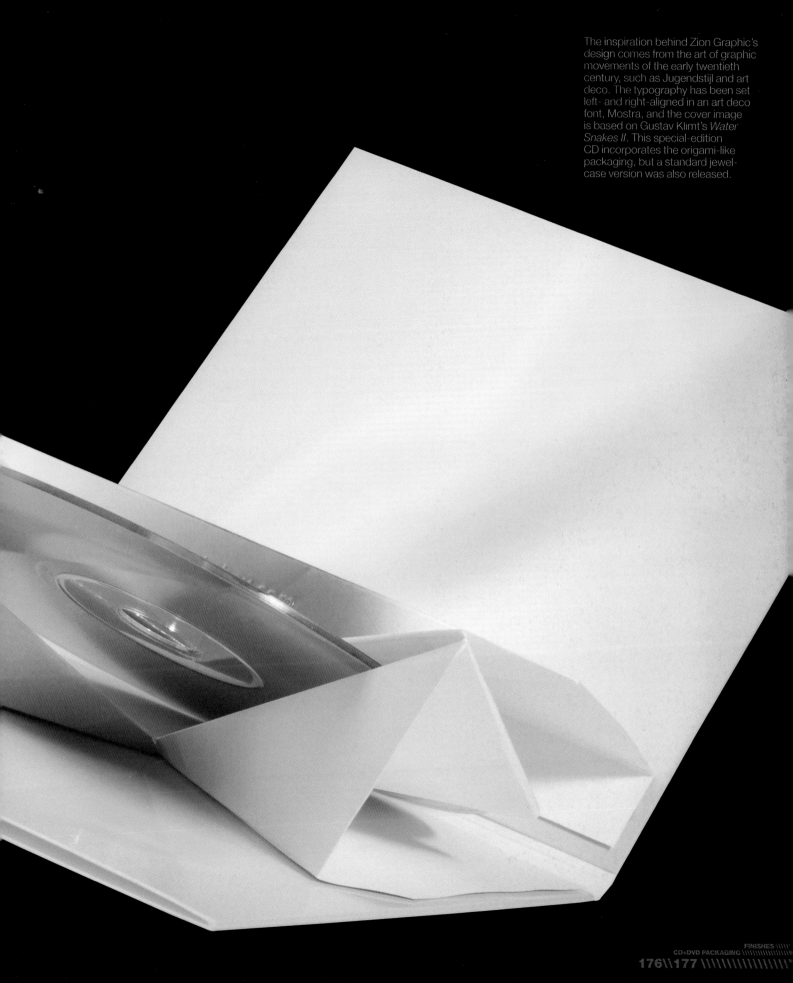

The inspiration behind Zion Graphic's design comes from the art of graphic movements of the early twentieth century, such as Jugendstijl and art deco. The typography has been set left- and right-aligned in an art deco font, Mostra, and the cover image is based on Gustav Klimt's *Water Snakes II*. This special-edition CD incorporates the origami-like packaging, but a standard jewel-case version was also released.

109
GIULIO TURTURRO
SEVEN STEPS: THE COMPLETE COLUMBIA RECORDINGS OF MILES DAVIS 1963–1964
USA

FEATURE
The attention to detail really makes this packaging—from the fabric-covered book with its metal spine, through to the black, hotfoil stamp. It's also a great example of die-cuts that are both practical and attractive. In addition to the three die-cut panels, the box and CD wallets feature the same triangular indent, providing easy access to their contents.

\\ART DIRECTORS
GIULIO TURTURRO
HOWARD FRITZSON
\\\\\\\\\\\\\\
\\DESIGNER
GIULIO TURTURRO
\\\\\\\\\\\\\\
\\CLIENTS
LEGACY RECORDING/
SONY MUSIC
ENTERTAINMENT
\\\\\\\\\\\\\\
\\PROJECT
7-CD BOX SET IN
FABRIC SLIPCASE
\\\\\\\\\\\\\\
\\SPECIFICATION
COMPLETE PACKAGE:
FABRIC-COVERED,
94-PAGE HARDBACK
BOOK WITH VELLUM
FLYSHEETS AND BLACK
HOTFOIL STAMP;
2-COLOR PMS PLUS
VARNISH; 7-CD SLEEVE
COMBINATION WITH
POLISHED NICKEL SPINE
\\\\\\\\\\\\\\

Giulio Turturro wanted to create packaging that would reflect Miles Davis and his group's music and sense of style. Clean, crisp, and cool; white shirts, gray suits; simple and understated, with a metallic edge. Needing to house seven CDs as well as plenty of archive images, the only real requirement was that everything sit together well as a user-friendly cohesive unit. Giving the packaging an edge of the smoky, mid-1960s jazz scene, Giulio printed the package in silver and black inks with a varnish. Even the fabric is silvery—not to mention the metal spine and the CDs themselves. Capitalizing on the simple Swiss style that was popular in the period, Giulio has used Helvetica and a contrasting script font. As an unexpected twist, the CDs are adorned with abstract expressionist drawings of the era, as well as a numeric bar system that organizes the CDs and sleeves.

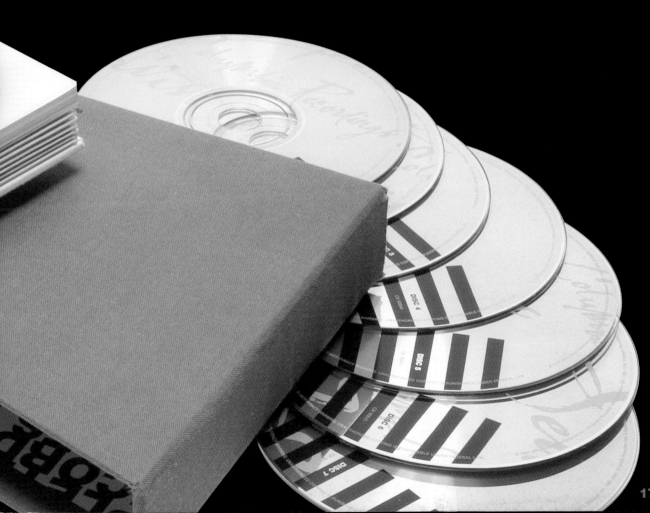

110 RICHARD CHARTIER
RICHARD CHARTIER & VARIOUS ARTISTS: RE'POST'POSTFABRICATED
USA

\\ART DIRECTOR
RICHARD CHARTIER

\\DESIGNER
RICHARD CHARTIER

\\CLIENT
DSP, ITALY

\\PROJECT
CD PACKAGING

\\SPECIFICATION
2-CD / DOUBLE
GATEFOLD PACKAGE
2 PANTONE SPOT
COLORS

The packaging in this project was designed to hold two CDs—*Post'PostFabricated* along with *Re'Post'PostFabricated*—remixed and remastered recordings of 1998 release *Postfabricated*. Printed in just 2 colors and on an interesting choice of stock, the packaging makes elegant use of die-cuts.

FEATURE
The simple die-cut slots provide a nice, simple way of gaining access to the CDs.

\ AIRSIDE
\\\\\\ LEMON JELLY: SINGLE
\\\ UK \\\\\\\\\

\\DESIGN STUDIO
AIRSIDE

\\CLIENTS
LEMON JELLY/
XL RECORDINGS

\\PROJECT
CD SINGLE PACKAGING

\\SPECIFICATION
MULTIPLE CD SLEEVES
DIE-CUT WITH SERIES OF
DECREASING CIRCLES

Completely free of type, this packaging takes inspiration from the loops and samples of music that Lemon Jelly use within its own music. Formed from two slipcases, the design features a series of colored circles that decrease in size. The outer sleeve is die-cut to reveal the inner sleeve, and the inner sleeve is cut to reveal the CD inside, incorporating its central hole into the overall design.

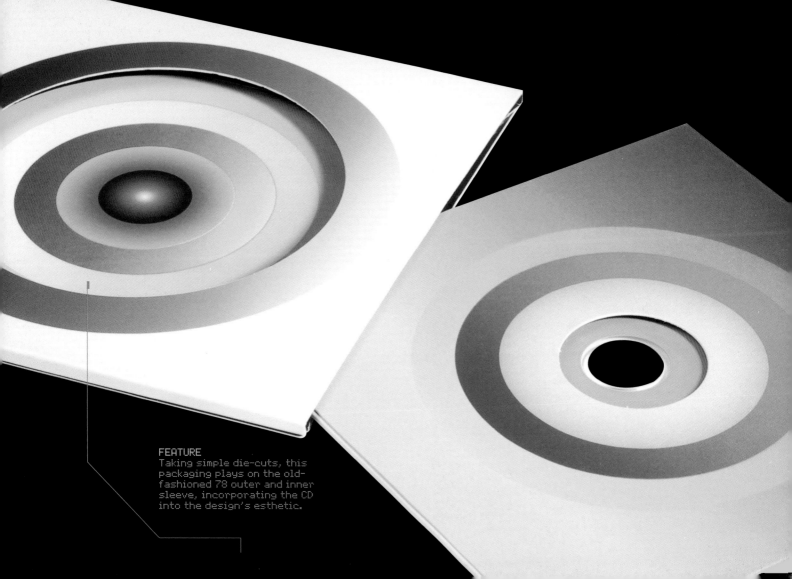

FEATURE
Taking simple die-cuts, this packaging plays on the old-fashioned 78 outer and inner sleeve, incorporating the CD into the design's esthetic.

\ **GLOSSARY**

CD+DVD

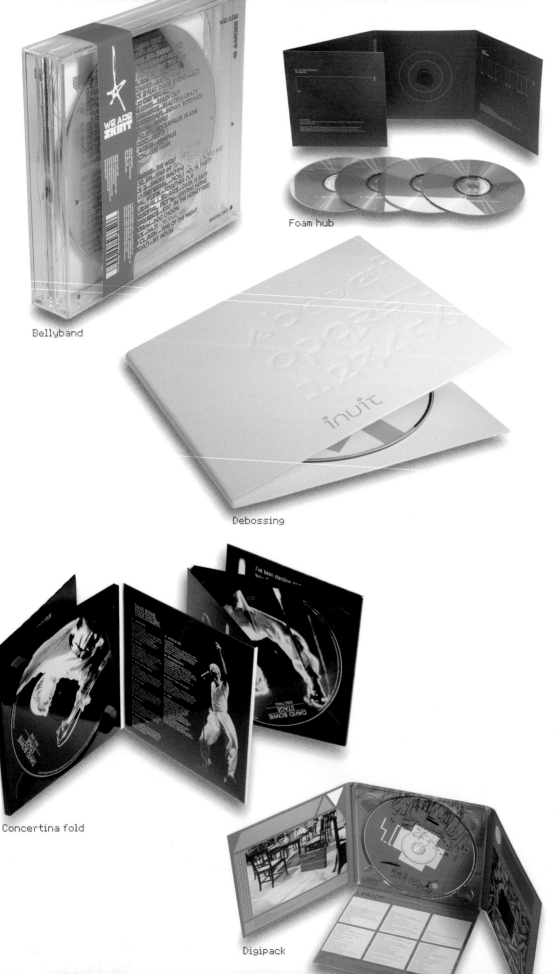

Bellyband

Foam hub

Debossing

Concertina fold

Digipack

\\ **BELLYBAND**
A strip of paper or other material that wraps around the middle of the case, book, or pack, preventing the covers from opening.
\\\\\\\\\\\\\

\\ **BLIND EMBOSSING**
see debossing
\\\\\\\\\\\\\

\\ **BOXBOARD**
Uncoated, pulped board usually used for making packing boxes.
\\\\\\\\\\\\\

\\ **COATED STOCK**
A smooth, hard-surfaced paper good for reproducing halftone images. Created by compressing the stock and coating the surface with china clay.
\\\\\\\\\\\\\

\\ **CONCERTINA FOLD**
Pages folded in a zigzag manner, like the bellows of a concertina.
\\\\\\\\\\\\\

\\ **CMYK**
See inks
\\\\\\\\\\\\\

\\ **DAY-GLO INKS**
See inks
\\\\\\\\\\\\\

\\ **DEBOSSING**
Pressing a surface detail down into the page. Also known as blind embossing.
\\\\\\\\\\\\\

\\ **DIGIBOX**
See digipack
\\\\\\\\\\\\\

\\ **DIGIPACK**
A generic term for any cardboard CD case. The name stems from the trademarked Digipak, a jewel case–style plastic CD tray glued inside a folding cardboard case. Originally thought of as a more eco-friendly alternative to jewel boxes, they are used less than jewel boxes due to higher construction costs and inferior durability.
\\\\\\\\\\\\\

\\ **EMBOSSING**
Pressing a surface detail up into the page, through the use of a male and female form.
\\\\\\\\\\\\\

\\ **FLUORESCENT INKS**
See inks
\\\\\\\\\\\\\

\\ **FOAM HUB**
A cylindrical foam or rubber device usually glued to the inside cover of a book or pack. It holds a CD by gripping through its hole.
\\\\\\\\\\\\\

\\ **FOIL BLOCKING**
A printing method that transfers a metallic foil to the page through the application of a metal block and heat.
\\\\\\\\\\\\\

\\ **FOUR-COLOR PROCESS**
See inks
\\\\\\\\\\\\\\

\\ **GATEFOLD**
A process whereby a long sheet of paper is folded into panels or pages, starting from the far left and far right, so that the pages meet in the middle.
\\\\\\\\\\\\\\

\\ **GSM**
Grams per square meter. A bulk weight which gives an indication of the thickness of paper.
\\\\\\\\\\\\\\

\\ **INKS**
Almost all mass-produced print uses lithographic inks. As a rule, full-color (four-color) printing is achieved through the combination of four process colors: cyan, magenta, yellow, and black (CMYK). However, additional "special" inks, such as fluorescents or metallics (creating shiny, gold, or silver effects), can also be used to produce distinctive results.
\\\\\\\\\\\\\\

\\ **JEWEL CASE**
A three-piece plastic case which usually contains a CD along with the liner notes and a back card. Two opposing transparent halves are hinged together to form the casing, the back half holding a media tray that grips the disc by its hole. The front lid contains two, four, or six opposing tabs which keep liner notes in place. Double albums can be packaged in a normal jewel case with a hinged media tray, or in a double jewel case with a hinged door at the front and the back.
\\\\\\\\\\\\\\

\\ **LETTERPRESS**
In letterpress, the oldest printing technique, a raised surface is inked and then pressed against a smooth stock to obtain an image in reverse.
\\\\\\\\\\\\\\

\\ **METALLIC INKS**
See inks
\\\\\\\\\\\\\\

\\ **NEWSPRINT**
A low-cost, low-quality paper used in the printing of newspapers. Made by a mechanical milling process without the chemicals that are usually used to remove lignin from the pulp. It generally has an off-white cast and distinctive feel.
\\\\\\\\\\\\\\

\\ **PANTONE**
The Pantone Matching System is an industry-standard series of ink colors used for spot or special colors.
\\\\\\\\\\\\\\

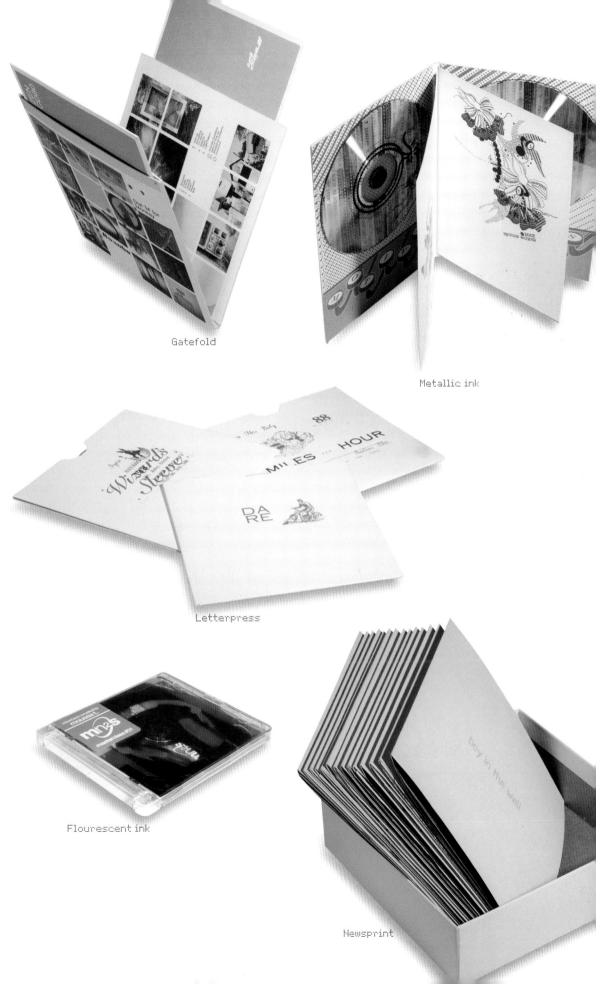

Gatefold

Metallic ink

Letterpress

Flourescent ink

Newsprint

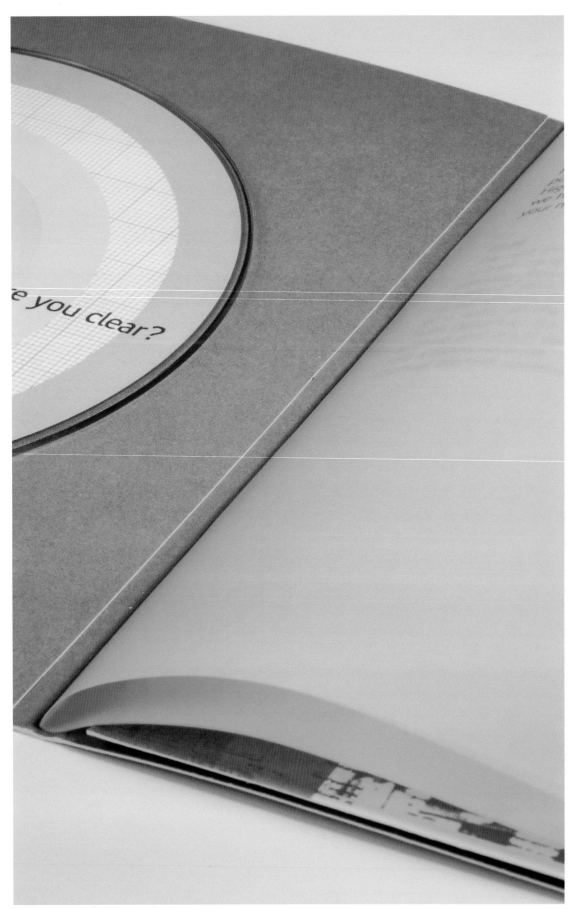

Roll fold

\\ **PERFECT BINDING**
A binding method in which pages in the gatherings of a book are notched along their uncut edges and glued together in the spine. The result is not usually as strong as a thread-sewn volume. However, this method allows for greater flexibility in the number of pages, and enables a variety of different stocks and printed sheets to be compiled in different sequences.
\\\\\\\\\\\\\\

\\ **PMS**
See Pantone
\\\\\\\\\\\\\\

\\ **POLYPROPYLENE**
A flexible, plastic sheet available in many different colors, including clear and frosted.
\\\\\\\\\\\\\\

\\ **PROCESS COLORS**
See inks
\\\\\\\\\\\\\\

\\ **REVERSED OUT**
See reversed type
\\\\\\\\\\\\\\

\\ **REVERSED TYPE**
Letters left unprinted, but with the surrounding area printed, allowing the type to reveal the base color of the stock or material.
\\\\\\\\\\\\\\

\\ **RING BINDING**
See wire binding
\\\\\\\\\\\\\\

\\ **ROLL FOLD**
A process whereby a long sheet of paper is folded into panels or pages starting from the far right, with each subsequent panel folded back toward the left; it is effectively rolled back around itself.
\\\\\\\\\\\\\\

\\ **RUBBER HUB**
See foam hub
\\\\\\\\\\\\\\

\\ **RUBBER STAMPING**
A craft in which an ink is applied to an image or pattern that has been carved, molded, laser-engraved, or vulcanized onto a sheet of rubber. The rubber is often mounted onto a more stable object, such as a wood or acrylic block, to produce a more solid instrument. The ink-coated rubber stamp is then pressed onto any type of medium, transferring the colored image in the process.
\\\\\\\\\\\\\\

\\ **SADDLE STITCHING**
The standard method for binding brochures and magazines. The process involves gathering the pages to be bound, stitching and cutting wire through the folded edges to give the feel of a stapled document.
\\\\\\\\\\\\\\

\\ **SCREEN PRINTING**
A printing method involving the application of ink to a material surface with a squeegee, through a fine silk mesh. This achieves a much denser application of ink than lithography and may be used on a great variety of surfaces.
\\\\\\\\\\\\\\

\\ **SHOW THROUGH**
Most commonly used with thinner stocks, this is where ink can be seen through the stock from the reverse side.
\\\\\\\\\\\\\\

\\ **SILK SCREENING**
See screen printing
\\\\\\\\\\\\\\

\\ **SLIPCASE**
A protective box with one edge open in which a CD or DVD case can be stored.
\\\\\\\\\\\\\\

\\ **SPECIAL INKS**
See spot color and Pantone
\\\\\\\\\\\\\\

\\ **SPIRAL BINDING**
See wire binding
\\\\\\\\\\\\\\

\\ **SPOT COLOR**
A special color not generated by the 4-color process method.
\\\\\\\\\\\\\\

\\ **STOCK**
The paper or other material on which something is printed.
\\\\\\\\\\\\\\

\\ **UNCOATED STOCK**
Paper that has a rougher surface than coated paper. Both bulkier and more opaque, it is less compressed than coated stock.
\\\\\\\\\\\\\\

\\ **WIRE BINDING**
WIRE-O BINDING
A binding method by which a thin spiral of wire is passed through a series of prepunched holes along the edge of the pages to be bound.
\\\\\\\\\\\\\\

\\ **WIRE STITCHING**
See saddle stitching

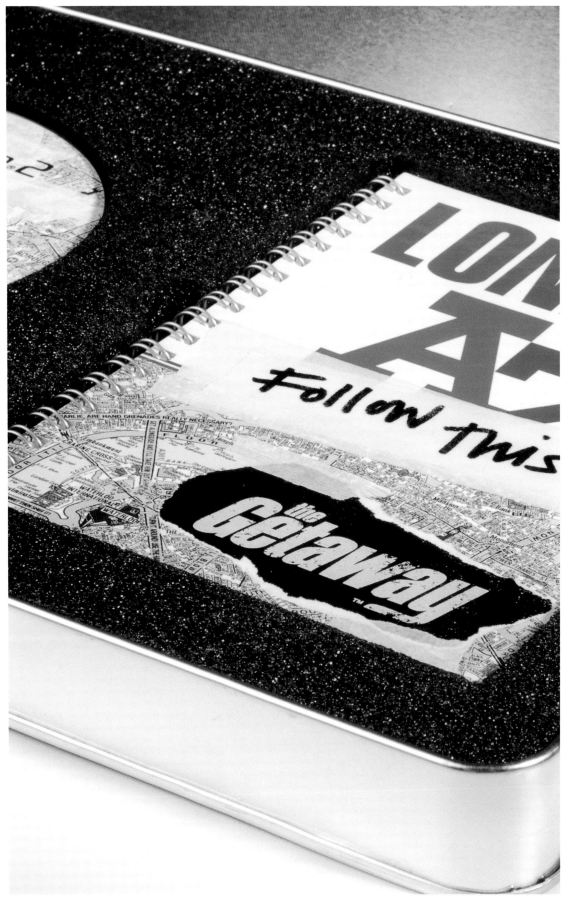

Wire-O binding

abstract expressionism 179
accordian-style packaging 33
Adapt or Die: Ten Years of Remixes 130–31
Ahrens, Justin 1-66
Airfix kits 145
Airside 90, 181
album covers 60
En Aldeles Forferdelig Sykdom 96
Alejadinho 151
Alexander, Rob 98
Alienoid Starmonica 102
The Aliens 102
Aloof Design 16–17
Aloof, Sam 16
An Alternative Ritual 43
aluminum foil 39
American Idiot 87
Anderson, Gordon 102
animations 90
Anjali Sisters 16
antistatic bags 35
Are You Clear? 22–23
Arjowiggins 160
The Ark 176
art deco 177
Arthur, Joseph 30–31
Astronaut: The Tour 168
Atkatz, Ted 91
Atkins, David 160
Atkinson, David 23, 25
audiovisuals 36
Augusto, Yomar 151
Azurdia, David 20, 160

Bache, Mikkel 146
Bacon, Billy 47
Bad Taste Records 50
Bakelite radios 74
bar codes 68
Bare n' Blue 166
BBC 22–25
The Beat Suite 71
bellybands 33, 43, 116
The Berkeley Hotel 79
Bernstein, Gregg 27, 114–15
The Best of R.E.M. 88
Bilheimer, Chris 12, 42, 87, 89, 143
blank media 66
Blast 20, 22–25, 52–53, 160–61
Blind 98
Bloodbank 52
Blueshift 124–25
BMG 70, 76, 80
Bolton, Chris 127

Bombshelter Design 30–31
Bonobo 60–61
booklets 36, 42, 51, 59, 61, 64, 68, 74–76, 79–81, 126, 132, 136, 151, 167
books 7, 30, 87, 98, 160, 169, 178–79
Bowden, David 56, 111
Bowden, Neil 59
Bowie, David 68–69
boxboard 16, 32
Boxed 80
brands 7, 24
A Breach of Etiquette 134
brochures 38
brown paper 48–49
Bruno Porto Comunicaçao (BPC) 46–47
budget 6–7, 16–17, 21, 23–24, 31, 33, 35, 52, 60, 64, 73–74, 76, 85, 99, 104, 115, 124, 126, 128, 130, 134, 136, 145, 151–52, 158, 165, 170, 173
Bullet in a Bible 143
Burgess, Paul 73
Burning Heart Records 99
Buzzin' Fly Records 128, 132

Calling Off Today 114
Canadian-bound covers 22–23, 25
Capitol Records 104
Capulet 152
cardboard 28, 89, 107
cards 7, 68, 90, 166
Carter Wong Tomlin 167
Mr Cato 166
CD-ROMs 52
cell phones 120
Chadwick, Peter 26, 56, 59, 111
Chantler, Jason 164
charities 52
Chartier, Richard 55, 180
Christmas 122
Chromeo 127
Chronictown 12–13, 42, 87–89, 142–43
cigarette-style boxes 79
clamshell 64, 68
Coast 139
coated stock 75, 151
coffee-table books 7, 31, 36
collections 6–7, 54, 64, 75, 77
colors 23
Comfort of Strangers 26
comics 169
commercial production companies 15
competition 51

The Complete Columbis Recordings of Miles Davis 178
concertina pack 69
copper blocking 30–31
Le Corbusier 118
cost 6, 15, 32, 40, 83, 87, 107, 118, 127, 169–70
Costello, Fin 64
Cox, Martin 20, 52
Crazy Diamond 85
createandconsume 136–37, 140–41, 152–53
CRI 124–25
Crush Design 35, 71, 172–73
ctrlaltdelete 34
Cube Juice 39, 82–83
Cube World 83
Culture Club 139
cut-throughs 122

D&AD 52
D-Fuse 112–13
D-Tonate_00 112–13
Da Lata 172–73
databases 52
Davis, Miles 126, 178–79
Day, Andrew 54, 64, 118, 169
Day-Glo 141
debossing 30–31, 160–61
Defected Records 111
Deluxe, Tim 58
999 Design 48–49
designers 66
Designers Dimensions 100
DESQ 170–71
Dial "M" for Monkey 60
die-cutting 7, 10–11, 16, 21, 43, 52, 55, 70–71, 74, 76, 80, 84, 123, 130–32, 136, 152, 154–55, 158, 162, 164–67, 169–76, 178, 180–81
Digibox 111
Digipak 27, 50, 63–65, 69–70, 80, 96, 105, 128, 138, 143, 147
directors 15
Discograph 19
distressing 115
DJ Spinna 71
Donohue, Peter 19, 171
Dowling, Robert 123
Dragonfly 98
drawers 169
Drewe Issue 169
The Droppin' Sides 46–47
DSP, Italy 180
Dueques, Isabel 40
Duran Duran 54, 168

EBTG 131
edutainment 170
elastic fastening 51
Eli Digital Imaging 174–75
Ellul, Jamie 160
embossing 7, 20, 38, 63, 129, 151, 160–61
embroidery 18–19
EMI 26, 65, 68–69, 102, 131, 176
Emmy Awards 77
envelopes 43
Ernstberger, Matthias 51
Eskimo Records 127
esthetic 7, 13, 34, 67, 86, 116, 181
Etiquette Recordings 134
Eurythmics 80–81
Evans, Darren 68–69
Everything But The Girl 130
Explosion 39

Fältskogg, Agnetha 76
Faulkner, Michael 113
Feral Media 32
Ferro, Pablo 128, 132
file boxes 90
file exchange 113
Flashman 118
flip-top boxes 54
14th Floor Records 30
fluorescents 7, 72, 94–96, 108, 134, 170
flysheets 179
foam hubs 55
foil blocking 18–19, 36, 38, 40, 85, 108–11, 122, 128–29
foil stamps 142
folds 7, 13, 77
fonts 118, 126, 128, 131–32, 151, 177, 179
format 7, 170
Free 120
French's craft paper 74
Fritzson, Howard 179
Funkstorung 113

Gabriella Music 147
Gagosian Gallery 37
gatefold packaging 34, 54, 60–61, 64, 71, 75–77, 84, 132, 136, 141, 144, 147, 152, 180
Genesis 65
The Getaway 48–49
Gifford, Colin 160
Gifford, Giff 20, 23, 25, 52
giftboxes 38
Gill, Gilberto 40
Gilmore, Stephen 100, 108

Gilsenan, John 128, 131–32
Gleason, Tim 38, 77
graffiti 71, 95
Green Day 87, 143
The Greenhornes 21
Gropius, Walter 118

hair 48–49
halftone 42, 136
handmade items 18, 21, 54, 115, 151, 166–67
handwriting 27, 49, 87, 151, 166
hardboard boxes 38
Hare, Sam 167
Hartung, Katya 32
Harvard University Graduate School 155
Hassenplug, Dan 166
Hawcock Books 169
Hawcock, David 169
headphones 11
healing 17
heat-sealing 20
Hedger, Neil 167
Hess, Fabienne 105
Hey Mercedes 115
Highly Evolved 104
Hinkula, Antti 119
Hiorthøy, Kim 96–97, 138
The Hit Music Company 85
Hodgson, Sam 34, 144–45
Höller, Carsten 36
Hotel 84
hotfoil stamps 178–79
Howard, Dominic 60
Hreinsdóttir, Erna 21
Hucklebuck 167
!Huff 38
Hughes, John 15
humor 46–47
hysteresis loops 35

illustrations 21, 26, 56, 90, 102, 118, 134
Iluminuras 40–41, 150–51
In Time (1988–2003) 42
5inch.com 66
instructions 46–49
interactivity 28, 113, 166, 170
Interkool 36–37
Inuit 160
investment 6
invisible pockets 51
Ishiura, Masaru 39, 82–83, 86, 134
Iwant Design 128–33
lyrie! 106–7, 135

Jensen, Josh 166
jewel cases 7, 10, 26, 35, 40, 56, 82–83, 86, 98, 104, 107, 114–16, 119–20, 124–26, 134, 139, 142, 151, 167, 177
Un Joli Mix Pour Toi 127
Jones, Mat 10–11
Jones, Rob 102
The Joneses 14–15
journalists 49
Jugendstijl 177

Kapok board 24–25
Karlsson, Hjalti 104–5, 125
karlssonwilker 104–5, 124
Kassinger, Rob 91
keepsakes 32
Ken Ishii 113
Kid 606 113
Kids Christmas 122
Kirin 108
kitsch 18
Kivar 6 stock 77
Kjellberg, Jonas 76
Klausen, Brad 47
Klausen, J. A. 47
Klimt, Gustav 177
Koch, Daniel 26
kraft paper 33
Krasilnikoff, Peter 156–57
Kukusi 54, 118, 168–69
Kumar, Barry 98

labels 14, 32, 35, 38, 74, 113, 156
lace 18–19
Larner, Zachery 30
Lau, David 74
Legacy Recording 179
Lemon Jelly 90, 181
Let Airplanes Circle Overhead 144
letterpress 7, 106–7, 123, 135
library effect 14
lighting 169
Lights and Sounds 142
Lik, Kerri 166
LINE 55
litho print 16
The Little Ginger Club Kid 58
Loewy 72–73
longevity 88
Loses Control 115
The Lovers 18
LSD Studio 80–81
Lubalin, Herb 127
Lucky Jim 28
lyrics 13, 21, 87, 98, 115

MacLean, John 102
madebygregg 27, 114–15
magazines 13
magnetic fastenings 77
mailing 38, 170–71
Manga 118
manifestos 155
manila envelopes 28
mantras 17
manuals 74
Martinez, Marcelo 47
Masterclass 01 10–11
Masters at Work 110–11
matchbook-style wallets 78
matte 27, 89, 96, 138
matte-celloglazing 158, 164
May, Chris 66, 91, 147
Meredith, Michael 155
Mies van der Rohe, Ludwig 118
mirror board 102
MN2S 10–11
mnemonics 120
modernity 20
Mondagreens 34
Money Brothers 99
Monoke 164
montage 24, 39, 98
Mosely, Andy 20
Motivesounds Recordings 34, 136, 141, 144, 152
MTV 20, 113
Muggie Ramadani Design Studio (MRDS) 146, 156–57, 162–63, 174–75
musicians 7, 11, 40, 66

Nascimento, Milton 40, 150–51
navigation 75
Newson, Marc 100, 120
newsprint 12–13, 42, 75, 169
Ninja Tunes 61
No Future 63
North 94–95, 100–101, 108–9, 120–22
note cards 7
notebooks 27
Notes for those Beginning the Discipline of Architecture: Alternate Ending 1: The Glimmering Noise 154
NYCO 91

oils 18–19
Once in a Lifetime 51
O'Neil Printing 166
opera 17
Ordnance Survey maps 49
Orton, Beth 26

Osterhus, Sofia 119
Our Troubles End Tonight 28
overprinting 114

Palm Pictures 173
panoramas 50–51
PANTONE 40, 50, 55, 80, 127, 141, 144, 146, 152, 156, 162, 174, 180
paper 160–61, 166
Passion 108–9
Pearl Jam 47
Pentagram Design 78–79
peonies 17
Perfect Match 70
perforations 10–11, 43
Peter and Paul 18–19, 170–71
Peyton, Chris 65, 102, 118
Ph.D 14–15
photo albums 40, 58
photocopies 32–33
photography 66, 90, 123, 145–46, 156–57, 166
Piercy, Clive 15
Pietá 150
Piratautorizado 46
plastic wallets 52, 68–69, 118
plastics 20
Play Label 86
Playstation 2 48–49
Pluer, Jane 79
pochette 102
Polaroids 27, 48–49
polybags 91
Polyvinyl Records 27, 114
pop-ups 7, 169
Portella, Cristina 40, 151
portfolios 123
Porto, Bruno 47
portrait format 68
Posner, Lori J. 38, 77
postcards 68, 90
posters 12–13, 28–29, 42, 56, 68, 90–91, 102, 113, 116, 127, 132, 135, 160
PostFabricated 180
postproduction process 22, 24–25
pouches 18–19
Presents Blaze 110–11
press packs 48–49
print 7, 15, 32, 34, 40, 169
print runs 31, 118, 124
profit 6

Q101 Radio 43
QDF 35
quality 7, 18, 32–33, 36, 64, 75, 89, 123, 161

R. Newbold 86
R.E.M. 12–13, 42, 88
radio stations 32
radio-shaped container 74
Ramadani, Muggie 146, 156, 162–63, 174–75
ransom notes 49
Raw Digits 62–63
rawness 21
Reardon, Paul 19, 171
record boxes 88–89
recycling 16–17, 40, 56
Red Design 28–29, 60–63, 116–17
The Red Hot Chili Peppers 43
The Red Hot Valentines 27, 114
Red Records 28–29
Red Star Entertainment 98
The Redroom 64–65, 68–69, 102–3
Re'Post'PostFabricated 180
Reprise 87, 143
The Reptile House 84–85
reversing out 17, 34
Rhino 51
ribbon 152
ring-bound finish 58
Rinzen 158–59, 164–65
Rise Robots Rise 63
roll fold 42–43, 50, 96, 123, 131
romance 18–19
Room 40 158, 164–65
Rosauro, Marcello 47
78rpm 74, 181
rubber 20
rubber stamps 167
Rule 29 166
Rune Grammofon 96, 138
Ruscha, Ed 152
Rush, Carl 35, 71, 173
Rushworth, John 79
Rysser, Claus 174

saddle stitching 126
Sagmeister, Inc. 51
Sagmeister, Stefan 51
St Tropez 84
Sam's Town 167
Scanner 113
scrapbooks 42, 60, 98
Scrase, Andrew 16
screen printing 20, 24–25, 32, 40, 67, 75, 86, 91, 100–101, 116, 121, 124–25, 135, 143
Segura, Carlos 66, 91, 147
Segura Inc. 43, 66–67, 91, 147
self-initiated 21, 73
Sells, Lance 56
Seven Steps 178

show-through 65, 95, 100, 111, 118, 142, 146–47, 166
shrink wrapping 104
signage 75
silhouettes 34
silk 18–19, 61, 162
silk screening 64, 66, 77, 151
Sip Design 56–57
Skint Records 116
Skirl Records 105
Skoud 140–41
Smith, Barry 136, 141, 152
snowflake effect 122
songs 7, 13, 21
Sony 48, 76, 80, 179
Sopp Collectives 32
Soul Heaven 110
Sound & Vision 68
Sound Virus 108–9
Spectral lemon 23
Spectrum: The Anthology 126
Spencer, Leslie 147
spines 14, 78, 90, 136, 138, 141, 147, 178–79
spiral-bound booklets 59
Splendorgel 23, 25
spot varnish 65, 80, 115
Spunk 96
sputter 114, 157
Stage 69
standard inserts 7, 11
staples 27, 46–47, 78
Starbucks 122
State of the Ark 176
Steinegger, Christoph 36
Stevens, Laurence 80–81
stickers 10–11, 28, 52, 74, 80, 157, 173
Stipe, Michael 13
stochastic screening 166
Stone, Scissors, Paper 86
storage 6
story-telling 7
stray threads 32
suburbs 15
Summer Fling 27
Super Collider 62–63
Supersilent 138
Suviala, Teemu 119
Sylvian, David 64
Syn 94, 108
Syrup Helsinki 119
Systems and Drafts 140

T-shaped packages 63, 71
T-shirt packaging 86
tactility 6–7, 20, 28, 33, 89, 102, 106–7, 123, 166

Talking Heads 51
Tank 98
target audiences 6
Teedot 162
teeth marks 52
Templeton, Ed 61
textbooks 63
texture 15, 24, 26, 40, 70, 110–11, 129, 172
TGB Design 39, 82–83, 86, 134
theater 75
There is an End 21
Tillblad, Ricky 70, 76, 176
Tin Drum 64
TNOP 66, 91, 147
To Die Alone 99
toys 82–83
tracing paper 68, 118
transparencies 11
trigger cases 66–67
Tundra Records 56
Tunng 32
Tunnicliffe, Paul 160
Turturro, Giulio 33, 74–75, 126, 178–79
Two 91
typefaces 17, 34, 160
typography 47, 52, 54, 64, 73, 76, 81, 90, 123, 127–28, 131, 136, 160, 166, 177

uncoated stock 27–28, 30–32, 43, 56, 59, 74–75, 110–11, 114–15, 119, 126, 162
Underwater Records 59
underwear 18
unwrapping 6
Urban Theory 71
USA Network 77
UV 39, 61, 70, 76, 80, 85, 116, 176

vacuum packaging 86
Vagrant Records 115
vampire teeth 52
Vanhorenbeke, Frederic 139
Verve Records 33, 74–75, 126
Victor Entertainment 39, 82–83
The Video Show 65
vignettes 84, 147
The Vines 104
vinyl 64, 71, 126
vinyl albums 60–61, 81
Virgin Records 64, 131

wallpaper 15, 21
Walse Custom Design 50, 99
Walse, Henrik 50, 99
Warner Bros 12, 42, 89

Warner Music Brasil 40, 151
Warren, David 98
watercolors 21, 26, 31
We Almost Made It 30
We Are Escalator Records 119
We Are Skint 116
WEA 12, 42, 87, 89, 143
Web sites 160
Webb & Webb Design 123
Welland, Richard 85
Weworkforthem 154–55
Whitaker, Adam 106, 135
Wilker, Jan 104–5, 125
Williams, Tony 126
wire stitching 25
Wood, Nick 94, 100, 108, 120, 122
Wood, Sean 48
The World is a Tragic Place, but there is Grace All Around Us, So Attend to the Grace 152
wraparound inserts 15
Wright, Frank Lloyd 118

X-rays 11
XL Recordings 90

Yellowcard 142
YESDESIGNGROUP 38, 77
Youworkforthem 154

Zion Graphics 70, 76, 176–77
Zip Design 26, 58–59, 110–11

THE CONTRIBUTORS

999 DESIGN	www.999group.co.uk
AIRSIDE	www.airside.co.uk
ALOOF DESIGN	www.aloofdesign.com
BLAST	www.blast.co.uk
BOMBSHELTER DESIGN	www.bombshelterdesign.com
BRUNO PORTO COMMUNICACAO	www.brunoporto.com
CARTER WONG TOMLIN	www.carterwongtomlin.com
CHRIS BOLTON	www.chrisbolton.org
COAST	www.coastdesign.be
CREATEANDCONSUME	www.createandconsume.co.uk
CRUSH	www.crushed.co.uk
D-FUSE	www.dfuse.com
ERNA HREINSDOTTIR	hexiadetrix3@hotmail.com
GIULIO TURTURRO	www.giulioturturro.com
ILUMINURAS	crisportella@terra.com.br
INTERKOOL	www.interkool.com
IYRIE!	www.iyrie.com
JONES	www.thejonesgroup.com
KARLSSON WILKER INC.	www.karlssonwilker.com
KIM HIORTHØY	rune@grappa.no
KUKUSI	andrew.day@kukusi.com
LOEWY	www.loewygroup.com
LSD STUDIO	www.lsdstudio.co.uk
MADEBYGREGG	www.madebygregg.com
MUGGIE RAMADANI DESIGN STUDIO	www.muggieramadani.com
NORTH	www.northdesign.co.uk
PENTAGRAM DESIGN	www.pentagram.com
PETER AND PAUL	www.peterandpaul.co.uk
PH. D	www.phdla.com
RED DESIGN	www.red-design.co.uk
RICHARD CHARTIER	www.3particles.com
RINZEN	www.rinzen.com
RULE 29	www.rule29.com
SAGMEISTER, INC.	www.sagmeister.com
SAM HODGSON	info@motivesounds.com
SEGURA INC.	www.segura-inc.com
SOPP COLLECTIVE	www.soppcollective.com
SYRUP HELSINKI	www.syruphelsinki.com
TANK	www.tankdesign.com
TGB DESIGN	www.tgbdesign.com
THE REDROOM	www.redroom.com.au
THE REPTILE HOUSE	richard@thereptilehouse.net
WALSE CUSTOM DESIGN	www.walsecustomdesign.com
WEBB & WEBB DESIGN	james@webbandwebb.co.uk
WEWORKFORTHEM	www.weworkforthem.com
YESDESIGNGROUP	www.yesdesigngroup.com
ZION GRAPHICS	www.ziongraphics.com
ZIP DESIGN	www.zipdesign.co.uk

Other titles in the Print and Production Finishes series

Print and Production Finishes for Brochures and Catalogs
Roger Fawcett-Tang
ISBN-10: 2-940361-23-1

This indispensable guide shows graphic designers how to create innovative brochures and catalogs. Extensive showcases, from areas as diverse as high fashion and mail order, reveal how the best in the business combine effective and innovative techniques and materials to convey clients' brand messages.

Roger Fawcett-Tang is Creative Director of Struktur Design, which has developed a reputation for clean, understated typography, attention to detail, and logical organization of information and imagery. It has won various design awards and has been featured in numerous design books and international magazines.

Print and Production Finishes for Promotional Items
Scott Witham
ISBN-13: 978-2-940361-68-7
ISBN-10: 2-940361-68-1

For ideas on everything from mass-mail flyers, billboard posters, lavish catalogs and calendars, to customized clothing, toys, badges, and bottles, *Print and Production Finishes for Promotional Items* is an indispensable ideas sourcebook and practical guide. By analyzing the best in the business, it gives readers a thorough understanding of materials, and of print and production processes that can be applied to any job. (Available from August 2007.)

Scott Witham is the founder and Creative Director of Traffic Design Consultants. He has previously worked for several of the UK's top design agencies.

Established in 1929, Loewy was the world's first design agency. Founder Raymond Loewy is something of a design legend. His many iconic works include the Coca-Cola bottle; identities for Shell, Exxon, and McLaren; the Greyhound bus, bullet train, and Studebaker car; and interiors for Concorde and Skylab.

Today Loewy is a full-service marketing and communications agency. Through creative excellence and effectiveness, the agency's 150-strong team constantly strives to keep Raymond Loewy's vision alive and relevant in the twenty-first century.

Loewy offers a broad range of core services, with expertise in disciplines as diverse as corporate identity, branding, brochures, advertising, Web sites, catalogs, packaging, sales promotion, and direct marketing.

ABOUT THE AUTHOR
LOEWY
LONDON
UK